Buffy

THE MAKING OF A SLAYER

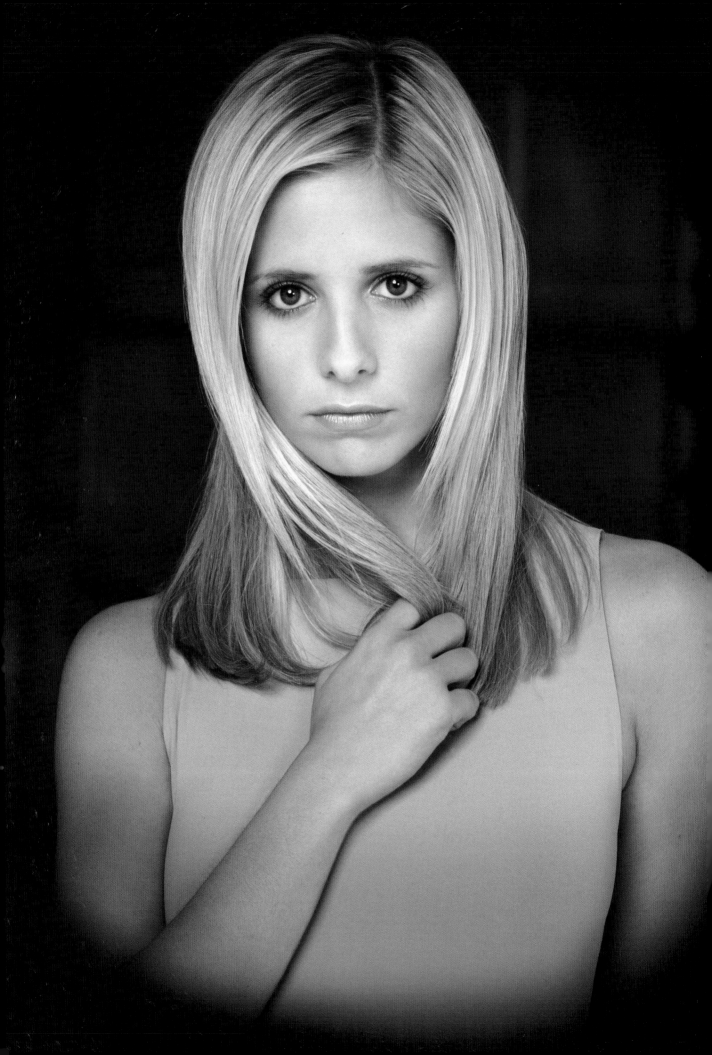

THE MAKING OF A SLAYER
THE OFFICIAL GUIDE

NANCY HOLDER

47NORTH

WHO ELSE COULD THIS BOOK BE FOR?
THANK YOU, JOSS.

Buffy: The Making of a Slayer is produced by becker&mayer!, Bellevue, Washington.
www.beckermayer.com

FIRST EDITION
Designer: Rosebud Eustace
Editor: Kjersti Egerdahl
Image Researcher: Kara Stokes
Production Coordinator: Shirley Woo
Product Developer: Lauren Cavanaugh
Managing Editor: Amelia Riedler

ISBN-10: 1612184138
ISBN-13: 9781612184135

Printed and bound in China

10 9 8 7 6 5 4 3 2 1

Published by 47North
PO Box 400818
Las Vegas, NV 89140

www.amazon.com/47north

CONTENTS

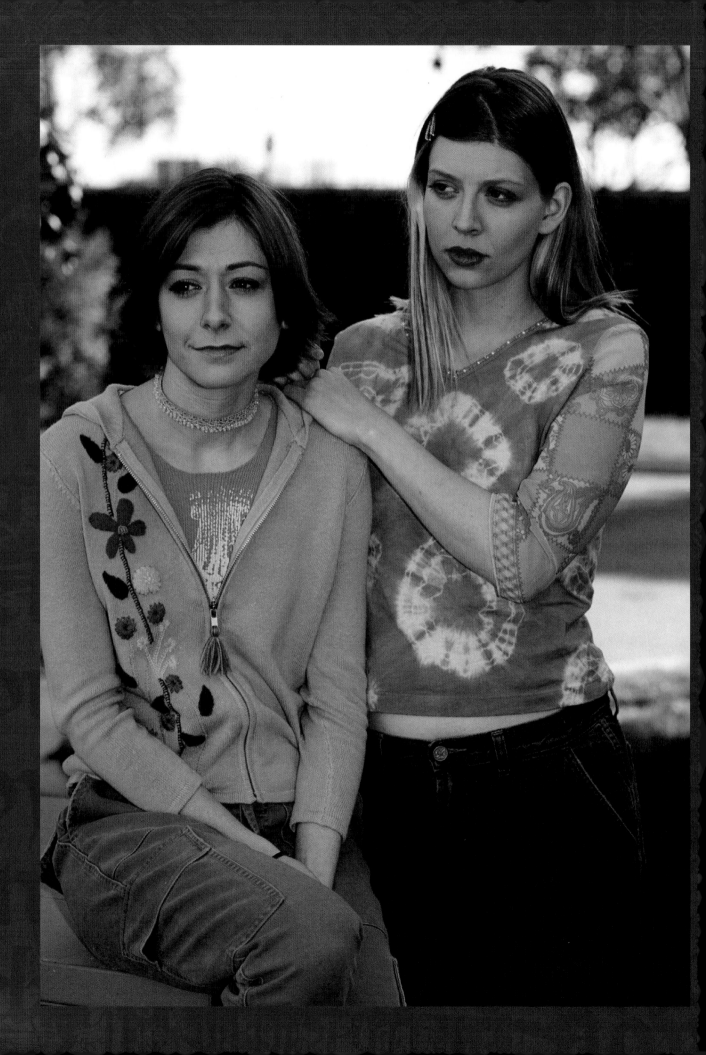

Foreword

If there's one thing I can say about my time on *Buffy the Vampire Slayer*, it's that Alyson Hannigan was right: I had no idea *what* I was getting myself into.

I remember the exact conversation.

Alyson—who will forever be enshrined in the science fiction and fantasy lexicon as Buffy Summer's best friend, Willow Rosenberg—was trying to explain to me how I was now a part of something that wasn't just entertainment, but a bona fide way of life. Of course, I had no idea what she was talking about. I was just there to do a couple of episodes of this sci-fi television show and that was it.

At least that's what *I* thought—little did I know back then how much this "sci-fi television show" was going to change my life.

Because Alyson was right: *Buffy* is so much more than just entertainment. It's a way of being that transcends its medium. It's opened minds, changed hearts, and shown people there are different and better ways to live—and it didn't just do it at home in the United States. No, *Buffy* became a worldwide phenomenon.

Without preaching from a soapbox, it tackled the day's hot-button issues, making grand statements about gender, sex, violence, and inequality—without talking down to its audience. The writing was clever, the relationships felt real, and there was at least one character each of us could identify with. In a nutshell, *Buffy* was smart, and it made you feel smart for "getting it."

But it wasn't just intelligence that marked *Buffy* as something different. In a world rigged to make us feel alone and insignificant, *Buffy* gave us hope. It made us feel as though we were a part of something bigger than ourselves; that we belonged.

If someone like Joss Whedon could find his way in Hollywood; if he could create an imperfect, human heroine like Buffy Summers and get someone as cool as Sarah Michelle Gellar to inhabit her; if this little mid-season replacement nobody cared about could get (and stay) on the air while, at the same time, growing a large and devoted audience of rabid fans . . . well, then maybe the Hellmouth was the place to be.

Even now, so many years after the end of the show, there are still new fans finding their way into Sunnydale. Buffy doesn't care that they're late to the game. She's been waiting for them—and she accepts all of them exactly as they are. Besides, no matter how many times you may have seen an episode, there's no such thing as an expert. I can guarantee there are always new and intriguing things to discover in *Buffy*; things that you somehow missed on previous viewings.

So as you dive into this lovely book, be prepared to lose yourself in its pages. As all initiated know: Once the Buffyverse has you in its clutches, it won't ever let you go.

—AMBER BENSON

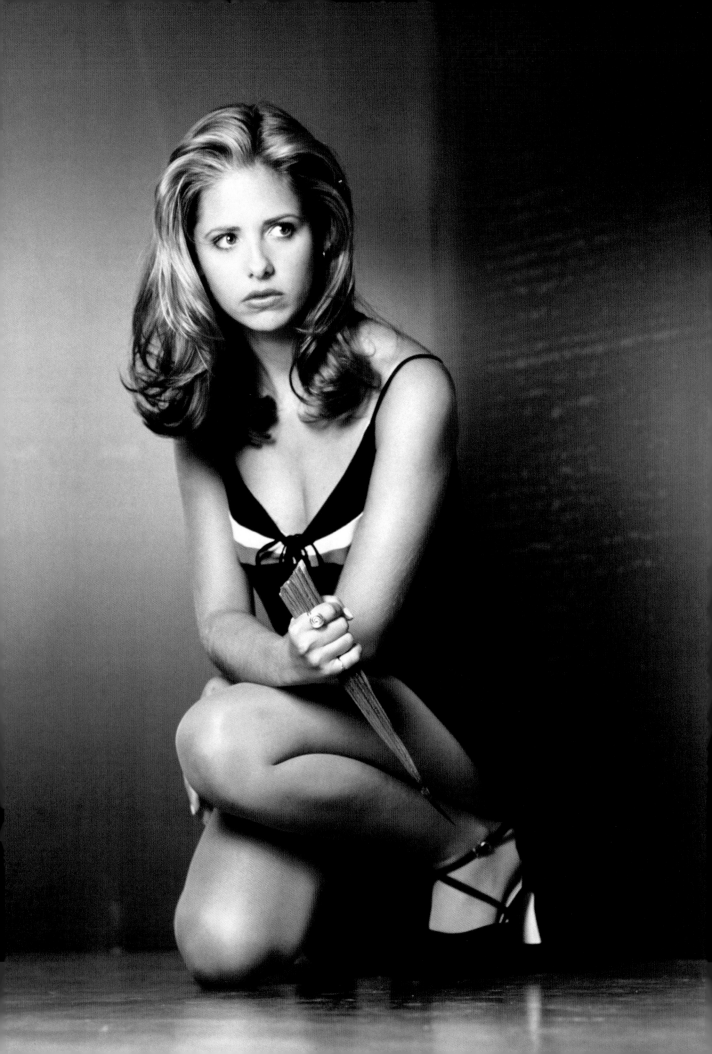

CHAPTER 1

Birth of Buffy

Joseph Hill "Joss" Whedon was born on June 23, 1964, in New York City. He attended Riverdale, a prestigious private school in New York, where his divorced mother served on the faculty. She took a half-year sabbatical in England during his sophomore year and he was enrolled in Winchester College, an all-male boarding school with the reputation of offering the very finest education in England. He says, "At Winchester, they tried to squash a lot of things. Certainly everything I wore or said bothered them, but at the same time I studied classic literature and drama with some of the greatest

He wrote "a sickening number of spec scripts" before landing his first job with *Roseanne*. His career progressed, and he was nominated for an Oscar for *Toy Story*. With his work on *Twister*, *Waterworld*, and *Speed*, he became known as a skillful script doctor—a writer who makes the already extant components of a script work together, rather than rewriting.

Meanwhile, he had been working on the script for *Buffy the Vampire Slayer*. "I've always been a huge fan of horror movies," he says, "and I saw so many . . . where there was that blonde girl who would always get herself killed.

I'd rather make a show 100 people *need* to see, than a show that 1,000 people *want* to see.

— Joss Whedon

teachers out there. You couldn't help but become more creative." He was invited to finish his studies there, and returned to the United States to go to college. He graduated from Wesleyan University with a degree in film. He's considered to be the world's first third-generation TV writer—a fate he resisted, because he felt initially that film was superior to television. His grandfather wrote for *The Donna Reed Show* and *Leave It to Beaver* in the 1950s, and his father worked on *The Dick Cavett Show*, *The Electric Company*, and *Golden Girls*.

I started feeling bad for her. . . . I thought, *It's time she had a chance to take back the night*." He jokes that the first incarnation of Buffy was "Rhonda the Immortal Waitress": "Just the idea of some woman who seems to be completely

PREVIOUS: Actress Sarah Michelle Gellar as Buffy Summers during Season I of *Buffy the Vampire Slayer*.

RIGHT: Joss Whedon, creator of *Buffy*, poses for a photo on set during Season I. He got the *Buffy* TV series onto the air five years after the film failed to make a splash at the box office.

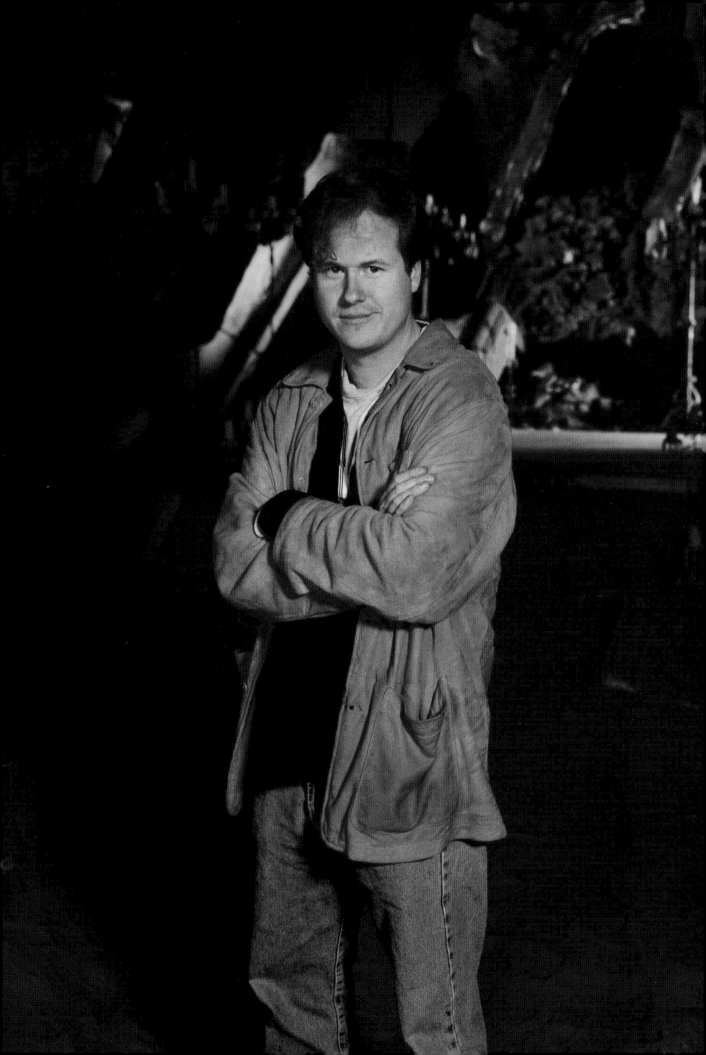

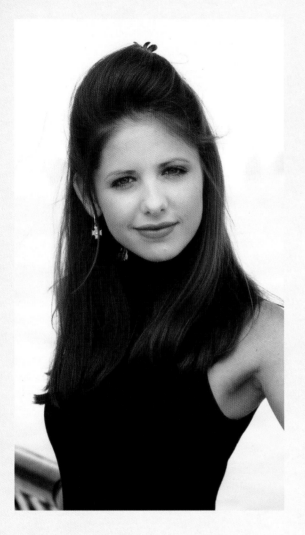

it would make a wonderful TV series, and pitched it as such before the movie came out. Nobody took her up on it. A movie deal was struck with Twentieth Century Fox and the film was rushed into production to make the summer schedule. Joss was on set during the shooting. Quick to spare the director, Fran Rubel Kuzui, from his ire, Joss says that he felt there were people working on the film who either didn't get it or didn't care, and he was so upset during production that he left. The film was released in 1992, and did not do very well at the box office. Joss moved to other things, and it seemed that the coffin lid had been dropped on *Buffy* forever.

But a couple of years later, *Buffy* director Fran Kuzui, who had originally bought the rights to *Buffy*, told Berman that there was some "theoretical interest" in *Buffy* as a TV series, and they agreed to try to put a presentation together. "We were contractually obligated to offer this to Joss," Berman recalls, because of his deal when the rights to his screenplay were originally purchased. "Everybody said he was a big movies guy now, and he'll never want to do this, including his agent, who said that to me on the phone. Then his agent called me back and said that, in fact, this was the only thing Joss *was* interested in doing."

One of the main points in the pitch for the show was that there were no young, empowered women on TV at the time. Joss says, "'Girl Power' was kind of a phrase, but it still wasn't a phase. And I was waiting for it." Joss and Berman began

insignificant, who turns out to be extraordinary." Because he was raised "by an extremely strong woman, uncompromising, fun, and funny," he says, "I wanted to make a somewhat . . . low-key, funny, feminist horror movie."

Gail Berman, who had started as the youngest female producer on Broadway and gone on to help launch *Mystery Science Theater 3000*, was working at the production company Sandollar when the original movie script for *Buffy the Vampire Slayer* came across her desk. She thought

pitching the series, but as Berman says, "People thought it was kind of a silly idea. There were lots of sets of rolling eyeballs when we left the room." Twentieth Century Fox expressed some interest, but the Fox network turned it down for broadcast. The WB, Warner Bros.' brand-new network, needed to build a viewership and thought a show titled *Buffy the Vampire Slayer* might attract young women. They ordered a twenty-minute presentation version of the pilot, grainy copies of which have since been uploaded in short segments by fans onto YouTube.

As soon as the pilot was ordered, Joss and Berman began a nationwide search for the actress to play Buffy. It wasn't easy: the pressure was on to find the perfect actress to embody Joss's vision of a sassy blonde who could "trounce" monsters.

Finally Sarah Michelle Gellar came to their attention. The dark-haired seventeen-year-old had already received a Daytime Emmy Award for her work on *All My Children*. She prepared for the role by watching the movie, not realizing that Joss was intent on recapturing his original vision of the Slayer. She was originally offered the part of Cordelia, but she continued to discuss the role of Buffy with Joss, trying to understand his vision—and auditioned "*quite* a few times" before landing the Buffy role.

With the pivotal character cast, the rest of the cast was assembled with an eye toward actors whose personalities would work well together with Gellar's and also successfully inhabit their new characters. Many of the actors

who auditioned for the role of Buffy's Watcher delivered a Rupert Giles who was stuffy and wooden, but Joss and Company appreciated the more nuanced read presented by British actor Anthony Stewart Head. (He had achieved fame

LEFT: Sarah Michelle Gellar as a brunette, circa 1994. In 1995, she won a Daytime Emmy award for her role on *All My Children*.

ABOVE: Publicity still of actor Anthony Stewart Head as Rupert Giles, taken on the library set.

The Creative Process of Joss Whedon

"I REALIZE THIS IS NOT *CITIZEN KANE*. . . . DURING THE CREATIVE PROCESS, ONE TENDS TO FEEL AS IF ONE IS MAKING *CITIZEN KANE* BECAUSE OF THE DIFFICULTY INVOLVED, YOU HAVE TO . . . GET YOURSELF INTO THE MIND-SET WHERE EVERYTHING YOU'RE DOING IS INCREDIBLY IMPORTANT AND GENIUS. . . . EVERY DECISION YOU MAKE AS AN ARTIST IS IMPORTANT TO YOU."

—*Joss Whedon*

Exposed

The idea of having nothing to hide behind is a recurring theme in Joss's creative process. Trying to avoid shooting "radio with faces," Joss decided to film an episode "Hush," [4x10], containing twenty-eight minutes without dialogue. Observing that "when people stop talking, they start communicating," he wrote another episode, "Once More with Feeling" [6x07], where the characters couldn't speak to one another; they could only sing. "The heart of the piece [is that] you say the things you wouldn't say if you weren't singing and the things you don't want to say, or perhaps shouldn't say, or need to say."

In "The Body" [5x16], he eliminated music because "music is a comfort," and he wanted none to be had during the long and painful process of coming to grips with the death of Buffy's mother. "The show only works if it resonates. Emotional resonance is true life."

He was also a huge fan of the "oner," which is a long take that follows the actors without stopping to shoot from different angles. Oners are risky because everyone has to work in sync: all the actors must hit their marks; camera, sound, and lighting must work for the entire long take; and there is no additional footage from other takes to splice together to create the best version of a scene. Joss noted that because he was the showrunner, he had the luxury of writing these in for himself where other showrunners might not have taken the time and trouble to film them.

Shock Treatment

Joss has stated that he always wanted the show to work visually, and that it was always a struggle to avoid complacency and "falling back on tricks." He had to make creative choices early on about how to show Buffy's world without relying on shock value. For example, he decided that his vampires would only occasionally morph into "vamp face," in part so that they would blend into the populace and heighten the tension, but also because "when Buffy was fighting them [the vampires], it was important to me that they look like demons, that they

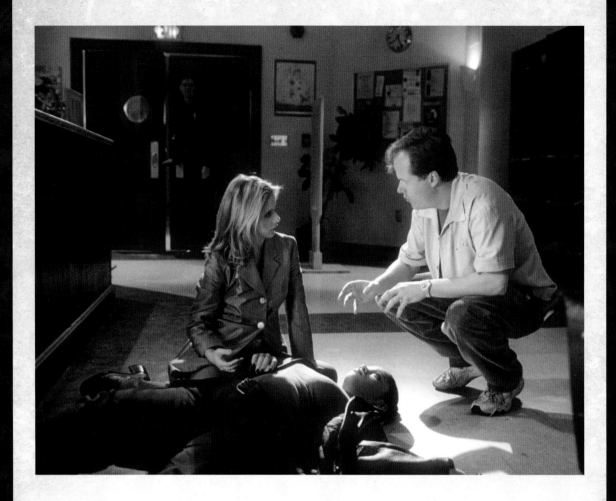

looked like monsters, because I really didn't think I wanted to put a show on the air about a high school girl who was stabbing normal-looking people in the heart." During the shooting of Kendra's death in "Becoming, Part 2," there were several retakes to cut back on the amount of blood shown after Drusilla slit her throat. The "efforts" (moans and cries) of dying demons and monsters were also louder on the sound track than those of humans.

Switching It Up

Joss often experimented with point-of-view shifts created by characters' swapping bodies or appearing magically as other characters. The most obvious example of this is the presentation of the First Evil, the source of all evil in the world, which can appear to Buffy and her friends only by taking the forms of the deceased—including vampires. "The First" manifested as characters who had died on *Buffy*, including Jenny Calendar, Joyce Summers, Glorificus, the Master, Cassie Newton, Mayor Wilkins III, Drusilla, Spike, and Buffy herself. Another example of this occurs in "A New Man," when Giles, feeling unappreciated, is transformed into a demon and can't communicate with anyone (except Spike, who speaks his demonic language), and in "Who Are You?" when Buffy and Faith swap bodies and literally see each other's point of view. In "The Killer in Me," Willow's grief and guilt when she attempts to move on from the death of her lover, Tara, are shown when she magically appears as Warren, Tara's murderer.

ABOVE: Joss Whedon directing Sarah Michelle Gellar in the scene in "Becoming, Part 1" where Buffy finds her fellow Slayer Kendra Young murdered.

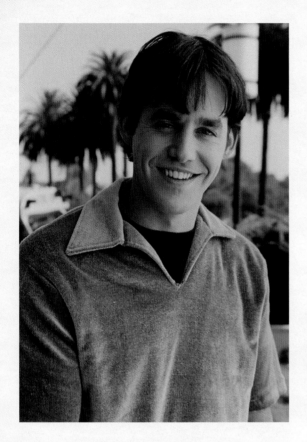

interview. "I didn't know what a mark was. What a *camera* was." Casting director Marcia Schulman remembers that he made them all laugh. A sense of humor was definitely key in portraying the *Buffy* character who was, at his core, Joss Whedon's stand-in. "Xander I've always identified as the figure that I most was like because he did have that inability to sort of talk to the girl and come through in the big moment . . . and he does make an idiot of himself a lot."

An actress named Riff Regan, who had coincidentally appeared in an episode of *Roseanne*, took the role of Willow Rosenberg. This character confused the network from the get-go, Joss reports, because she was not the stereotypical glossy model with glasses "coding" her as a nerd.

The twenty-minute presentation was made and shown to the WB. Then Joss and company waited for May, which is the month when the networks select the shows they're going to feature in their fall lineups. *Buffy* didn't make the cut; a show called *Seventh Heaven* did. Gail Berman remembers that despite the rejection, "I thought, *We're going to be picked up.* I don't know why. Knowing Joss, believing in him, just seeing his vision, being around that kind of creativity, just watching, that is an awesome thing."

And just four months later, the network decided to order twelve episodes in order to use *Buffy* as a midseason replacement for *Savannah*, which they were going to cancel. (Constance M. Burge, the creator of *Savannah*, went on to

in America after appearing in a series of intriguing Nescafé/Taster's Choice coffee commercials.)

Next, former San Diego Chargers cheerleader Charisma Carpenter took the Cordelia Chase role that Sarah Michelle Gellar had vacated. She was waiting tables to put herself through school for a teaching credential before her manager signed her on. When *Buffy* came calling, she was already acting in such series as *Malibu Shores*.

The role of Alexander "Xander" Harris went to first-time actor Nicholas Brendon. Brendon had kicked around Hollywood, working as a production assistant on another show. "I was really excited, and I was really terrified," he said in an

create *Charmed*.) They requested one substantive change: a recasting of Willow's character. A search was conducted and the list of possible actresses whittled, until it came down to two contenders. Though she felt she had blown her final audition, Alyson Hannigan was offered the role.

Initially assumed to be a temporary character in the two-part series premiere, David Boreanaz was cast as Angel. The struggling actor was spotted walking his dog by the man who became his manager. *Buffy*'s original casting director, Marcia Shulman, reminisces that as soon as she saw him, she wrote "He's the guy" in the margin of her casting sheet.

The writing staff and crew were assembled, with David Greenwalt as Joss's co–executive producer, his "number two." Of Joss, he says: "On the series, we say, 'Into every generation one is born.' That's this guy. . . . By the time he's fifty, he will be as rich, and as successful, as Steven Spielberg."

Production began, with the goal of having all twelve episodes filmed and ready to go before the 1997 midseason date. Joss freely admits that when he began shooting *Buffy*, he had no idea how to run a television show, because he was used to the production pace and budgets of movies. He initially didn't grasp the constraints of time and money that would be placed on him. The standard schedule for *Buffy* was eight days of preparation time, and eight days of shooting. This presumed a completed shooting script and everyone from makeup to editing being lined up

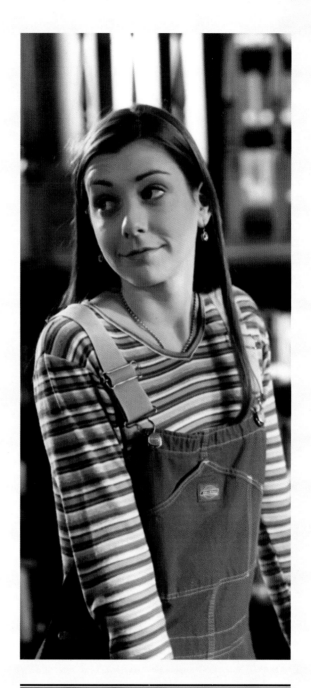

LEFT: Nicholas Brendon as Alexander "Xander" Harris, on the Sunnydale High campus.

ABOVE: Alyson Hannigan as Willow Rosenberg, photographed on the library set.

The Producers and Writers

"THE THING I'M GOING TO MISS THE MOST IS THE WRITERS. ULTIMATELY, FINDING THE STORY AND BEING IN A ROOM FULL OF WRITERS AND KNOWING THAT YOU FOUND IT, KNOWING THAT MOMENT WHEN YOU GO 'OOOH, THAT'S THE THING,' IS THE BEST FEELING IN THE WORLD."

—*Joss Whedon*

The Writers

In interviews and conversations, Joss has always lavished praise on his entire cast and crew, but he reserves a special affection for his fellow writers. These four writers have the most credits for the seven years of *Buffy*, with their credited number of episodes listed after their names. On DVD commentaries, in interviews, and in private conversations, all the *Buffy* writers are quick to point out that the stable of writers ("the room") often helped one another out with uncredited rewrites and polishes.

Jane Espenson (23 episodes)

Espenson joined the writing staff during the third season. Her first episode was "Band Candy," and she is beloved by the fans of the Jonathan Levinson character (played by Danny Strong) for penning "Earshot" and "Superstar," as well as the one-shot comic book *Jonathan*. Espenson began her career in TV by pitching ideas to *Star Trek: The Next Generation* while a grad student at UC Berkeley. She wrote for *Gilmore Girls* after *Buffy*, cocreated *Warehouse 13*, and is the consulting producer on *Once Upon a Time* and the cocreator of the web series *Husbands*.

Marti Noxon (23 episodes)

Noxon wrote spec scripts for seven years before she joined the *Buffy* writing staff, eventually serving as showrunner and executive producer in seasons six and seven. She has worked on a number of TV shows since *Buffy*, and wrote the screenplays for *I Am Number Four* and the remake of *Fright Night*.

David Fury (17 episodes)

Fury and his wife, Elin Hampton, cowrote "Go Fish," a freelance script that aired in the second season. By series end, he was a co–executive producer. He was the only writer besides Whedon to write a season finale episode "Grave," [6x22]. Of late, he has served as co–executive producer or executive producer on such shows as *Lost*, *24*, and *Fringe*.

Doug Petrie (17 episodes)

Petrie's first Hollywood credit was the screenplay for *Harriet the Spy*, starring Michelle Trachtenberg, who played Buffy's little sister, Dawn. He finished the series as a co–executive producer. Other shows to his credit since *Buffy* include *Tru Calling*, *CSI*, *Pushing Daisies*, and the new revival of *Charlie's Angels*.

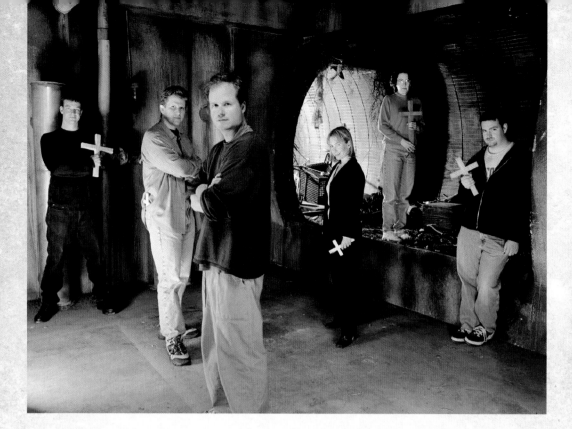

The Producers

In contemporary TV parlance, *producer* usually means "writer," and most of the credits such as "supervising producer," "coproducer," "co–executive producer," and "executive producer" usually indicate seniority on a show's writing staff.

David Greenwalt

David Greenwalt left *The X-Files* to serve as Joss's co–executive producer on *Buffy* for its first three seasons. He cocreated the spin-off, *Angel*, and served as its executive producer and, later, as consulting producer. He has served as consulting producer on shows such as *Eureka*, and is the cocreator and executive producer of *Grimm*.

Gareth Davies

Davies did what most people tend to think of when they hear the word *producer*—he coordinated all the departments in order to get the show made. He was also in charge of the budgeting; the man who could, essentially, veto plans for the show or let them move forward. He has since produced *Firefly* and *Miss Matched*, among others.

David Solomon

Solomon began working on *Buffy* as the coproducer in charge of postproduction; he was not a writer. He helped Joss film and cut the original presentation reel, and it is his hand that makes Whedon's little "Grr, argh" Mutant Enemy bob along the screen after the credits. He wound up directing nineteen episodes of *Buffy*. He has gone on to direct and/or co–executive-produce shows such as *Las Vegas*, *Dollhouse*, *Grimm*, and *Fringe*.

ABOVE: *An Entertainment Weekly portrait of the Buffy writers on set, by Joseph Cultice. From left: Doug Petrie, David Greenwalt, Joss Whedon, Marti Noxon, Jane Espenson, and Dan Vebber.*

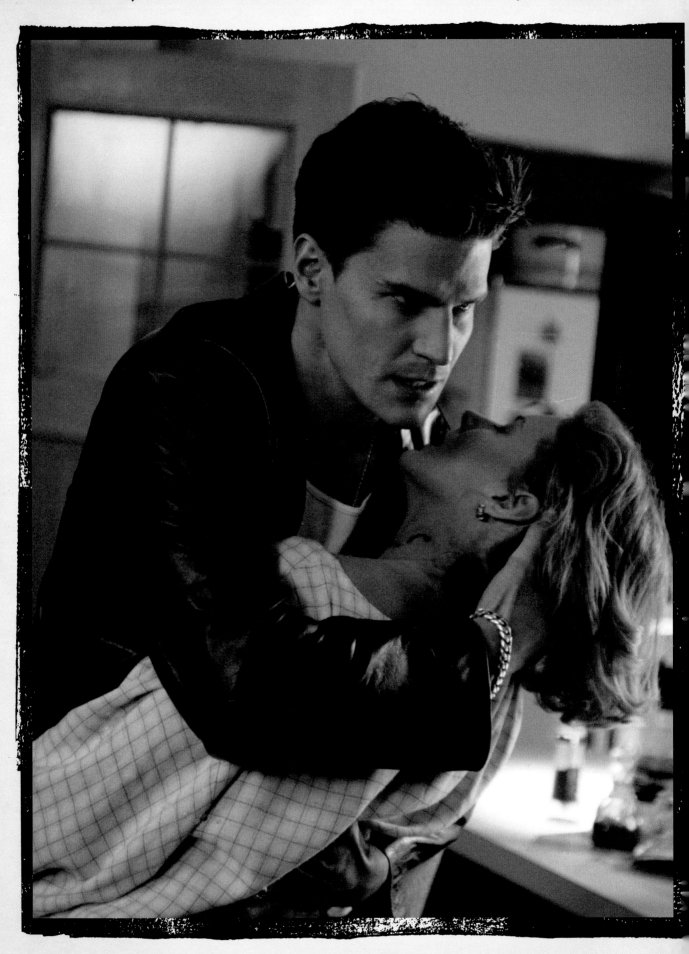

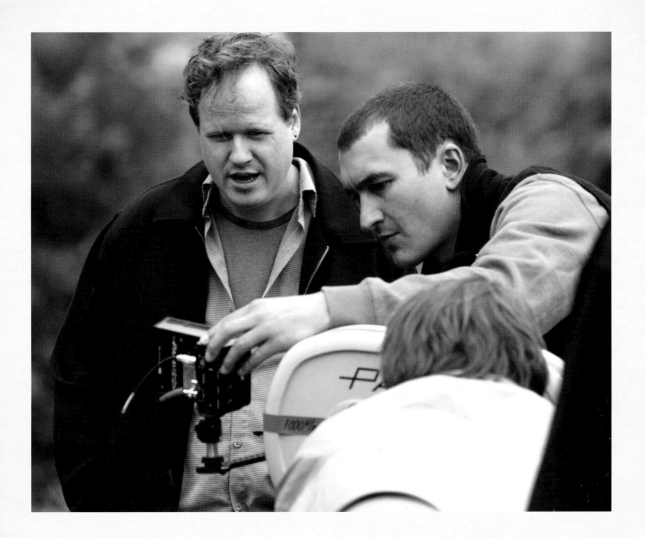

and ready to go, but all functioning at the faster pace of a TV show and on a shoestring budget. For example, for the series premiere, Joss wanted to create a bridge between the film and the first episode of the TV show, through an elaborate dream sequence that would recapitulate Buffy's last days in L.A., and take her to Sunnydale. This sequence would dramatize the exposition that would be needed to bring the viewer up to speed—what a Slayer was, and that Buffy was one already; that her first Watcher had been

killed; and that her mother had moved her out of L.A.

But he didn't have the budget or the time to shoot this sequence as he wished, and so he culled images from the twelve episodes he had already shot. As a result, the explication of who

LEFT: David Boreanaz as Angel, 'apparently feeding' on Joyce after Darla flees, in "Angel."

ABOVE: Joss Whedon directing on the *Buffy* set with crew members.

and what Buffy was took place in the library with lines delivered by Giles, as did so many exposition scenes (so many that eventually Anthony Stewart Head would sing "The Exposition Song" in "Restless" [4x22]). Still, Joss continually pushed the envelope to get rid of as much "talking against a wall" as possible.

ABOVE: Anthony Stewart Head as Giles, singing "The Exposition Song" in "Restless."

RIGHT: Jonathan Levinson, played by Danny Strong, basks in the attention he's always longed for in "Superstar."

He had planned to include shots of Eric Balfour, who played Xander's friend Jesse, in the premiere's opening credits, with a second set at the ready once the season got under way. Inclusion in the credits would have signaled longevity for Jesse, and Joss wanted the audience to be shocked when Jesse died—to dramatize the clear message that in Sunnydale, no one was safe. But he had neither the time nor the money to shoot duplicate credits. Later on *Buffy*, he would do so twice—in Jonathan's magical star turn, "Superstar," [4x17] and in "Seeing Red"

[6x19]—the first episode that Amber Benson's character Tara is listed in the opening credits is the one she dies in.

Xander was originally supposed to be a skateboarder, but Joss immediately got rid of the board because it took too long and required extra resources to shoot Xander riding on it. And Joss lost a stunt scene he'd planned for when Buffy breaks into the girls' locker room to investigate the death of "the extreme dead guy"—the one Darla killed in the first episode's teaser. Instead of double flips, she cracks open the door.

On his maiden voyage as showrunner, Joss had to learn to scale back. But once he fully grasped the limitations of episodic TV, he found them to be an actual blessing. "The less elaborate I could be, the more I just had to make things matter," he says. "I couldn't hide things with a dog and pony show. I couldn't afford the pony. I only had a dog."

In his DVD commentary for the series premiere, "Welcome to the Hellmouth," Joss reiterated his idea that he wanted to turn the little blonde who is almost always the victim into a hero. Enough people understood his subversive approach to "genre-busting" that out of the gate, *Buffy* gained attention from critics and core groups of vocal fans who would tell their friends that the new show with the goofy name was really good.

Buffy was originally envisioned as more of an anthology show. A "monster of the week" would serve as a metaphor for a teen challenge

or fear. One example is Moloch, the demon who was sucked into the Internet when Willow scanned in a book for the library's new IT system—he served as a metaphor for the perils of sharing information and dating on the net.

As the show developed, however, the producers realized that it was the relationships among the characters, and not so much the monsters, that attracted viewers to *Buffy*. Joss shorthands this as "the soap opera"—dramatizing

In the Writers' Room

As the first step in creating a *Buffy* episode, writers usually pitched individual story ideas to Joss (and later Marti Noxon) in a one-on-one process. Jane Espenson's first episode, "Band Candy," was a pitch she made during her job interview. Tracey Forbes pitched "Beer Bad" during hers. David Fury and his writing partner/wife, Elin Hampton, sold "Go Fish" as freelancers. Writers would have one-on-one pitch sessions with Joss in addition to brainstorming ideas together. Espenson relates that while you would never be dismissed for any idea, no matter how outlandish, you could become the butt of jokes "for particularly cheesy ideas."

Once the idea for an episode was set, a different process kicked in—figuring out what happens in the script. This is called "breaking the story." The writing staff assembled in "the room"—a room specifically set aside for them. Once an idea was chosen, Joss (later, Joss and Noxon) and the writers would sit in the room together and start to break the story. Espenson said there always needed to be a certain amount of joking and horsing around until people could settle down and focus.

When breaking a story, key points in the plot were written on a whiteboard. The smallest unit of action is called a beat. Beats collected together create acts. There are four acts in an episode of *Buffy*. Each act needs to end on an "act out"—the little cliff-hanger that compels the viewer to return after that act fades to black. Once the basic structure, plot points, and act outs had been established in the writers' room, the more detailed work of getting the characters from one beat or plot point to the next was designated a "WP"—the Writer's Problem. In other words, it was up to the credited episode writer to figure that part out.

According to Espenson, at the beginning of a season, the writers got two weeks to write a script; by season's end, they would get one or less, earning the show its nickname, "Buffy the Weekend Killer." In the most notorious example, Espenson and Drew Goddard shared cowriter credit for "Conversations with Dead People" [7x07], but it was actually written by four writers over a weekend—Goddard, who wrote the scenes between Jonathan and Andrew; Espenson, who wrote Dawn's scenes; Noxon, who wrote the conversations between Willow and Cassie; and Joss, who wrote the segments with Buffy in the cemetery.

LEFT: "Conversations with Dead People," in which an apparition in the form of Joyce Summers, played by Kristine Sutherland, comes to Dawn.

ABOVE: Michelle Trachtenberg as Dawn having a vision of her mother, Joyce, in "Conversations with Dead People."

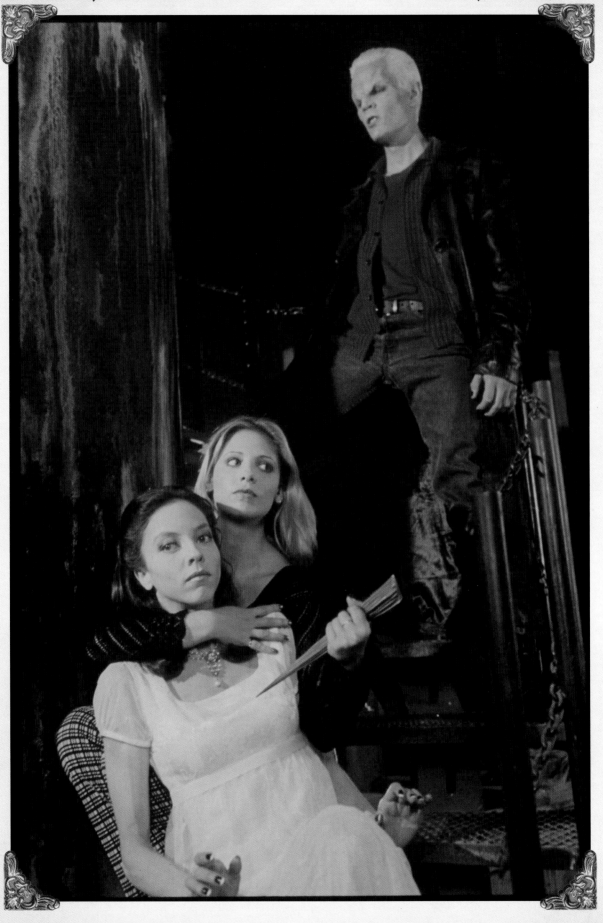

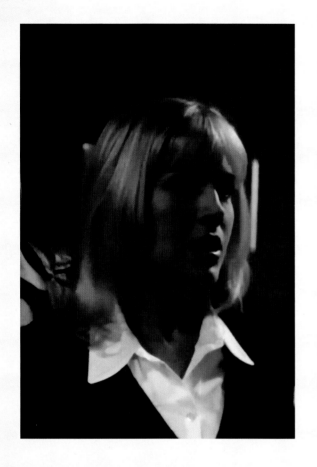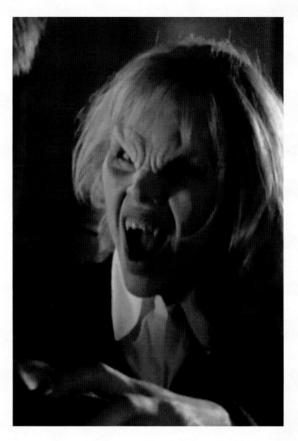

relationships that changed radically over time, with characters who grew and matured through the seasons.

In his keynote address at the very first Slayage Conference on *Buffy the Vampire Slayer*, May 28, 2004, noted TV critic and vociferous *Buffy* supporter David Bianculli said that he became a fan of the show in the first minute of airtime, when the little blonde victim (Darla) turned out to be the monster. Of Buffy, he says: "One of the strengths of a compelling weekly TV show when it takes advantage of the form is to tell narrative stories that evolve like a novel— characters change, grow, even die." He compared *Buffy* to shows that have remained static, presenting stand-alone episodes that can be shown in any order and never make viewers worry that they've missed too much of a season to catch up: "I like those shows, but I don't love them."

And right out of the starting gate, the love for *Buffy* grew.

LEFT: Buffy in "Lie to Me," threatening to stake Drusilla unless Spike frees the group of teenagers the vampires have trapped.

ABOVE: Darla reveals herself as a vampire in the series premiere, "Welcome to the Hellmouth."

CHAPTER II

High School Is Hell

uffy went to high school for the first three seasons of the show—what some fans regard as *Buffy*'s golden years, and Joss himself feared might be "the coolest years." "Sometimes I thought, *Oh, I wish I could've kept them in high school a little bit longer*, but it would have started to look silly." In high school, classic rebellious teenager Buffy will initially balk at, then accept, her role as Slayer; meet and lose her first great love; attempt to kill a human being in order to save her boyfriend's life; and blow up

inexplicable local deaths ceased. Now it's Buffy Summers's turn. (The prologue was not shown on TV again, and is not included in the first episode on the DVD set.)

A second montage features a nightmare of frightening images, culminating in a close-up of the batlike vampire called the Master, the "Big Bad" of season one. Buffy is the one having the nightmare, establishing that the Slayer is often plagued with prophetic dreams. Joss Whedon intended for the dream sequence to clue non–movie viewers in to

If Joss Whedon had had one good day in high school, we wouldn't be here.

— David Greenwalt

her school. She will also do fantastically well on her SATs.

The first episode of *Buffy* contained a lot of exposition, revealing that Buffy and her mother, Joyce Summers, have moved to Sunnydale from Los Angeles because Buffy has been expelled from her old high school—Hemery—for fighting and burning down the gym. Sunnydale High is the only school that will accept her. The airing of the series premiere included a short prologue consisting of old-fashioned photographs of young women in different time periods and a voice-over narrative explaining that each time one of these young women arrived on the scene, the spate of

what the show was about, while acting as a sequel to those who had seen the movie.

The next morning, Buffy is off to her first day at her new school (Go, Razorbacks!), making friends with the people who will become her support system and meeting the school librarian, Rupert Giles, who introduces himself to her as her new Watcher. Giles is stunned to discover that Buffy has no idea he has been expecting her. She has assumed that her move to Sunnydale was entirely random. She informs him that she's "both been there and done that," and has retired from the slaying game. It falls to Giles to convince Buffy that her sacred duty is a lifelong

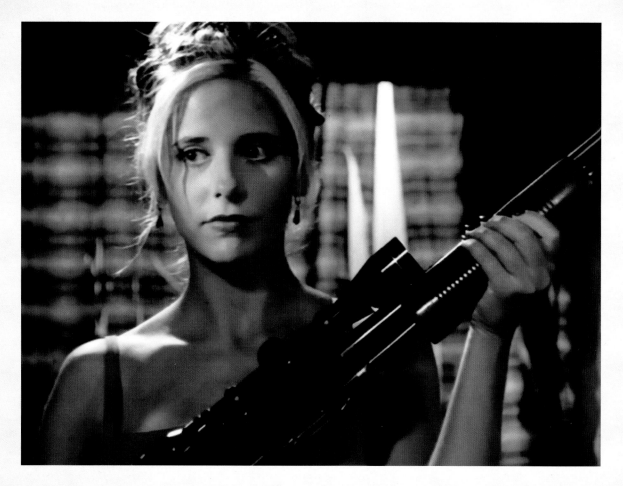

commitment, and she must take up the mantle in Sunnydale: "There's a reason that you're here, and a reason why it's now."

Then, unaware that another student, Xander Harris, is lurking in the library, Giles sets the scene for season one: Sunnydale was founded by Spanish settlers who originally called it *Boca del Infierno* (Mouth of Hell). It turns out that Sunnydale actually sits atop a hellmouth, a center of mystical convergence that serves as a portal from the many demon dimensions into ours. The hellmouth's evil vibe attracts monsters and demons already present on this plane—thus promising the viewer that Buffy will have many scary-cool enemies to fight.

Joss was constantly seeking ways to catch the audience off guard, while playing fair. "The rules are very important in a horror movie," he insisted. And his number one rule was the show's mission statement: "Nothing is as it seems."

PREVIOUS: Season 1 publicity photo of Buffy with the Master, played by Mark Metcalf.

ABOVE: "I look cute in a tiara;" Buffy runs for homecoming queen and ends up fighting for her life alongside Cordelia in "Homecoming."

Guidemap To
Sunnydale

A Location Map and Guidebook in One!

The Unique, easy-to-read guide to the City of Sunnydale

ABOVE: The cover of a map of Sunnydale, or "Boca del Infierno," from the prop department.

RIGHT: Buffy goes to a frat party and finds herself chained in a basement in "Reptile Boy." This on-set photo shows a crew member's hand in the foreground and exposes the actor's legs beneath his demon-snake costume.

Buffy was created with the intention of subverting old horror movie tropes, starting with the theme song: after a few bars of classic horror movie organ music and a wolf howl, the rock-and-roll beat announced that Buffy was one little blonde who wouldn't actually put up with being in a horror movie. Darla's attack on her lecherous date was another promise that conventions would be turned on their head.

In "The Pack," the murder of Principal Flutie is made all the more horrible by the fact that the hyena-possessed students *ate* him—and while Xander didn't partake, he definitely devoured Herbert, the piglet mascot of the SHS Razorbacks, while possessed.

The "monster of the week" conceit carried throughout the first season. High school was literally hell. A teacher hitting on Xander turns out to be a giant praying mantis in need of virgin human boys to fertilize her eggs. A girl who is constantly ignored becomes an invisible killer. A witch, longing for her glory days as Sunnydale High's head cheerleader, swaps bodies with her teenage daughter. The swim team on steroids changes into Creatures from the Black Lagoon.

In addition to these "little bads," Joss instituted the idea of a "Big Bad," a main villain that the Slayer and her friends would battle over the course of an entire season. This would build in a structure and provide for a satisfying conclusion to each season. These adversaries were especially important to seasons one and five, when it was unclear if the show would return (the

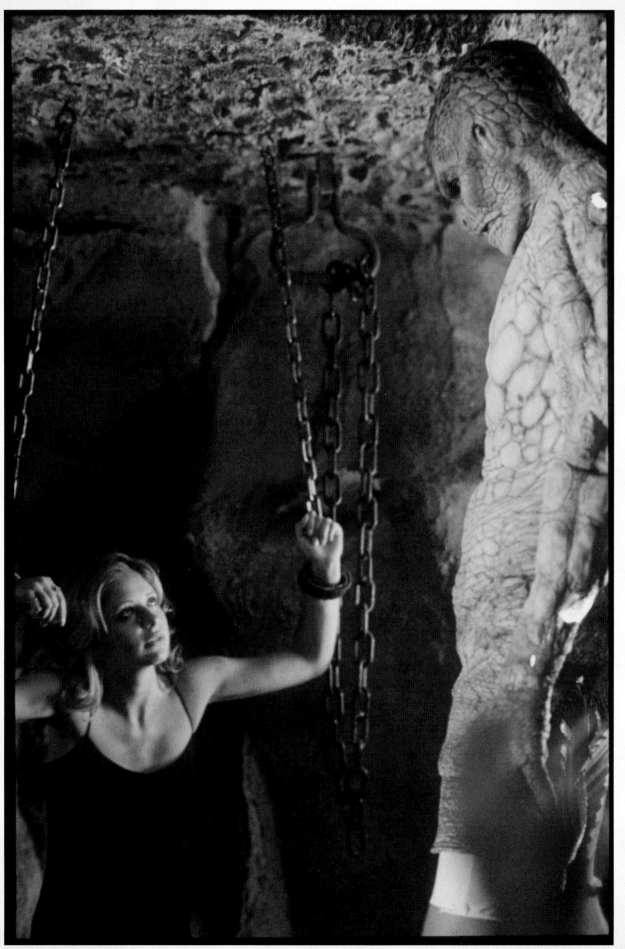

The Big Bads

Season One: The Master

An imprisoned ancient vampire seeking to harvest enough human blood to walk the earth again.

Season Three: The Mayor

A quasi-supernatural being aspiring to become pure demon.

Season Two: Angelus, Spike, and Drusilla

Vampires seeking to end the world—although they can't quite agree on their mission.

Season Four: Adam

The demon-hybrid creation of scientist Maggie Walsh, leader of the Initiative.

Season Five: Glorificus the Hellgod

Glory seeks to open a portal to a hell dimension with the key—Buffy's mystical sister, Dawn.

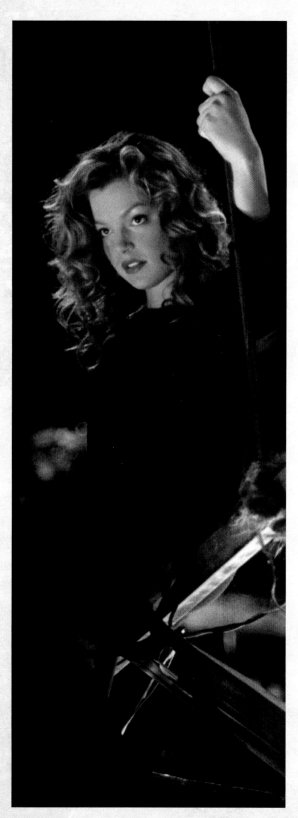

Season Six: The Evil Troika (Warren, Andrew, and Jonathan) and Dark Willow

Also known as "the Evil Trio," Warren, Andrew, and Jonathan aspire to become rich and powerful super-villains. Dark Willow marshals the forces of black magic to destroy the world after Warren shoots her beloved girlfriend, Tara.

Season Seven: The First Evil

Manifesting as dead people and aided by its minion, Caleb (nicknamed "the Second" by *Buffy*'s writing staff), the First Evil seeks to open the hellmouth and allow the pure demons—the Turok-Han—to take over the world and destroy humanity.

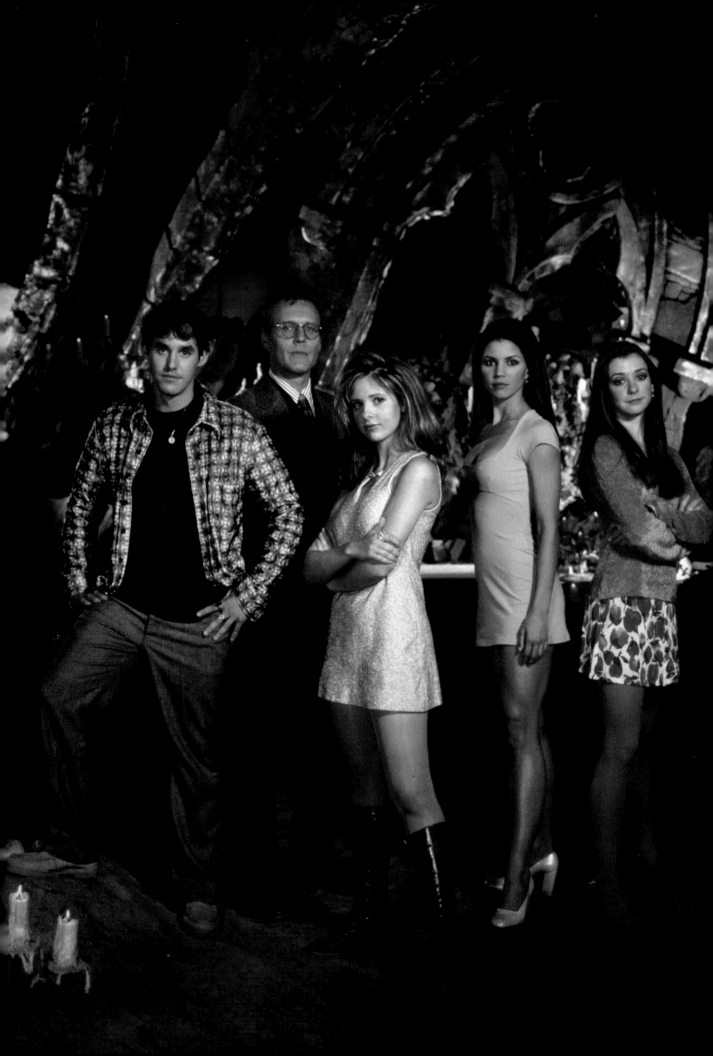

cast regulars had signed five-year contracts, and *Buffy*'s original home, the WB, considered canceling the show at the end of those contracts).

The plan was for the "little bads" to be interspersed between the first and last episodes of each season. This strategy is evident in the first season, with the Slayer and her "Slayerettes" (Willow's suggestion for their group nickname) going on adventures as they get to know one another. But teen—or rather, human—issues and developing complex relationships with one another became the beating heart of the show, allowing less room for static unconnected episodes and, frankly, the grand guignol of traditional horror. As Joss said, "Whatever horror is out there is not as black and terrible as what is already within and between us."

THE CHARACTERS IN BUFFY'S WORLD

According to Slayer tradition, every Slayer has a mentor called a Watcher, but otherwise, she was expected to walk alone, protecting her secret identity and sparing herself the distraction (and possible endangerment) of loved ones. Buffy was the first Slayer to break this rule, and to insist on having—or attempting to have—a normal life. She tried out for cheerleading, ran for homecoming queen, and dated (albeit rather disastrously). Throughout the series, Slayer traditionalists such as the Watchers Council and Kendra the Slayer criticized Buffy for not toeing the party line. Just as often, Buffy's immersion in teen culture and

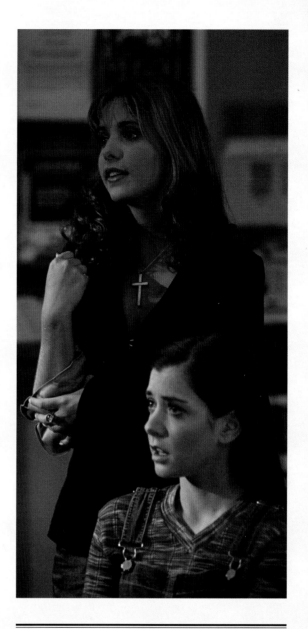

LEFT: Publicity still from Season 1. Xander nicknames the group "the Scooby Gang" in the Season 2 episode "What's My Line, Part 1." From left: Nicholas Brendon, Anthony Stewart Head, Sarah Michelle Gellar, Charisma Carpenter, and Alyson Hannigan.

ABOVE: "The Harvest," in which Giles and Buffy introduce the shocked Xander and Willow to the world of vampires, demons, and Slayers.

her adoption of an extended "family" saved the day, the world, and, occasionally, Buffy herself.

The Scooby Gang: Xander nicknamed the group "the Scooby Gang" in "What's My Line, Part One" [2x09]. In "Witch" [1x03], Willow calls them "the Slayerettes," and fans occasionally refer to Buffy, Xander, Willow, and Giles as "the Core Four."

Willow Rosenberg is Buffy's shy, nerdy best friend. As a computer hacker, she can access

role on *Buffy*, including working with Seth Green (Oz) in *My Stepmother Is an Alien*. Hannigan is currently starring in *How I Met Your Mother*.

Alexander Lavelle Harris is Buffy's other close friend. "Xander" is Joss's alter ego, the character most like him—not so much an outcast as socially inconsequential, who, nevertheless, is witty (and verbose). Although Willow carries a torch for Xander for years, he loses his virginity to Faith and winds up dating Cordelia.

A Slayer with family and friends. That sure as hell wasn't in the brochure.

— Spike, "School Hard"

sewer plans, police reports, and the like. Joss referred to the computer as the show's "element of cheese." He says, "It just made life easier to throw everything onto the computer," because what he wanted viewers to care about was "the emotion, not the procedure." Willow experiments with magic until, eventually, she becomes a practicing witch. Joss felt that Willow would be the most popular character, because she was relatable, whereas Buffy, as a hero, was slightly unattainable.

Willow was played by Alyson Hannigan, who had already enjoyed a long acting career before her

RIGHT: An on-set photo of Giles and Buffy in the library with the Vampyr book that he presented to her upon their first meeting.

He attracts "demon chicks," including a humanoid praying mantis, a resurrected Incan mummy, and (later on in the series) a demon who tries to sacrifice him to open the hellmouth. As high school draws to a close, he gets together with Anya, herself a former demon.

Newcomer Nicholas Brendon starred as Xander. His twin brother, Kelly Donovan, appeared with him in "The Replacement" [5x03] and in many scenes of "Intervention" [5x18] when Brendon was ill. Brendon has recently appeared on *Criminal Minds* and *Private Practice*.

Rupert Giles: Buffy's Watcher and the school librarian. Giles initially came off as a stereotypically stuffy, tweedy Englishman, but as the series unfolded, viewers learned that when

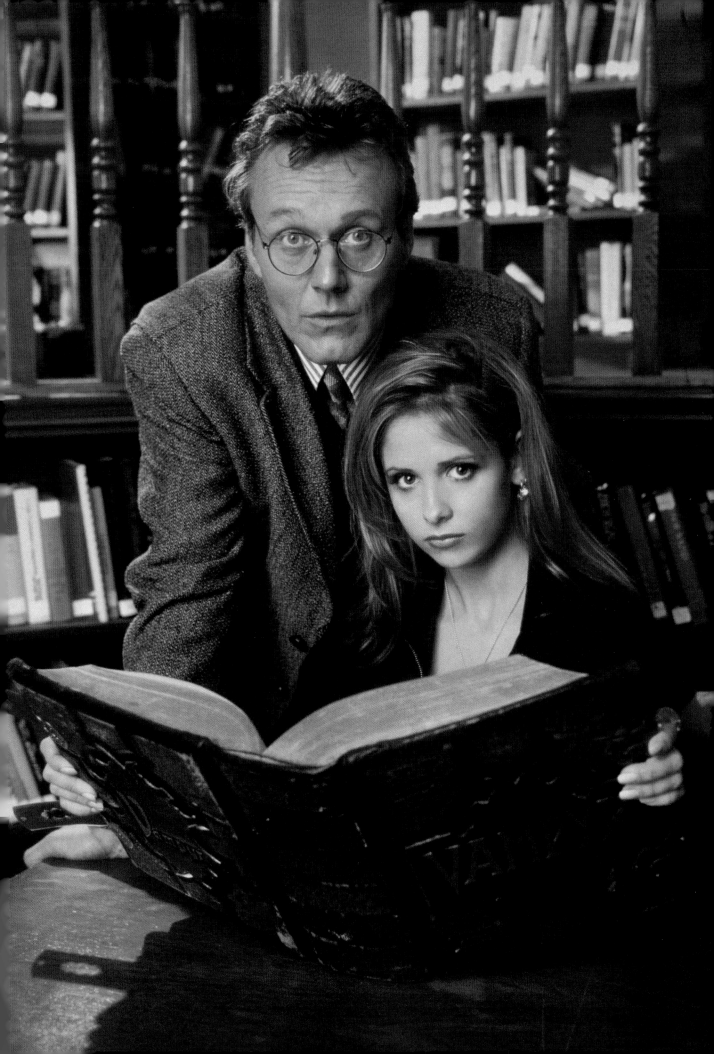

The Watchers Council of Britain

Buffy's Watcher, Rupert Giles, is a member of the hidebound, autocratic Watchers Council of Britain. Like Slayers, Watchers are mystically called to their positions; unlike Slayers, they are paid and can be fired. The Council goes above the law to dole out punishment and does not hesitate to send their special-ops teams to eliminate perceived threats (such as rogue Slayers). However, for all their posturing, they are haphazard and disorganized.

The Watchers train the Slayers in close-quarter fighting styles that include blades, crossbows, and stakes—but no guns or modern weapons. They have written a Slayer's Manual, but Giles never bothers to give it to his nonconformist charge. Watchers also learn ancient languages and magic spells to help the Slayer in her battles.

Quentin Travers, the head of the Watchers Council, fires Giles after Giles interferes with Buffy's "Cruciamentum," a barbaric test imposed on Slayers on their eighteenth birthdays. Buffy's second Watcher, Wesley Wyndam-Pryce, is fired for ineptitude (and eventually joins Angel's detective agency in Los Angeles). Though Buffy quits the Council, she later agrees to work with them once they reinstate Giles with back pay.

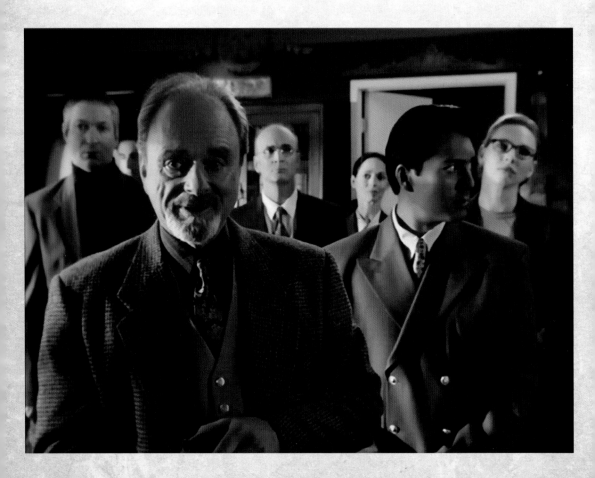

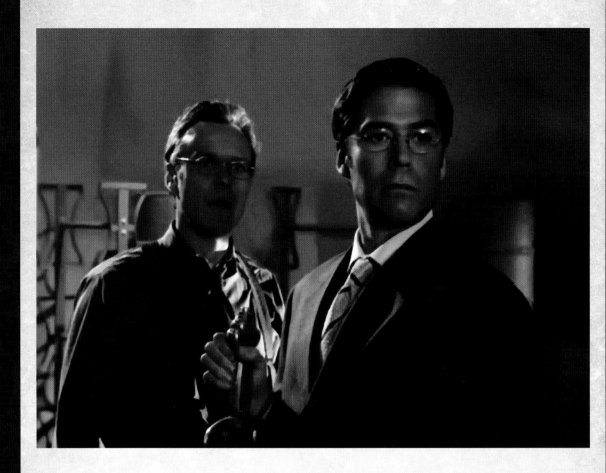

When the First begins its assault against humanity, its minion, Caleb, blows up the Watchers Council headquarters in London. The surviving Watchers attempt to locate girls who can be activated as Slayers and send them to Sunnydale. All the Watchers, including Giles, are unaware that a society of women has been tracking the Watchers on behalf of the Slayer. They are called the Guardians, and they have created a magical scythe for the Chosen One—Buffy—to defeat the primordial evil. The last Guardian is killed by Caleb, but not before she confirms that the scythe is the Slayer's ultimate weapon.

In the wake of the destruction of the original Council, the surviving Watchers from around the world form a smaller, less centralized organization in the season eight comics series; they are financed by the assets of the first Council. Xander serves as the liaison to Buffy and oversees the training of a cadre of young Slayers in Scotland; Robin Wood becomes a Watcher and is stationed at the hellmouth in Cleveland, Ohio; Andrew Wells, also based out of Scotland, beomes a sort of "Watcher troubleshooter," traveling all over the world primarily to deal with crises on behalf of the newly activated Slayers. The overall number of existing Watchers is undetermined.

LEFT: Quentin Travers, head of the Watchers Council of Britain, and a large team of Watchers arrive at the Magic Box in "Checkpoint."

ABOVE: Giles with Buffy's stuffy new Watcher, Wesley Wyndam-Pryce, portrayed by Alexis Denisof, in "Bad Girls."

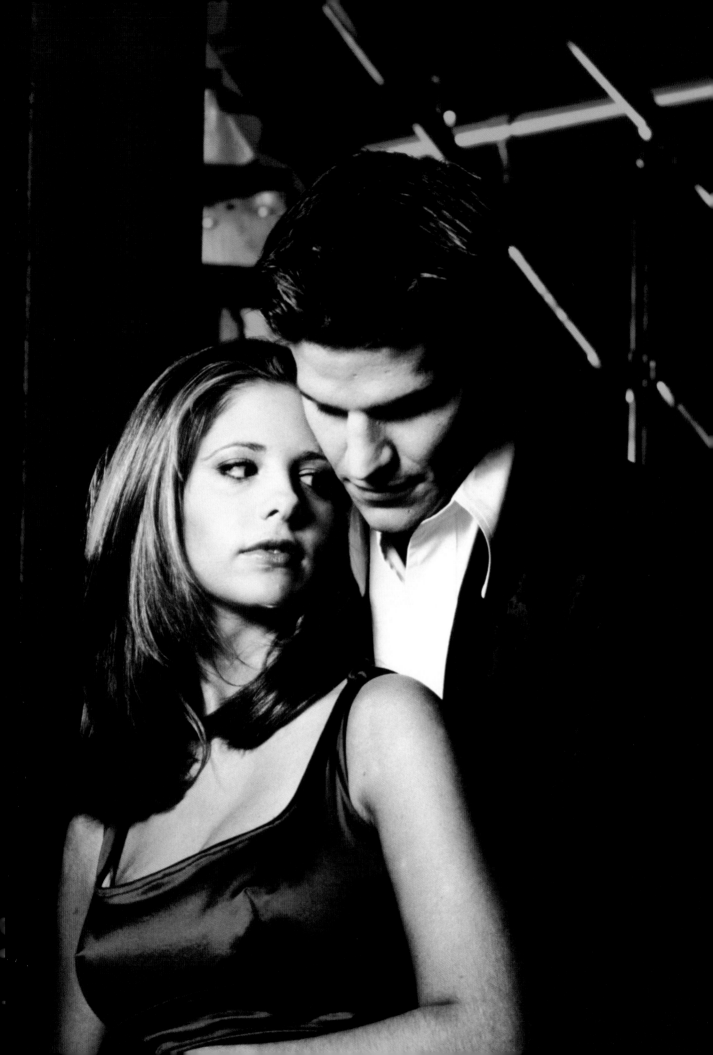

he was at Oxford, he attempted to resign from his destiny as a Watcher. He dropped out and moved to London, exploring dark magic with a circle that included Ethan Rayne, a sorcerer who plagued Buffy and company with his nefarious schemes. He was also quite the hipster guitarist in his day.

Anthony Stewart Head recently portrayed Uther Pendragon in the BBC production of *Merlin*, and has appeared on *Doctor Who* and in *The Iron Lady* with Meryl Streep.

BEYOND THE CORE FOUR

Angel is Buffy's first serious boyfriend and, many fans argue, her soul mate. Born in Galway in 1727 with the name Liam, he was turned into a vampire by Darla, who in turn was created by the Big Bad of season one, the Master. As **Angelus,** the most brutal, sadistic vampire in recorded history, he ran in a kind of "brat pack" with vampires Spike, Drusilla, and Darla. Darla sired Angel; Angel sired Drusilla; and Drusilla sired Spike. All was well for them until Angel killed a Gypsy girl in 1898, and her clan, the Kalderash, cursed him with regaining his soul. Driven insane by unbearable guilt and remorse, Angel abandoned his vampiric family and lived on the streets of New York, subsisting on rat's blood.

The mystical Powers That Be sent the demon Whistler to recruit Angel as a champion in order to even the balance between good and evil. Whistler took Angel to Los Angeles to witness Buffy's first Watcher, Merrick, approaching

Buffy and telling her that she was the Chosen One. Angel vowed to help her, and followed her to Sunnydale to warn her of the Master's plan to bring about the "harvest."

Angel appears in the series premiere, and was not intended to be a regular. Joss was afraid that a romance between a vampire and a Vampire Slayer would be too clichéd, and in fact was surprised that more people didn't figure out Angel was a vampire by the end of the first

LEFT: Buffy and Angel share an intense romantic relationship throughout the first three seasons, until Angel leaves town to give Buffy the normal life she always wanted.

ABOVE: Buffy Summers's high school notebook, covered in doodles, from the prop department.

few episodes. When Angel first meets Buffy, he gives her a cross, but it's inside a jewelry case. Joss meant the gesture to be a slight misdirect—of course Angel can't touch a cross, and the box protects him from it—in part to stave off the audience's realization that Angel *did* bite. Because fan reaction to him was incredibly strong, Angel was added to the permanent roster of Sunnydale.

After all their romantic ups and downs, an older, wiser Angel realizes that Buffy can never have a normal life with him. Not wishing to deny her that, he leaves town after they defeat the mayor of Sunnydale on graduation day. He moves to Los Angeles, and although Buffy still has sporadic contact with him, she attempts to move on from the intense romantic love they share.

Joss chose to remove Angel from the scene and give him his own spin-off show in *Angel*. He did this in part because he couldn't see any way to keep their romance fresh—and also because he wanted Buffy to suffer. He had learned that

making Buffy cry and putting Willow in danger were two surefire ways to keep viewers watching the show.

David Boreanaz, who played Angel, starred in the spin-off for all of its five seasons. As of this writing, he has starred on *Bones* for seven seasons.

Cordelia Chase at first is eager to make friends with the new girl from sophisticated L.A., but backs way off when Buffy makes it clear that she isn't going to dump social pariahs Willow and Xander in order to be more acceptable to the SHS elite. In the first season, Cordelia vies for Angel's affections; learns the truth about Buffy; helps the gang fight evil (while insulting them at every turn); and eventually dates Xander.

When faced with certain death, Xander and Willow explore what might have been and passionately kiss. They are caught in the act by Cordelia and Oz, their respective partners at the time, and Cordelia can't bear the humiliation of being cheated on by someone so far beneath her socially. Her wish for vengeance summons Anyanka the vengeance demon, who becomes the human Anya, Xander's next love interest.

When Giles is fired from his position as Buffy's Watcher, Cordelia develops a crush on the new Watcher, Wesley Wyndam-Pryce, but once she graduates from high school and the obstacle to their attraction is removed, they find they lack chemistry. Cordelia leaves town, and she and Wesley both wind up working with Angel in Los Angeles.

Cordelia was played by Charisma Carpenter, who has recently appeared in *The Expendables* and *The Lying Game*.

Daniel Osbourne: Oz is the laconic, laid-back lead guitarist of Dingoes Ate My Baby, a local Sunnydale band. After his werewolf cousin bites him, he becomes a werewolf—around the same time that he and Willow connect.

LEFT: Buffy and Angel share a romantic yet tense moment in "Revelations."

ABOVE: Seth Green as Daniel "Oz" Osbourne, Willow's boyfriend, midway through his monthly transformation into a werewolf.

One year older than Buffy, Xander, and Willow, Oz presented a problem for Joss when he realized how popular the character had become. In fact, he was originally "scheduled" to be the character Angelus kills, not Jenny Calendar. Instead, he became a cast regular. "I had Oz repeat a grade because I wanted him to be there for Willow, and he had ostensibly already graduated," Joss says. "So that was my one cheesy maneuver."

Actor Seth Green went on to appear in the *Austin Powers* movies and *The Italian Job*, and is the co-creator of *Robot Chicken*, which is an Annie Award–winning adult stop-motion animation show featuring action figures (Seth Green is a collector), toys, and Claymation.

Anya Christina Emanuella Jenkins: Anya began life as Aud, a young Swedish woman who cursed her unfaithful sweetheart, Olaf, and turned him into a troll. Impressed by her gift for vengeance, the Lower Being D'Hoffryn offered her an immortal existence as a vengeance demon, and she accepted, becoming Anyanka. When Cordelia wishes for vengeance after Xander cheats on her with Willow, Anyanka casts a spell that creates an alternate reality in which Buffy serves as Slayer for the hellmouth on Cleveland, not Sunnydale. In that reality,

Giles (who is on the Watchers Council but is not Buffy's Watcher) discovers Anyanka's power center—her necklace—and destroys it. As a result, our dimension reasserts itself, and Anyanka becomes mortal. She is trapped in our dimension, nearly a thousand years old but unable to buy a beer because she's underage—and flunking math to boot. As reluctant a high school student as ever there was, Anya discovers that she has fallen in love with Xander just as Buffy and friends attempt to destroy their nemesis, the mayor of Sunnydale, during the Sunnydale High School graduation exercises.

Emma Caulfield, who played Anya, is the creator of the web comic *Contropussy* and recently appeared on *Once Upon a Time*. She was awarded Best Actress (Comedy) by the Indie Soap Awards this year for her new web series, *Bandwagon*.

Spike, also known as William the Bloody, dresses like Billy Idol and boasts a platinum dye job. Joss has been quoted as saying that Spike was the most developed of all the characters on *Buffy*, treading a path from supreme villain to a hero willing to sacrifice himself for the greater good. In the high school seasons, Spike and Drusilla initiate a plan to kill Angel in order to cure Drusilla of her tuberculosis-like illness. They are thwarted, and Spike winds up in a wheelchair, seething and planning revenge when Angel, now Angelus, moves in on Drusilla. Spike allies himself with Buffy to stop the destruction of the world, claiming a fondness for it: "The truth is, I like this

RIGHT: James Marsters as Spike, a vampire whose roles range from villain to antihero. Creator Joss Whedon thinks of Spike as the "most fully developed" of his characters.

The Slayers

"Into every generation she is born: one girl in all the world, a chosen one. She alone will wield the strength and skill to fight the vampires, demons, and the forces of darkness; to stop the spread of their evil and the swell of their number. She is the Slayer."

According to *Buffy* mythology, there have been hundreds of Slayers through the millennia. Although the exact nature of discovering one's calling as a Slayer is ambiguous, most potential Slayers seem to have been more aware of their status than Buffy herself. There have been stories about additional Slayers in comic books and novels, but only some of these Slayers' stories can be considered official "canon." In chronological order, these are the Slayers mentioned on the show:

The First Slayer:

Called "the Primitive," also known as Sineya. In ancient Africa, the Shadow Men chained her to a rock and forced her to ingest the essence of a demon, giving her dark power. This began the Slayer line, and the Shadow Men morphed into the Watchers Council.

Lucy Hanover:

The Civil War Slayer. When she arrived in Virginia in 1866, the killings of the local Civil War widows stopped.

Unnamed Slayer in Chicago:

Forty-one deaths occurred around Union Station, but the killing stopped when she arrived in May of 1927.

Xin Rong:

This young Slayer was killed by Spike during the Boxer Rebellion in 1900, and he tells Buffy that her death was "the best night of my life." The name Xin Rong comes from the *Spike and Dru* comic.

Nikki Wood:

The mother of Buffy's ally, the new Sunnydale principal, Robin Wood. Spike killed her in 1977 on a New York subway. She leaves behind the magical items that send Buffy on a vision quest to meet the three Shadow Men and learn how the Slayer line began.

Buffy Anne Summers:

Called "the hellmouth's last guardian" by the Shadow Men, Buffy and her army of Slayers destroy the invading Turok-Han vampires and their commander, the First. When confronted by the overpowering evil of the First, she still rejects the Shadow Men's offer of more of the demonic power that began the Slayer line. Instead, she shares her power with all the potential Slayers in the world.

Kendra Young:

This Jamaican girl was called to be the Slayer after Buffy drowned during her battle with the Master. Her Watcher, Sam Zabuto, trained her to be an emotionless killing machine. Kendra was given her last name by Joss for a role-playing game supplement.

Faith Lehane:

From a rough Bostonian background, she was called after Drusilla the vampire killed Kendra. Faith was traumatized by losing her Watcher to the evil vampire Kakistos. After accidentally killing a human, Faith joins the dark side and the Watchers Council attempts to eliminate her. Angel sets her on the path to redemption in Los Angeles, but upon learning of the imminent war against the First, she returns to Sunnydale to help Buffy. By series end, Robin Wood, the son of slayer Nikki Wood, is her love interest. Joss also gave her a last name for a role-playing game supplement.

The Potentials:

Willow performs the magic spell that turns all the Potentials into Slayers. Among them are Molly, Annabelle, Amanda, Caridad, Chao-ahn, Chloe, Colleen, Dianne, Dominique, Eve, Kennedy, Rona, and Vi. After the death of Tara, Kennedy becomes Willow's new love interest.

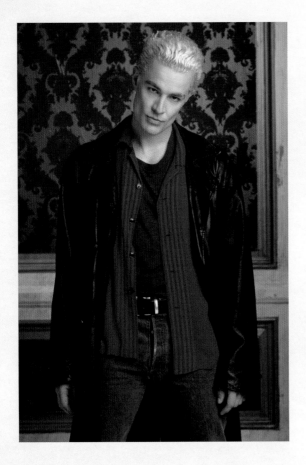

who argue that Angel was Buffy's true love call themselves "Bangles," and those who side with Spike are "Spuffies."

Spike was played by James Marsters, who moved to *Angel* after the conclusion of *Buffy*. He appeared as Brainiac on *Smallville* and in many other films and TV shows, such as *The House on Haunted Hill* and the new revival of *Hawaii Five-O*.

Faith Lehane is a Slayer. According to the mythology of the Vampire Slayer, when one Slayer dies, another "activates" to take her place. When Spike's lover Drusilla kills Kendra the Vampire Slayer, Faith is called. She is wild and out of control, reveling in her power as a Slayer. Emotionally damaged by a rough childhood and her own inability to prevent her Watcher's violent death, Faith is pushed over the edge when she accidentally stakes and kills a human being. She goes over to the dark side, murdering demons and humans alike for Mayor Wilkins, who is preparing to "ascend" and become an enormous demonic snake. Eventually Faith goes to Angel in Los Angeles for help in redeeming herself, and she returns in the last season of *Buffy* to help Buffy in the battle against the First Evil.

Eliza Dushku went on to star in *Tru Calling*, for which *Buffy* writers Doug Petrie and Jane Espenson both wrote scripts. Joss created *Dollhouse* for her—a science-fiction series about people who are programmed with temporary personalities and abilities for specific assignments. She has also appeared on *The Big Bang Theory* and *Torchwood*.

world. You've got the dog racing, Manchester United, and you've got people: billions of people walking around like Happy Meals with legs. It's all right here."

Spike takes on greater importance in the *Buffy* universe after high school, and some fans asserted that Spike, and not Angel, was Buffy's great love. In the world of *Buffy* fandom, fans

ABOVE: Spike, aka William the Bloody, sporting his Billy Idol punk look.

RIGHT: Buffy meets her mother's new boyfriend Ted, played by John Ritter, who turns out to be an evil robot.

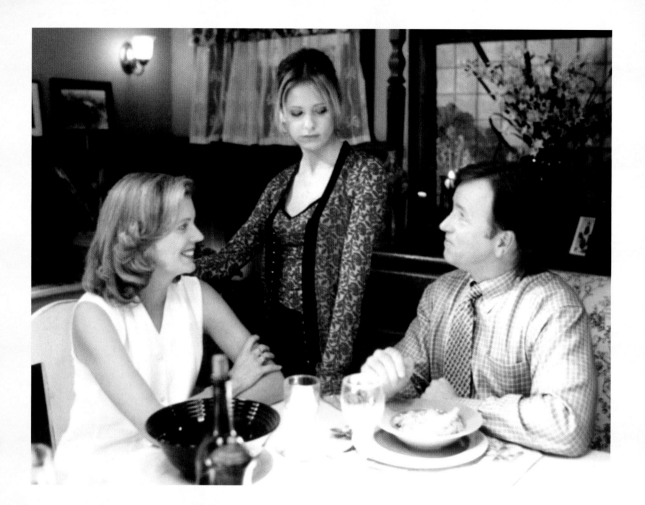

THE HIGH SCHOOL SEASONS

Despite being the superpowerful Chosen One, Buffy must contend with going to high school and growing up, just like the normal American teenage girls she envies. The problem is, when her mother grounds her, the world really might end. The lives of the boys she dates are in peril, or else they are frustrated with her because she always seems so *distracted*. And when she runs with the wrong crowd and parties too hard? She's nearly eaten by a reptilian monster worshipped by frat boys, and a human being is accidentally killed.

During a behind-the-scenes interview at a Buffy reunion in 2008, Seth Green and Sarah Michelle Gellar discussed Buffy's dilemma when reminiscing about how much fun it was to get dressed up for SHS's prom—even as the world was about to end (again). "Do you celebrate this moment when you know what the world is really like?" Gellar mused.

Green added, "Can you have an innocent moment in the midst of a very adult situation?"

It is said that with great power comes great responsibility, and Buffy attempts to evade her

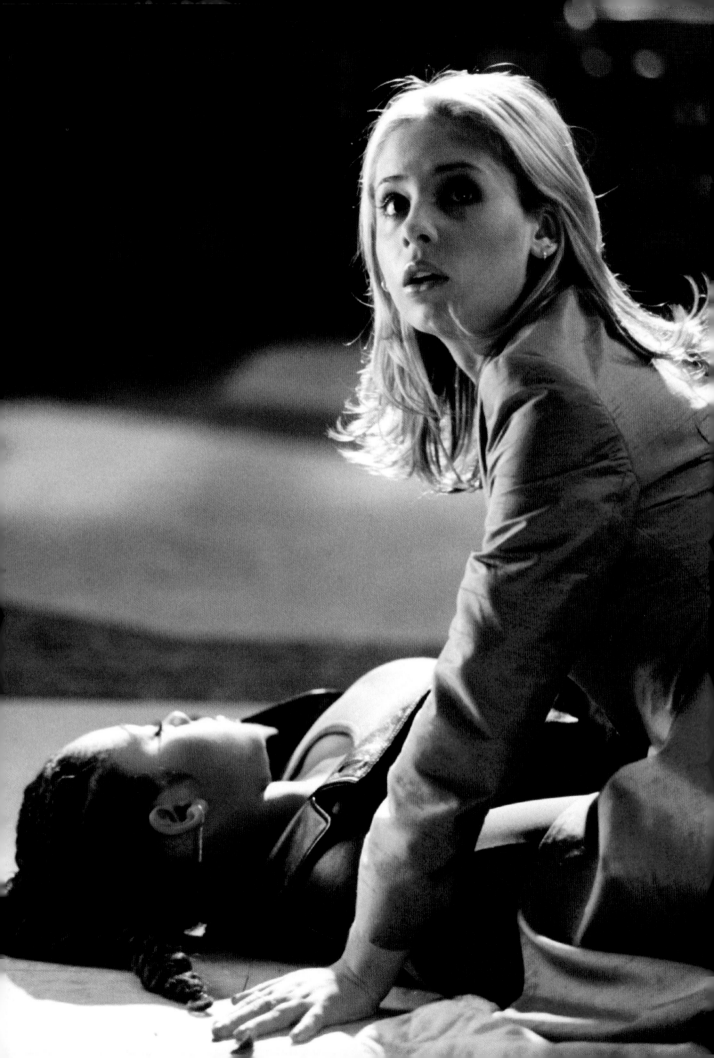

very adult responsibilities as Slayer three times. When she arrives in Sunnydale, she insists that her days in the slaying game are over—until a student turns up dead. In "Prophecy Girl" [1x12], she learns that her death at the hands of the Master has been foretold, and she announces that she is the Slayer no longer—until vampires invade the school and kill some boys that

of the intense pressure of making *Buffy*. But at the end of the day, they could go out for a drink and resolve any tensions.

David Fury recalls his own final exam of sorts: "After writing 'Go Fish' with Elin, Joss and David Greenwalt wanted to offer us a staff position for season three. But Elin wanted to stick with sitcoms, so she took a job on *Mad*

Everyone has [power]. Not everyone knows how to express it. And high school is, institutionally and hormonally, an easy place to forget you have it.

—— Joss Whedon

Willow knew. After Kendra is killed and Buffy is arrested for her murder, Buffy escapes and leaves Sunnydale—returning after saving a fellow runaway from a hell dimension. In each instance, she is drawn back into her role as Slayer by the need to save the lives of those around her.

When the Council fires Giles and refuses to help Buffy save Angel's life, she declares that she is the Watchers Council's Slayer no longer—but she *is* the Slayer. Giles affirms that she no longer needs a Watcher. Buffy has graduated.

This same sort of maturing process occurred for the cast, crew, and staff of *Buffy* as well. "We grew up on the show together," Emma Caulfield said. Early on, there were marriages and divorces—"all this drama"—within the crucible

About You. Since Joss and David needed to see if I could write by myself, they took another pitch from me for another freelance script, which became 'Helpless.' They were happy enough with that to offer me a special assignment: Write the second episode of the *Angel* spin-off they were in the middle of developing. The *Angel* assignment was particularly daunting since that universe didn't exist yet . . . With *Buffy*, I felt I was able to capture enough of Joss's voice, as well as the characters he created. But with the follow-up episode of a new series, a darker, more adult, more

LEFT: Buffy arrives too late to save Kendra from Drusilla and is caught by a policeman in "Becoming, Part I."

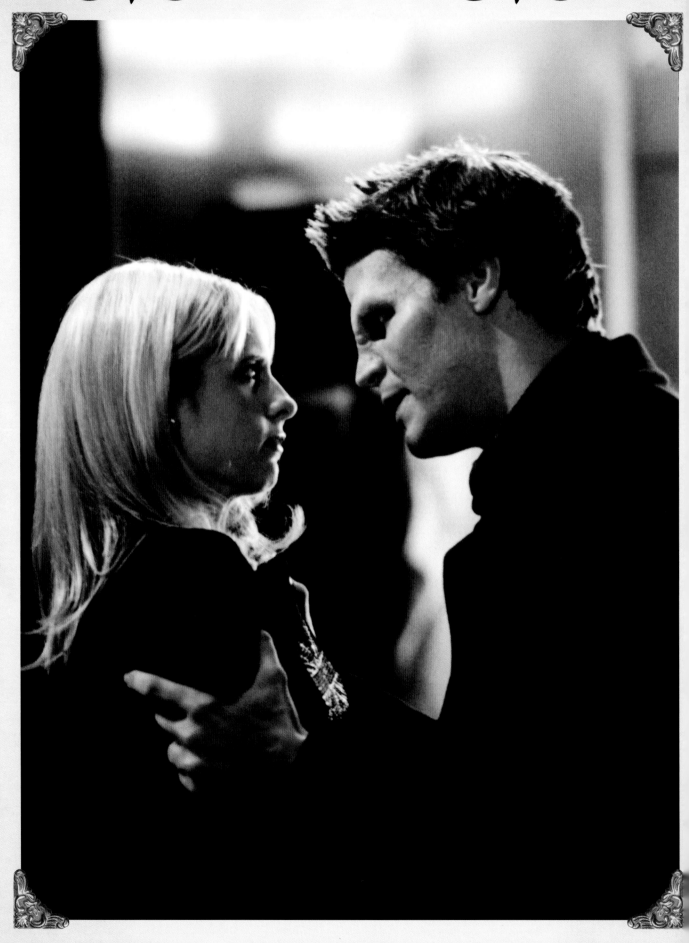

male version (outside the comfortable confines of Sunnydale), I was sweating their reaction to my draft. When Greenwalt came out of a closed-door meeting over my script with Joss, I assumed they hated it and I was to be fired before I'd even been hired . . . Particularly after David told me: 'Well, Joss read it, and I'm sorry, but he thinks you're going to be a great asshole—I mean, ASSET to the show.' And that's how I learned I'd be producer on the next season of *Buffy*."

During Buffy's high school years, Joss faced challenges of his own. One big one was to sort out the nature of the Gypsy curse he had inflicted upon Angel. As he had designed it, Angel's curse was to be given back his soul so that he could suffer remorse for all the horrible things he had done without it. Finding his purpose in helping the new Slayer, Buffy, he fell in love with her, and they consummated their relationship. Then Joss did what he sought to do at every possible turn in *Buffy*: surprise the audience. He did everything he could to ensure that the audience would fall in love with noble, suffering Angel, and then turned him evil. Having found true happiness with Buffy, Angel triggered the second part of the curse: his soul was taken away from him again. The problem with this was that the Gypsies, therefore, had knowingly released the fiend Angelus back into the world. "This is insanity!" Jenny Calendar/Janna Kalderash insisted.

Seeing the flaw in this logic—that the Gypsies would willingly bring back the most ruthless vampire in recorded history—Joss went for a walk along the Santa Monica beach. Reminding himself that he had established a reputation as a script doctor, he set his mind to work to reconcile the problem. The answer came to him in the dialogue he assigned to Jenny Calendar's uncle Enyos: "Vengeance is a living thing." Later, Enyos explains: "Angel is meant to suffer, not to live as human. One moment of true happiness, of contentment, one moment where the soul that we restored no longer plagues his thoughts, and that soul is taken from him."

Another tricky problem arose concerning the episode "Earshot" [3x18]. When Buffy kills a mouthless demon, some of its blood drips on her, causing her to be able to hear people's thoughts. She hears someone plotting to kill everyone at school, and the race is on to find the mass murderer before this new "gift" drives Buffy insane.

While investigating, she sees the glint of a weapon in the school's clock tower (constructed specifically for this episode). She arrives to find Jonathan, a recurring character who has been the butt of many jokes, gazing down on the school with a high-powered rifle. Discussion between the two reveals that Jonathan was not planning to open fire on his schoolmates, but to end his own pain by killing himself. The real killer is the lunch lady: Xander catches her pouring rat poison into the mulligan stew.

LEFT: Angel loses his soul and becomes Angelus again.

Unfortunately, the massacre at Columbine High School occurred about two weeks before the episode was scheduled to air. In the actual event, two students did open fire on their classmates with semiautomatic weapons, killing thirteen people and wounding twenty-one others. The WB felt that the events of "Earshot" were similar enough that airing the episode so soon afterward would be irresponsible—particularly as the show contained dialogue such as this:

> XANDER: I'm still having trouble with the fact that one of us is just gonna gun everybody down for no reason.
> CORDELIA: Yeah, because that never happens in American high schools.
> OZ: It's bordering on trendy at this point.

Joss and his staff agreed with the network. He said, "Any comment on the situation *after* that horror would have been offensively trite."

Then "Graduation Day, Part Two" [3x22], the second half of the season three finale, was also pulled—with two hours' notice—because it showed students with weapons engaging in a huge battle on campus. This time, Joss felt that the decision was inappropriate. He has pointed out in commentary about the episode that, rather than promoting organized violence against

RIGHT: Production Designer Carey Meyer's sketches of the scene from "Graduation Day, Part 2" in which Mayor Wilkins turns into the giant snakelike demon Olvikan.

school authority figures, the students are banding together to protect one another against a giant demon snake. After hearing that the episode had aired in Canada, he urged fans to "bootleg the puppy!"—an act that angered the network.

A longer-lasting consequence of Columbine was a general nervous backlash in the public zeitgeist against violent video games, thrash metal, and the Goth subculture. It reached such a pitch that parents were advising their students not to wear black T-shirts or heavy black makeup to school, and not to turn in any kind of homework—especially poetry, art, or creative writing—that could be red-flagged as antisocial in any way.

This heightened anxiety was explored in "Gingerbread" [3x11], in which two children are discovered murdered, with an occult symbol written into their palms. Evidence suggests that the murderer is human.

Buffy's and Willow's mothers, Joyce Summers and Sheila Rosenberg, organize "MOO"—Mothers Opposed to the Occult. Knowing full well that Buffy is the Chosen One, Joyce rallies the community to take back their town from "the monsters, the witches, and the Slayers." Paranoia and hysteria take over, spurred by the same demon that was responsible for the Salem witch trials. "MOO" spearheads an actual witch hunt, in which Buffy, Amy Madigan, and Willow are denounced as witches and sentenced to burn at the stake.

Buffy learns tough lessons during high school—that try as she might, she never will

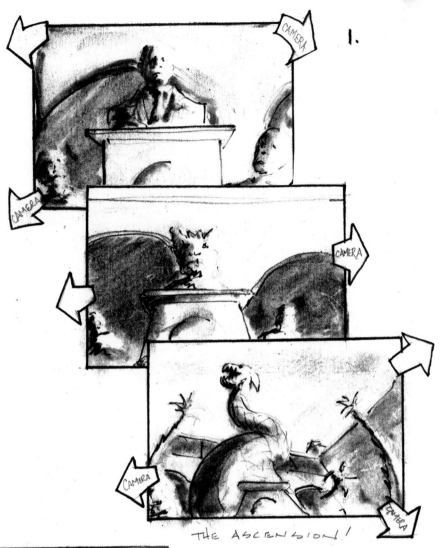

THE ASCENSION!

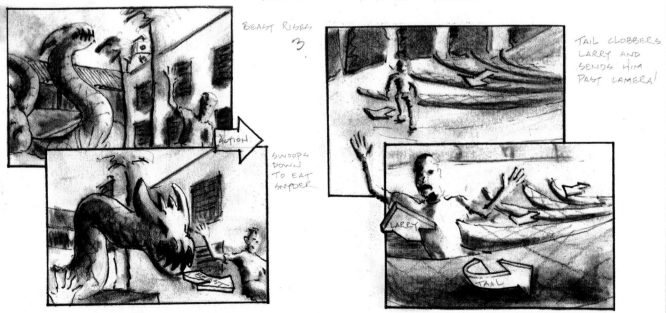

LOCK OFF

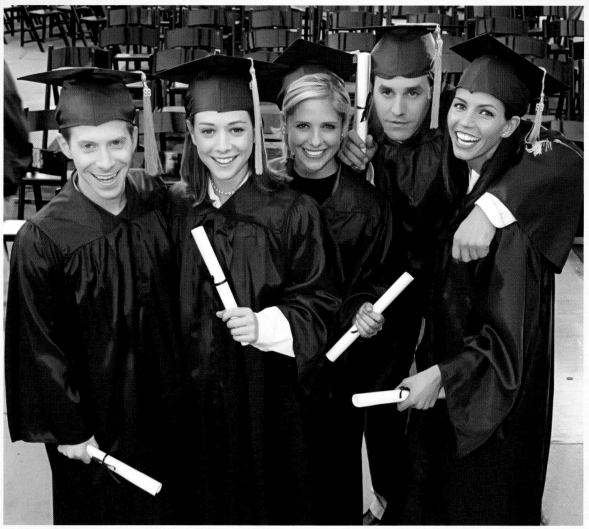

be a normal girl. She is the Slayer, the Chosen One. Joss realized that he was also set apart: "You asked what lessons I had learned, and one of the most important ones was 'When you're a leader, you can't be everybody's buddy.' You have to be a leader. That doesn't mean you can't be kind, that doesn't mean you can't be friends, it just means you have to be a leader." This meant facing some painful facts: "I thought I was going to be one of those guys. You start up a show and then you go on to do the next thing. But I couldn't leave. I was in love."

Oz: Guys, take a moment to deal with this: we survived.
BUFFY: It was a hell of a battle!
Oz: Not the battle. High school.
—"*Graduation Day, Part 2*" [3x22]

LEFT: Carey Meyer's sketches of the snake-demon Olvikan chasing Buffy through the halls of the high school.

ABOVE: A candid on-set photo of the whole gang in their graduation caps and gowns. From left: Seth Green, Alyson Hannigan, Sarah Michelle Gellar, Nicholas Brendon, and Charisma Carpenter.

BUILDING SUNNYDALE

As *Buffy* was being developed, it quickly became apparent that because vampires have to avoid sunlight, *Buffy* would be a dark show indeed, filming only at night or on dimly lit sets, unless a mechanism could be developed that would allow Buffy's titular nemeses to move around during the day. Steve Hardie, *Buffy's* first production designer, introduced sewer pipes that would allow the Master's vampire minions to enter and leave the underground church in which the Master was imprisoned. This gave the vampire underground an industrial look of "cement, dirt, rust, and grime." His successor, Carey Meyer, developed the sewers into a complex system that ran underground beneath the entire town, acting almost like a transporter machine in a science-fiction show. Creative enhancements such as floors that broke away, manholes, and grates added shooting possibilities. It's less expensive and time-consuming to shoot on a soundstage than on location, so the creation of the sewer system was a very important development in the production of *Buffy*.

A section of the sewer was dressed as the cargo bay of a 747, for when Kendra came to

RIGHT: Production designer Steve Hardie's Season I early sketches of the school library, which became one of the most featured sets on the show.

FOLLOWING PAGE: Map of Sunnydale from the prop department at Fox. Around the edges it's clear that the map was adapted from a real map of San Diego; look for the San Diego Pops amphitheater at bottom center.

town. The underground grotto in "Go Fish" and the cavern of the Zeta Delta Kappas in "Reptile Boy" are two more examples of the underground-sewer look.

Buffy the Vampire Slayer was shot on three soundstages inside a large warehouse located in the Bergamot Station complex in Santa Monica, at 1800 Stewart Street. The writers' offices; production offices including props, costuming, and makeup departments; as well as the editing bays, were all housed in a large building with "Mutant Enemy" painted in large letters on the side. (Mutant Enemy was the name of the typewriter Joss received when he was fifteen.) Between sixty and eighty sets were built on-site during a season.

The high school set was initially a single hall and grew to a more complex set complete with stairs. Joss intended for the school library to be a dark, labyrinthine chasm that would itself be a scary place to learn about scary things, but the realities of episodic TV—time and money— resulted in a rethink. The bright library, nicknamed "the bat cave," also became known as the "death set," the locus of hours of shooting of expository scenes in which Giles provided the information about that week's crisis—the nature of the threat, how dire the situation was, and the rules for prevailing over it. This aura of the magical was nicknamed "the phlebotinum" by co–executive producer David Greenwalt.

Joss guarded against simply putting his actors in front of walls and having them talk—a great way to shoot quickly, but boring, he felt, for

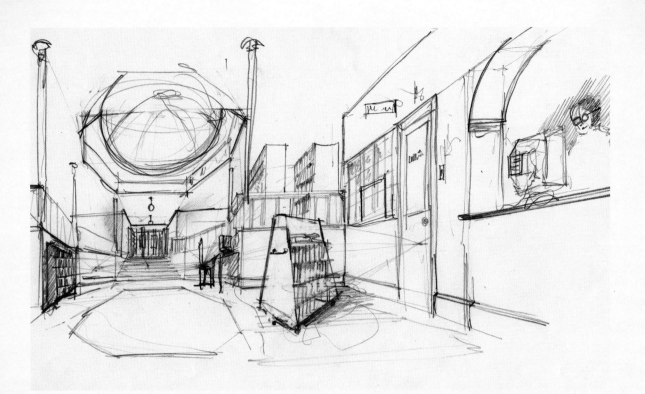

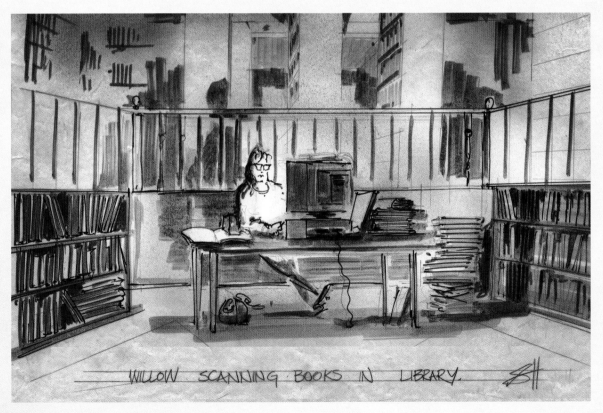

WILLOW SCANNING BOOKS IN LIBRARY.

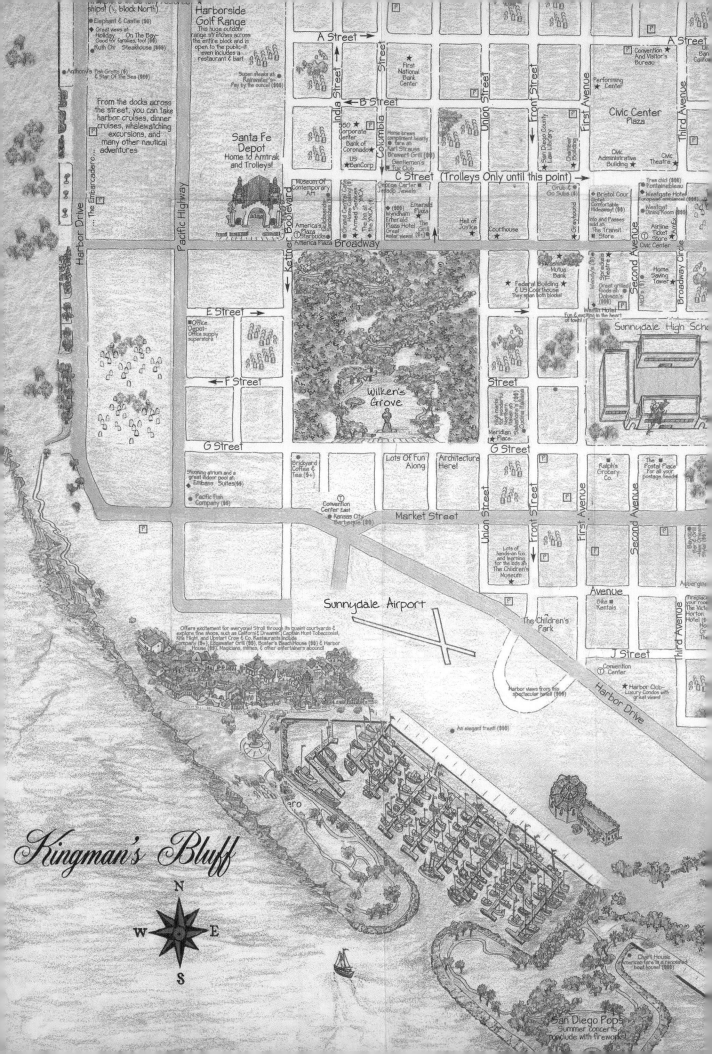

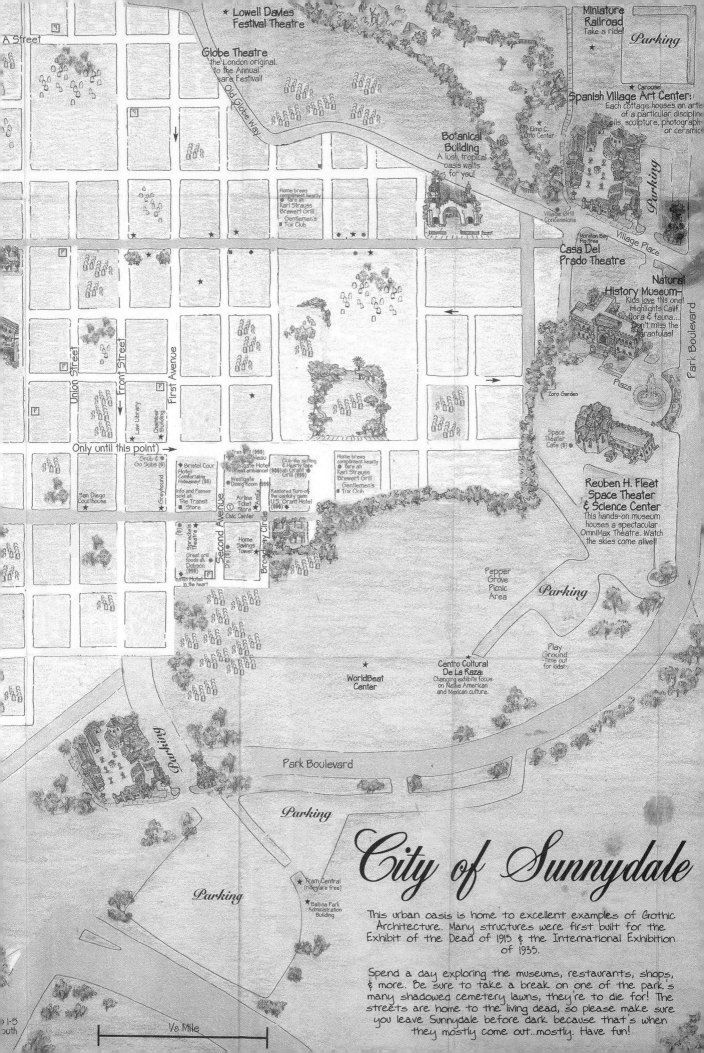

★ Lowell Davies Festival Theatre

Globe Theatre
the London original.
to the Annual
...eare Festival!

A Street

Old Globe Way

Miniature Railroad
Take a ride!

Parking

Carousel

Spanish Village Art Center:
Each cottage houses an artist
of a particular discipline
oils, sculpture, photograph...
or ceramic

Elmo C.
Otto Center

Botanical
Building
A lush, tropical
oasis waits
for you!

Home brews
compliment hearty
fare at
Karl Strauss
Brewery Grill
★ Gentlemen's
★ Tox Club

Village Grill
Concessions

Moreton Bay
Fig Tree

Village Place

Casa Del
Prado Theatre

Parking

Natural
History Museum—
Kids love this one!
Highlights Calif.
flora & fauna...
Don't miss the
tarantulas!

Park Boulevard

Union Street

Front Street

First Avenue

Law Library

Chamber
Building

Zoro Garden

Plaza

Space
Theater
Cafe ($)

Only until this point)

Grub &
Go Subs ($)

Greyhound

San Diego
Courthouse

Tres ... ($$)
...leau
...igone Hotel
...ear ambiance
Westgate
Dining Room
Airline Ticket
Store

Civic Center

Restored turn-of-
the-century gem
U.S. Grant Hotel
($$$)

Club-like setting
& hearty fare
($$$) at Grant
Grill ($$$)

Home brews
compliment hearty
fare at
Karl Strauss
Brewery Grill
★ Gentlemen's
★ Tox Club

Reuben H. Fleet
Space Theater
& Science Center
This hands-on museum
houses a spectacular
OmniMax Theatre. Watch
the skies come alive!!

Second Avenue

Broadway Circle

Spreckels
Theatre

Home
Savings
Tower

Great grill
foods at
Dobson
($$$)

...stin Hotel
In the heart

Pepper
Grove
Picnic
Area

Parking

Play
Ground
-Time out
for kids!-

WorldBeat
Center

Centro Cultural
De La Raza:
Changing exhibits focus
on Native American
and Mexican culture.

Park Boulevard

Parking

Parking

Tram Central
(rides are free)

Balboa Park
Administration
Building

Parking

1-5
...uth

1/8 Mile

City of Sunnydale

This urban oasis is home to excellent examples of Gothic
Architecture. Many structures were first built for the
Exhibit of the Dead of 1915 & the International Exhibition
of 1935.

Spend a day exploring the museums, restaurants, shops,
& more. Be sure to take a break on one of the park's
many shadowed cemetery lawns, they're to die for! The
streets are home to the living dead, so please make sure
you leave Sunnydale before dark because that's when
they mostly come out...mostly. Have fun!

and the explosives planted at the school to film Sunnydale High's demise were so loud that *Buffy* was thereafter banned from shooting in the city.

As the high school seasons progressed, the production department was able to expand the Sunnydale Street on the Mutant Enemy backlot. They also built the cabin in "Homecoming" in the complex's parking lot (and blew it up there, too). Caroline Quinn, the set designer, enjoyed doing shout-outs to crew members by naming various Sunnydale stores after them. Meyer's Sporting Goods, where Buffy and Faith steal their weapons, is named after Carey Meyer. There was a Quinntronics and also a Decker Hardware. (Decker was Caroline Quinn's maiden name.)

DUSTING VAMPIRES, MAKING MONSTERS, AND DRESSING SLAYERS

SPECIAL EFFECTS

Bruce Minkus served as the special effects coordinator for eighty-nine *Buffy* episodes. Snow, fire, and explosions all fell under his purview. He reported that "Graduation Day, Part 2" was probably his department's biggest achievement during the high school seasons, but only about 20 percent of the footage of the explosion of Sunnydale High was used in the episode. The rest was cut to lessen the impact, due to network concerns after the Columbine massacre.

His department created the zombie cat in "Dead Man's Party," which was dubbed "the

viewers. The need for Giles to explain so much in the library rubbed up against that notion, and—especially in the first few episodes—actors, writers, and directors alike tired of frequenting the library as the "rules" of *Buffy* were revealed to the audience. When the set was blown up at the end of season two, the company rejoiced—although the city of Torrance did not. The exteriors of the high school were shot at Torrance High School,

ABOVE: Sketch of Lagos, a demon featured in "Revelations," by special makeup effects supervisor John Vulich.

RIGHT: Photo by John Vulich of the finished makeup on the demon Lagos, portrayed by actor Gary Kasper.

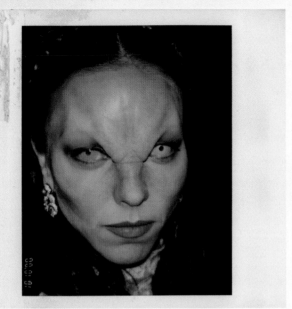
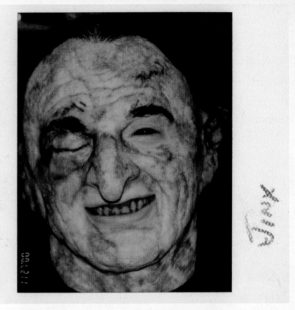
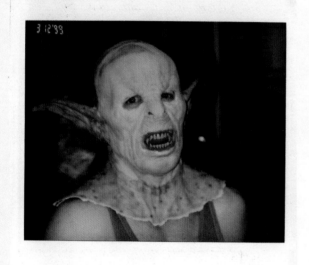
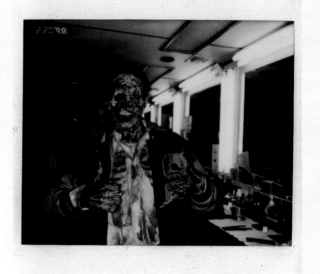

GORE 15

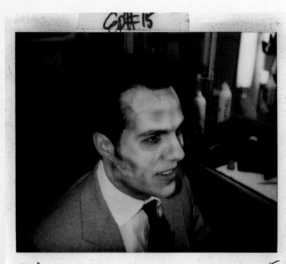
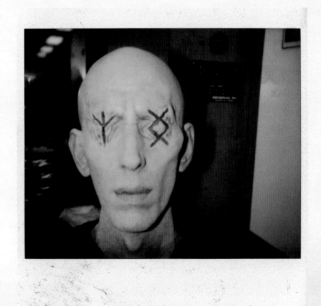

1-20-99

DSc 1 N1

Exorcist Cat" because during its initial appearance, its head spun around very fast.

Whenever a stunt person was set on fire, the special effects department was responsible for the fire, while the stunt department was responsible for the flame-retardant gel and the stunt person. Although it was difficult to do fire scenes on the *Buffy* soundstages, with their low ceilings and sprinkler systems, many fire scenes were successfully shot there. It was a point of pride for Minkus that the sprinkler heads never "popped" during the entire series's run.

"Never change anything; that's our rule. If you do it the same every time, it'll always work," Minkus explained.

SPECIAL MAKEUP EFFECTS

John Vulich and his team were responsible for creating the "special makeup effects" for *Buffy*'s first five seasons. This referred to the prosthetic pieces of silicone, Ultra-Cal, and other materials applied to the faces and bodies of the actors and stunt people to create vampires and demons, age characters, and give them wounds. Vulich's team created life masks and carved features for them out of foam. Although many demon designs involved horns, he tried to think of other things to add to their appearance, such as ridges or loops of flesh. (Joss disliked the look of demons with tails, which was why the writers added a tongue-in-cheek discussion about Buffy possibly growing a demonic tail in "Earshot.") He created Balthasar, the five-hundred-pound demon

in "Bad Girls" [3x14], in approximately three days. Other examples of his monstrous creations included the hellmouth monster in "Prophecy Girl" and Machida, from "Reptile Boy."

The original makeup for the vampires was ghoulish and very white, but Joss backed off in order to make the vampires look more human— partly because of Angel, and partly because it took so long to put it on. Still, as a horror movie buff, he was sorry to see it go.

COSTUMING

Cynthia Bergstrom served as the costume designer for more than one hundred episodes. Although she purchased many of the show's costumes in stores such as Fred Segal, Barneys, Neiman Marcus, and Macy's, she avoided copying looks in fashion magazines because she felt that between the time she bought the costumes and the time the show aired, the clothes were going to look dated. For Buffy, who had once lived to shop, being fashion-forward was vital. But when costuming Buffy in slaying clothes, Bergstrom stuck to a sleek, almost militaristic look.

For demons, Bergstrom often drew inspiration from medieval and Renaissance art books. She found the techno-pagan teacher

LEFT: Behind-the-scenes Polaroids from makeup supervisor Todd McIntosh showing the special effects creature makeup on a variety of characters. McIntosh and John Vulich worked closely together and shared a makeup Emmy with their teams.

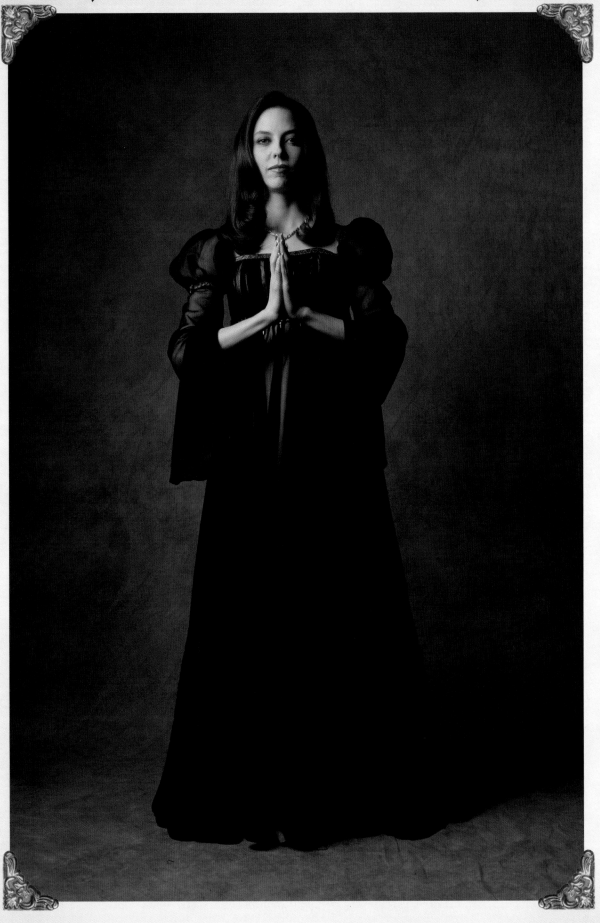

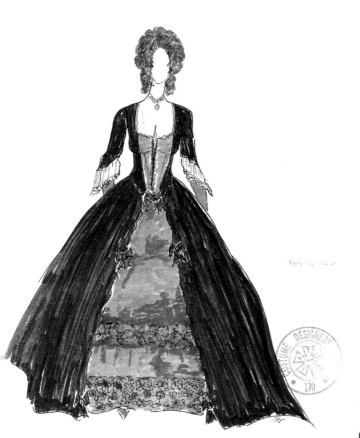

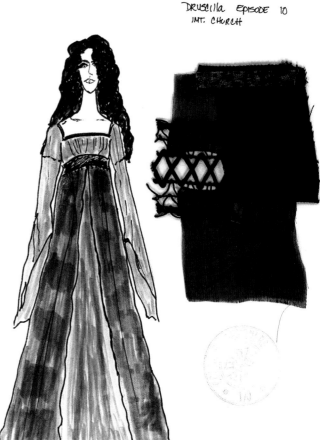

DRUSILLA EPISODE 10
INT. CHURCH

Jenny Calendar one of the easiest characters to costume. Knowing that Jenny was a Gypsy, Bergstrom dressed her in tiny paisleys and copies of vintage jewelry. Spike's original duster cost $1,600, and the costuming department "literally beat the heck out of it." Many of the clothes the actors wore were softened to reduce their potential for making noise during shooting. Bergstrom also softened them with heat. Only natural fibers could be used, because synthetic fibers could burn, but all the clothing that she softened with heat was also dipped and sprayed by a certified

fireproofer just in case. Another noise-reduction tactic Bergstrom employed was attaching rubber soles to the actors' shoes.

LEFT: Costume reference image of actress Juliet Landau as Drusilla wearing a Renaissance costume designed by Cynthia Bergstrom.

ABOVE: Bergstrom's sketches of the same Renaissance gown with the original fabric samples; another Bergstrom sketch, showing Buffy's eighteenth-century-style gown from Ethan Rayne's costume shop, which transforms her into a helpless noblewoman in "Halloween."

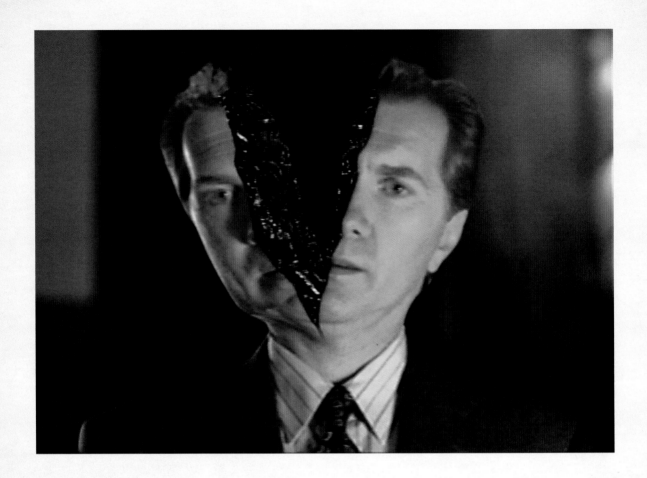

DIGITAL EFFECTS

Loni Peristere served as *Buffy's* digital effects supervisor for 100 episodes (as well as 61 episodes of *Angel*), and created the iconic digital "vamp face." Vampires appeared human unless roused to fight or feed. Joss felt that when Buffy fought and staked them, it was important for them to look like monsters. "It would take them to a level of fantasy that would be safer." It would also allow Angel to switch back and forth, appearing as his historical nickname, "the One with the Angelic Face." Among other duties, his team was charged with creating and improving what happened to

a vampire when it was "dusted" (i.e., staked), which happened at least twice an episode in the high school seasons. Joss wanted the vampires to appear as if all the moisture had been sucked out of their bodies, literally turning them to dust. This was originally accomplished by creating an image of a person with all the moisture sucked from it, dubbed a "dust man"—Joss's idea of what happened to a vampire when it was staked. This image replaced the actor's face as a step in the digital dusting process. As digital systems became increasingly sophisticated, Persistere added 3-D animation and compositing to the dustings, which

showed time-lapsed destruction of skin, muscle, and finally the skeleton as the vampire exploded.

The digital effects team also created morphs of characters from vampire and/or demon to human and back again. An example is the high school boy's morph into a Dr. Jekyll–Mr. Hyde–style monster in "Beauty and the Beasts" [3x04]. By the third season, they were able to do facial replacements on bodies—termed "multiplicity." An example of this is Good Willow and Vamp Willow touching each other in the same frame in "Doppelgangland" [3x16]. Willow's face was digitally cut and pasted onto a stuntwoman's body.

They also created many other effects including CGI fire; the black pool effect in "Anne" [3x01]; the lightning attracted by the Glove of Myhnegon in "Revelation" [3x07]; and 3-D monsters such as the huge Mayor Wilkins snake in "Graduation Day, Part 2" [3x22], rendered with the latest software available at the

LEFT: One great example of special digital effects: Mayor Wilkins's face splits open in "Graduation Day, Part 2."

ABOVE: Vamp Willow looks over Willow's shoulder in "Doppelgangland."

Weapons often reflect the character who uses them.

— Doug Petrie

time. After Joss read an article in the visual effects magazine *Cinefex* explaining about new technology to digitally create "thousands" of bad guys, Peristere and his company created the epic battle featuring the hordes of Turok-Han at the hellmouth for the end of the series.

ARMING THE SLAYER

A curious fact about *Buffy* was the absence of guns, which has served as the subject of academic studies. Guns were used in very few instances: Darla packed two six-shooters in "Angel"; Xander knows how to lock and load after wearing a magical soldier costume on Halloween; Jonathan

had a rifle in "Earshot"; and Warren killed Tara with a gun in "Seeing Red" [6x19]. The aesthetic argument was made that the Slayer's fighting techniques have been handed down for generations and they are by their nature medieval. As for vampires, they didn't need weapons (Darla's guns notwithstanding) because they were living

LEFT: The series premiere, "Welcome to the Hellmouth," in which Buffy attempts to get her point across—she's not a helpless blonde in a dark alley. She's the Slayer.

ABOVE: From the prop department, the hunga munga and Kendra's lucky stake, Mr. Pointy, two of the more memorable weapons used on the show.

Live at the Bronze

"THE RELATIONSHIP OF MUSIC TO STORY COULDN'T BE STRONGER."

—Joss Whedon

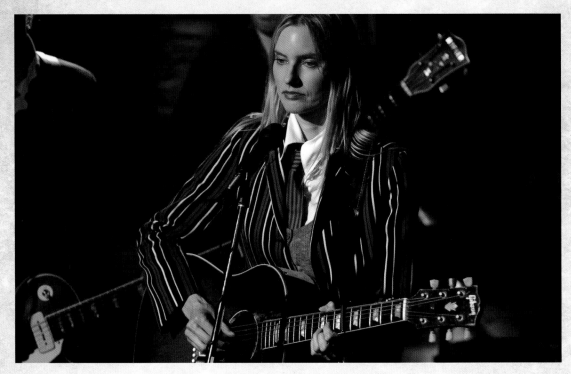

Here is a list of real singers and bands who played on camera at the Bronze or elsewhere in Sunnydale:

Aimee Mann: "This Is How It Goes," "Pavlov's Bell"
Sleeper [7x08]
Mann also had a speaking line: "Man, I hate playing vampire towns."

Belly Love: "Back to Freedom"
Anne [3x01]
This was the song that was playing on Xander's "depressing night."

Bif Naked: "Moment of Weakness," "Anything," "Lucky"
The Harsh Light of Day [4x03]
They played at the campus party; Parker and Buffy danced to "Lucky."

Cibo Matto: "Sugar Water," "Spoon"
When She was Bad [2x01]
Fun fact: bassist Sean Lennon is the son of John Lennon.

Darling Violetta: "Cure," "Blue Sun"
Faith, Hope, and Trick [3x03]
They also composed and performed the theme song to the *Buffy* spin-off *Angel*.

devics: "Key"
Crush [5x14]
Four Star Mary: All the music performed by Oz's group, Dingoes Ate My Baby, and "The Exposition Song"
Restless [4x22]
The band appeared onstage with Giles when he sang "The Exposition Song"; *Buffy* score composer Christophe Beck was at the piano.

K's Choice: "Virgin State of Mind"
Doppelgangland [3x16]

Lotion: "Blind for Now"
Phases [2x15]
Their song "West of Here" is heard as the Dingoes leave the stage in "Revelations" [3x07].

Man of the Year: "Just as Nice"
All the Way [6x06]

Michelle Branch: "Goodbye to You"
Tabula Rasa [6x08]

Nerf Herder: "Rock City News," "Mr. Spock"
Empty Places [7x19]
Brought to Joss's attention by Alyson Hannigan, Nerf Herder composed *Buffy*'s opening credits theme song. Nerf Herder's lead singer, Parry Gripp, said they had written the song some time before but were having trouble finding lyrics for it. The original recording of the song loses the tempo partway through; it was rerecorded for the opening credits of season three and used from then on. Nerf Herder took their name from a line in *The Empire Strikes Back*: Princess Leia called Han Solo a "stuck-up, half-witted, scruffy-looking nerf herder."

Nickel: "1000 Nights," "Stupid Thing"
School Hard [2x03]

Royal Crown Revue: "Hey Sonny [Where'd You Go]," "Trapped [In the Web of Love]"
Superstar [4x17]

Splendid: "Charge," in "I Only Have Eyes for You" [2x19]; and "You and Me," in *The Freshman* [4x01] Splendid member Angie Hart also wrote the song "Blue" with Joss, the lyrics of which became a key thematic point in the episode "Conversations with Dead People." Angie Hart performed it in the episode, and Drew Goddard referred to her performance as "our little rock video."

Sprung Monkey: "Things are Changing," "Believe"
Welcome to the Hellmouth [1x01]

Velvet Chain: "Strong," "Treason"
Never Kill a Boy on the First Date [1x05]

Official *Buffy* Albums:
Buffy: The Album
Radio Sunnydale
Buffy: Once More with Feeling
Buffy: The Score

LEFT: Aimee Mann, one of *Buffy*'s many guest artists, singing at the Bronze in "Sleeper."

ABOVE: A sketch of the Bronze set by production designer Carey Meyer.

weapons. Practically the only thing that would kill them was a stake to the heart, requiring the Slayer to get up close and personal.

The prop department was on a constant search for new and interesting weapons to keep Buffy's arsenal fresh. Marti Noxon also noted that Buffy, who loved to shop and look trendy, would also keep on the lookout for these cool accessories. Wooden stakes were actually carved by the

prop department, and stakes used to dust vampires were retractable. Swords, battle-axes, and crossbows were also used. Giles was given a sword fight in "Band Candy" in part to help him "escape his tweed," and Joss was especially impressed by the look of the sword fight between Buffy and Angel in "Becoming, Part 2."

A key find was a hunga munga, the unusual ax-like weapon Buffy is holding in the credits of season two. With a ball bearing added to one end, the hunga munga could be made to look like it was spinning through the air. Faith had an elaborate knife, a gift from the evil mayor, that Buffy taunted him with in order to lead him to his destruction.

ABOVE: Oz at the school with a sticker from the band Widespread Panic on his locker: a shout-out from on-set dresser Johnny Youngblood.

COMPOSING THE SCORE

French Canadian composer Christophe Beck was the main composer during seasons two through four of *Buffy*, winning an Emmy Award in 1998 for his work on the show. Later on, he returned to work on special projects such as "The Gift" and to orchestrate Joss's compositions for "Once More with Feeling." He composed both the Buffy/Angel and Buffy/Riley themes, finding the Buffy/Angel theme easier to reuse and reference because it was more sweeping.

His normal schedule for an episode was approximately a week, but "when Joss is directing," sometimes that time would be cut in half. Beck worked electronically, with samplers and synthesizers, usually creating between nineteen and twenty minutes of music per episode. He usually brought in at least one live instrument per episode, often a woodwind, and as with the weapons and costume departments, he was always on the prowl for new material to keep the sound of *Buffy* fresh.

THE SOUND TRACK

Taking a (musical) cue from Buffy Summers's persona as a maverick outsider, music supervisor John King actively sought out new and/or unsigned bands to perform their music onstage at Sunnydale's local club, the Bronze. He said he liked to do this "because, one, they're the ones who need the exposure. And number two, because we like to give it to them." King tried to find independent bands that he considered good enough to actually play the local scene.

In the same spirit of shout-out inclusion, on-set dresser Johnny Youngblood decorated the lockers and bulletin boards of Sunnydale High and the Bronze with artwork sent to him by independent bands, most notably Widespread Panic. These bands and their fans would eagerly watch *Buffy* in hopes of catching a glimpse of their posters. This breaking of the fourth wall (inviting the viewer into the reality of a TV show) became a staple of *Buffy*, via online chat rooms and posting boards including the Bronze. In these chat rooms—a fairly new phenomenon in 1997—the writers and producers would interact with fans and include them via occasional shout-outs on the show. (One example is the creation of the Polgara demon, named after a fan's online name, "Polgara.")

In turn, "the Bronzers" began throwing an annual Posting Board Party to benefit the Make-A-Wish Foundation. Joss and many of the actors and staff attended these parties, and the bands Darling Violetta, Velvet Chain, and Four Star Mary often performed, in addition to the real-life bands of some of the actors, such as James Marsters's Ghost of the Robot and Adam Busch's Common Rotation (Adam Busch played Warren, the most evil of the Troika). Velvet Chain went on to create new songs based on Buffy's story, soliciting input from the Bronzers, and released *The Buffy EP* at the 1999 Posting Board Party. Seth Green played guitar on the track "Buffy."

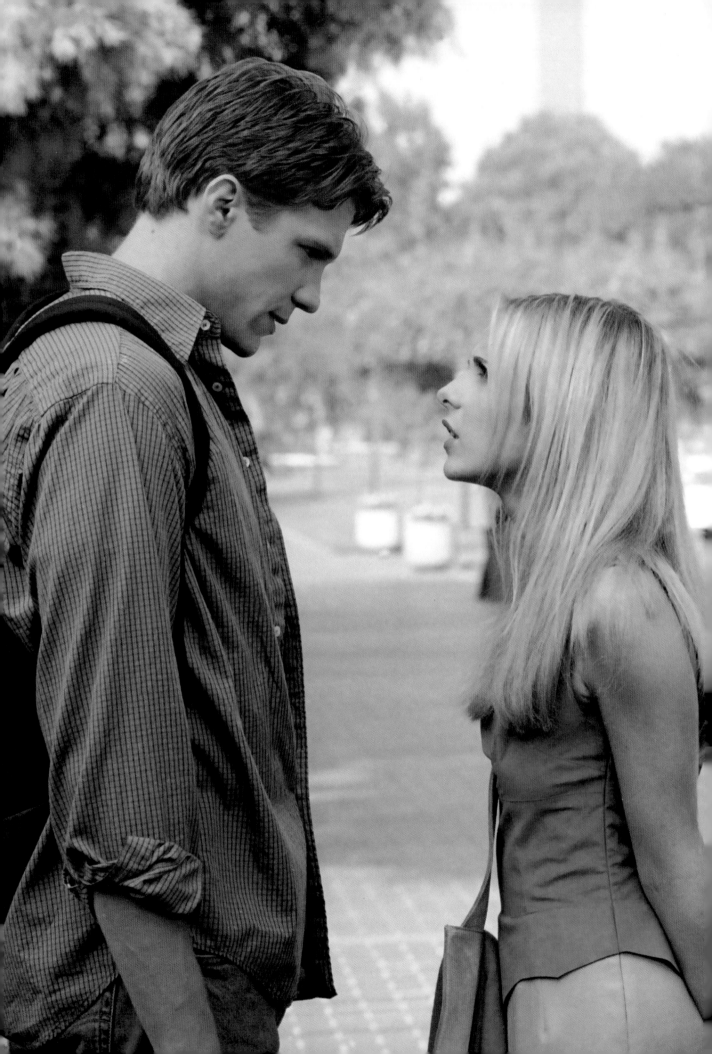

CHAPTER III

College Magic

Buffy the show strove to surprise the viewer at every turn; and so it was that Buffy the Slayer, academically challenged (to say the least) in high school, winds up with SAT scores so stellar that she could—and should—go to college. Since it is Buffy's duty to monitor demonic activity at the local hellmouth, Buffy enrolls at UC Sunnydale. Loyal best friend Willow follows suit, despite a massive stack of acceptance letters from prestigious schools including Harvard, Yale, and Oxford.

followed Buffy to the brave new world beyond high school. Fans congregated to discuss the show, often meeting on Tuesdays at lunch (when the show was on Mondays) to discuss the previous night's episode. Online, they went to the Bronze Posting Board (and later to Bronze Beta and the UPN site) and created special clubs for beloved characters. They offered memberships to Joss, the writers, and the actors. These VIPs came into the "Bronze" and other posting boards to discuss episodes and let the "in-crowd" know

Buffy lost her security blanket. With the loss of Angel, nothing's quite right.

—— Marti Noxon

("That's where they make Gileses!") Aside from the friend factor, Willow thinks fighting alongside the Slayer is a worthy trade-off for the more-hallowed halls. She also hopes she'll advance in her studies of witchcraft by sticking around the über-vibey hellmouth. Willow's interest in witchcraft will blossom into a passion, and then into an obsession in her life; and magic will pull double duty as a metaphor during Willow's college years and beyond.

From its beginnings as an underdog show championed by those who "got it" (such as critics Matt Roush of *TV Guide* and David Bianculli), *Buffy* accumulated devoted fans who gladly

about shout-outs they were arranging for the group. In return, the fans designated themselves virtual "Keepers"—imaginary guardians—of such things as Spike's duster. A wonderful discussion of this devoted fandom can be found in Allyson Beatrice's book, *Will the Vampire People Please Leave the Lobby?: True Adventures in Cult Fandom.*

The fans as a whole were very concerned about the departure of Angel on *Buffy* at the end of season three. Joss wanted them to go through what he, the writers, and Buffy were feeling—a sense of loss and uncertainty about the future without Buffy's special guy. Many claimed that

when Buffy sees a man in a bar who looks just like Angel from the back, it really was David Boreanaz in an uncredited appearance, there to add verisimilitude to the spark of hope that Angel really was back. Joss and Jane Espenson confirmed for this book that David's head was likely used. "Buffy lost her security blanket," Marti Noxon explains. "With the loss of Angel, nothing's quite right." The audience was used to seeing Angel—evil or not—at Buffy's side.

Buffy's skills as a Vampire Slayer do not necessarily spell success in her new environment, and Joss framed Buffy as small and insignificant,

surrounded by towering buildings and noisy, happy crowds of students. Some of the UC Sunnydale exteriors and the first scenes in the library were shot at the University of California at Los Angeles, but the interior sets were built at *Buffy*'s Mutant Enemy complex. Striving to

PREVIOUS: Buffy and cute TA Riley try to hide their various demon-hunting activities from one another at the beginning of "Hush."

ABOVE: Feeling lost in the crowd at UC Sunnydale in "The Freshman."

Crossing Over

Angel, the Buffy spin-off, premiered on October 5, 1999, to excellent ratings. During its run, it occasionally attracted more viewers than *Buffy*. In Los Angeles, Angel works to forget Buffy and to atone for more than a century of soulless torture and murder. Cordelia and former Watcher Wesley Wyndam-Pryce join him. Harmony Kendall, a vapid Sunnydale student who became Spike's vampire girlfriend, joined the cast—as did Spike, after he sacrificed himself in the *Buffy* series finale.

During *Buffy* seasons four and five, there were seventeen episodes in which characters from the two shows either physically visited the alternate show or made reference to characters and events—seven on *Buffy* and ten on *Angel*. These crossover events were designed to help establish the new series, and it worked.

Former Bronze Posting Board Party committee member Wendy Lieb Schaprio recalls, "I think at first almost *all Buffy* fans started watching *Angel*, to be honest. There was a tremendous groundswell of support for Joss and the 'team' as well as for David, Alexis, and Charisma . . . I have the impression that a good portion of the *Angel*-only fans were fans of individual actors or characters on that show."

Angel executive producer David Fury has this to say about viewers: "Most, it seemed, were *Buffy/Angel* fans. But there were a substantial base (maybe 20 percent) who watched *Angel* solely. Some never having seen an episode of Buffy before, or [had] and thought it too glib for their tastes."

The premiere of *Angel* showed Angel still pining for Buffy, who is shown in flashbacks (which were requested by the studio). Angel's new sidekick, Doyle, explains that it's vital that Angel connect emotionally with the people he wants to help, because he's recently drunk human blood—Buffy's. Angel is metaphorically a recovering alcoholic—one drink away from a very dark path. At the end of the episode, yearning for Buffy, he calls her. *Angel* viewers heard her voice. Without responding, he hangs up.

In the corresponding *Buffy* season premiere, "The Freshman" [4x10], viewers saw Buffy receive a phone call, and she hangs up when no one speaks. But viewers could guess that the caller was Angel; composer Christophe Beck deliberately inserted a handful of notes from the Buffy/Angel love theme as a tip of the hat to the show's devoted followers.

Buffy, Faith, Oz, and Willow all found reasons to visit Angel in L.A. In "Pangs" [4x08], Angel arrives in Sunnydale to help Buffy without her knowledge because his sidekick, Doyle, has had a vision that Buffy is in danger. This necessitates a trip by Buffy to *Angel* to express her ire that he snuck around behind her back ("I Will Remember You" [1x08 *Angel*]). During

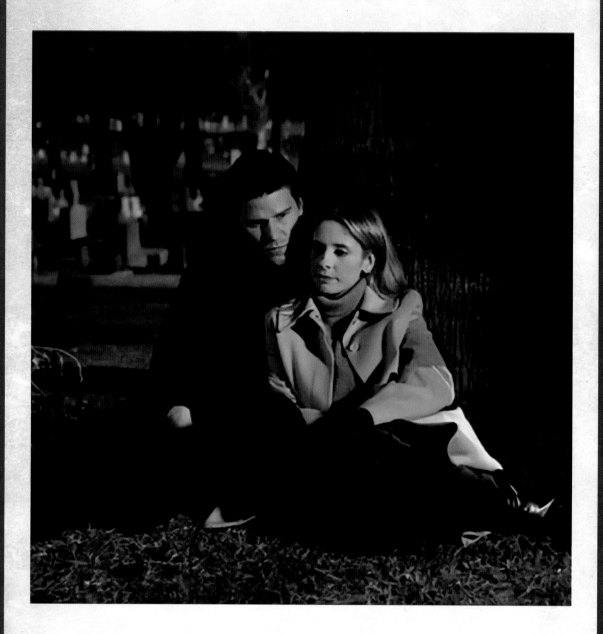

their confrontation, demonic Mohra blood renders Angel human. Buffy and Angel rejoice and make love with abandon. The grand passion of Buffy and Angel is reignited on *Angel*, luring "Bangles" (fans of the Buffy/Angel pairing) to the new show. Sadly, Angel learns that to save Buffy's life, he must give up his humanity, become a vampire again, and magically turn back time so that their idyllic time together has never happened.

Angel's selfless sacrifice provides a conclusion for the Buffy/Angel relationship, showing that as things stand, it simply can't work. This finally frees Angel of his connection to Buffy so that he can brood (and have other love interests) and returns Buffy to her vulnerable lack-of-Angel status.

ABOVE: Angel returns to Sunnydale in "Forever" to comfort Buffy and pay his respects after her mother's death.

match the distinctive look of UCLA, production designer Carey Meyer went as far as scanning in photographs of the tile used at UCLA to decorate his hallways and classrooms. The writing staff loved the large lecture hall, and Marti Noxon named the dorms after the colleges of UC Santa Cruz, which she attended.

ABOVE: Buffy is singled out by a professor and told to get out of his class in "The Freshman."

RIGHT: Willow is nothing short of ecstatic about the classes, activities, and parties on campus, while Buffy is stuck feeling left out.

"The Freshman," the premiere of season four, featured long shots of Buffy standing alone, even when surrounded by a crowd. SATs aside, academia is still not her world. She registered for her classes late and is still trying to figure out her schedule, while Willow is basking in curricula. A professor ridicules Buffy and throws her out of his class. She breaks the frozen yogurt machine in the cafeteria and drops a pile of books on the cute psychology TA, Riley Finn, who can't even remember her name.

On the other hand, Willow, ostracized in high school as a nerd, glows with confidence in great

clothes and a kicky new haircut. Miss "I Chose My Major in Playgroup" even has an on-campus musician boyfriend—Oz.

Buffy and Willow aren't rooming together, making Buffy's patrolling problematic at best while adjusting to a literal "roommate from hell." Mean girl–bloodsucker Sunday and her hangers-on kill or turn the occasional "weak" freshman, steal all their stuff, and leave behind an "I left because I can't handle school" note. Sadly, no one questions these disappearances because college is tough, and people do leave. Buffy finds one of these notes in her own cleaned-out dorm room, ostensibly signed by her, even though she's not dead. It's clear to her that Sunday figures the Slayer's defeat is a fait accompli.

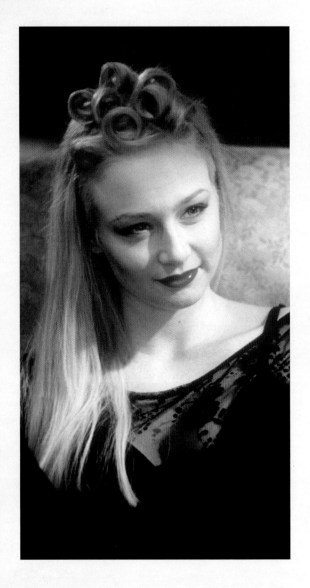

Buffy believes she can't defeat Sunday alone. "That has *never* happened," writer Doug Petrie asserted—she's not even doing a good job of being a Slayer. Her backup "Core Four" are caught up in their own lives, and even her mother is already using her room to store inventory from her art gallery. Eventually Buffy's friends assemble to help Buffy defeat Sunday, but one of the season's main themes—that high

school graduation changes things—is stated here, and will be repeated in plot and characterization throughout the college episodes. As Joss said in an NPR interview, "This last year was about college. It was about the sudden freedom and how you try on new personas and how your gang kind of falls apart, and at the end of your first year of college, you're in a very different place." And as the other characters on *Buffy* try out new personas, they grow increasingly uncomfortable and out of place, with themselves and with one another.

Even though the characters were drifting apart on-screen, viewers could still find something to relate to. "The important thing is always to match whatever your characters are going through to whatever you're going through as a creator to what the audience is going through," Joss explained. "You know, it's taking the challenges, it's taking the fears that you have and letting everybody go through them, because ultimately, everybody always does."

Xander, still stuck in his parents' basement, definitely feels like an outsider, tagging along to frat parties and enduring insults when he bartends at the local college watering hole. His Slayerette credentials are stretched even thinner when he starts dating Anya, the ex–vengeance demon with a gift for phrasing things in the most inappropriate way imaginable. Giles, no longer a Watcher or a school librarian, feels as displaced as Buffy herself. Anthony Stewart Head said of playing Giles, "I'm a lost soul, a bit of a lounge lizard."

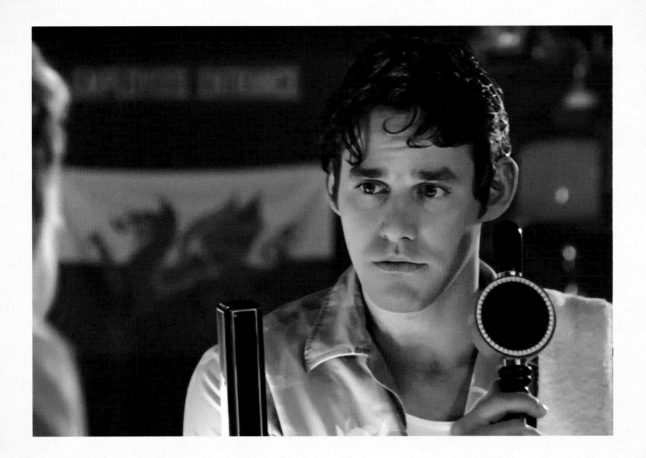

Willow appeared to be off to a good start, but things soon go wrong between her and Oz. This story arc is Oz's last as a regular cast member. When Oz was first introduced, Joss had not intended for him to become a cast regular, but Oz became so popular that he signed Seth Green up. In the world of episodic TV, being a cast regular provides a guarantee that the actor will be featured in every episode. In return, the actor guarantees that they will make themselves available to work every shooting day. Seth Green eventually asked for the character of Oz to be written out. He explained his decision to fans on Whedonesque, a website dedicated to all things Joss Whedon: "I began having other opportunities and working on a show five days a week, 12–14 hours a day, in scenes with 10 people, waiting for hours to say a line like 'I think Buffy's right,' precluded me from taking advantage of them."

LEFT: Sunday, the mean-girl vampire on campus, abducts freshmen from their dorms and leaves a "goodbye, I quit" note to make everyone think they've dropped out. She almost manages to do the same to a demoralized Buffy.

ABOVE: Xander gets a job in a pub near the university, where he's harassed by frat boys and feels like he's tagging along with Buffy and Willow all the time.

This necessitated a redesign of Willow and Oz's arc, which became, in part, a study of the savagery of the id. Maggie Walsh of the Initiative, who kept a day job as a psychology professor at UC Sunnydale, provided the exposition necessary for the theme: "These are the things we want. Simple things: comfort, sex, shelter, food. We always want them, and we want them all the time. The id doesn't learn; it doesn't grow up. It has the ego telling it what it can't have, and it has the superego telling it what it shouldn't want. But the id works solely out of the pleasure principle—it wants. Whatever social skills we've learned, however much we've evolved, the pleasure principle is at work in all of us. So how does this conflict with the ego manifest itself in the psyche? What do we do when we can't have what we want?"

Oz, who has sought to contain his inner wolf by locking himself up every three-night full moon cycle, has never sought to control his id. After he meets Veruca, a female werewolf who fully embraces her savage nature, he can't summon the strength to deny what he wants, and cheats on Willow with her. Willow is tempted to use a spell for payback, although she stops before she can cause harm—a choice she will not always make. When Veruca attacks her rival, Willow,

Oz kills Veruca in werewolf form. Shattered, he leaves town to find a cure.

Willow is heartbroken after he leaves, but she can't find the comfort she needs from her preoccupied friends. Magic is now her companion and her solace, and from this point on, becomes the defining aspect of her character. She casts spells in an attempt to spare herself the drawn-out grief process. The spells go awry, and she is not spared from her sorrows. But under her spell, Buffy and Spike seemingly fall in love and plan their wedding, giggling and kissing. ("Spuffies" could now try out the altered identity of a Buffy who has replaced Angel with Spike.) Giles chastises Willow, pointing out that she's trying magics she's not ready for, and that her spells come out wrong whenever she's upset—and she is definitely upset over the loss of Oz. But she persists in secret.

EVERYONE HAS A SECRET

At the beginning of the college arc, Angel has just left and Buffy is alone. The Slayer is ripe for the plucking by womanizer Parker Abrams, who reels her in with promises of intimacy and then summarily dumps her once they've slept together. Writer Jane Espenson says that a deleted scene shows Buffy telling Willow that the entire time she was with Parker, she kept telling herself that she was over Angel . . . but really, all she was thinking about was Angel. Espenson was sorry that it was cut, as many fans felt Buffy slept with Parker too soon, an act that was disrespectful of Angel.

RIGHT: Ethan Rayne, a former friend and now enemy of Giles, turns Giles into a Fyarl demon. Buffy almost kills him, but recognizes him when she looks into his eyes: "You're the only person in the world that can look that annoyed with me."

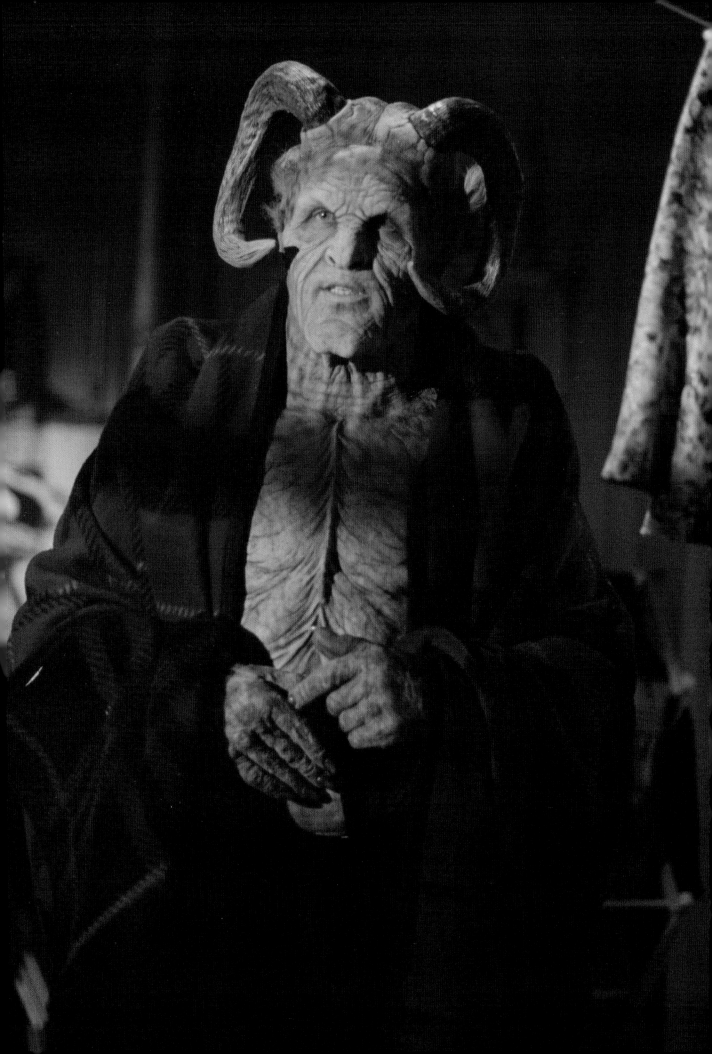

Hush

In keeping with his creative vision of *Buffy* as a genre-busting show (a mixture of horror, comedy, and action), Joss decided it was time for another surprise for the audience—and for himself. He created "Hush" in part because he was afraid that he was growing stale as a TV director and wanted a challenge: an episode that went twenty-seven minutes without dialogue. James Marsters marveled at his risk-taking, saying, "Joss terrifies himself on purpose. So many people came up to him and said, 'The reason *Buffy*'s so great is because your dialogue is the best I've ever heard.' He hears that ten thousand times . . . and then he writes a show without any words."

Joss also decided to use "Hush" to really frighten the audience. "Horror is the one thing the series has had the least of," he said, explaining that because the scripts were so packed with character development, it was hard to move slowly enough to "build up the scary." So he set himself an extra challenge to ratchet up the tension solely with visuals and music. There is one scream, and one scream only, in "Hush." "If I don't talk for three acts, then I really will

have no choice but to direct it visually," he said. There would be no chance that "Hush" could be described as "radio with faces."

The floating, creepy Gentlemen were born in a nightmare of Joss's. Well-known "creature actors" stepped in, such as Doug Jones (*Pan's Labyrinth*) and Camden Toy (the Turok-Han and the Gnarl demon on *Buffy*, and the Prince of Lies on *Angel*). Other Gentlemen were played by mimes. Much of the episode was shot on the Universal Studios backlot. Loni Peristere, visual effects supervisor, explains that the Gentlemen were carried down the streets of "Sunnydale" on a giant crane, like a huge puppet. All the rigging lines were digitally deleted, frame by frame.

Aware that there would be more music required, given the lack of dialogue, Christophe Beck, the composer, says, "I knew I was in for a treat, and a nightmare." "Hush" introduced the Buffy/Riley music love theme. Joss has said he prefers this theme to the sweeping Buffy/Angel theme, finding it more adult, a little "bluer and stranger."

Fans and critics alike praised "Hush," giving it more attention than a single episode of any show would normally warrant, and crediting it with proving the series could stay fresh after moving on from high school.

LEFT: The Gentlemen in "Hush": floating, cadaverous specters who steal the voices of their victims before sending in their hunchbacked lackeys to attack.

ABOVE: This newspaper prop from "Hush" features headlines that are relevant to the wonderfully creepy storyline, but the "articles" themselves, which were not legible on screen, are totally unrelated, hilarious minor works of art.

Eventually, the much nicer Riley Finn owns up to his attraction to Willow's peculiar friend, but Buffy wonders if he's just too normal for her. She's got a huge secret. What she doesn't know is that Riley has one, too. During "Hush," revelations erupt one by one. Under Joss's mission statement that "real communication begins when talking ends," Riley and Buffy discover that each of them is a demon-hunter. Once they have defeated the Gentlemen—fairytale-like monsters who have stolen their voices—they find themselves fumbling for the words to explain who they really are. Buffy's taken aback when Riley confesses that he's never heard of the Slayer. She's also unnerved by his assumption that now that they know each other's secret, a relationship between them seems not only possible but inevitable.

Buffy hesitates, at first believing it's because she's been burned a few times. It is left to Spike to needle both her and Riley with repeated reminders that Buffy "likes a little monster in her men." While Buffy ponders the accuracy of that observation, she puts on her game face, entering Riley's world of demon-hunters.

THE INITIATIVE

In subterranean headquarters deep beneath the university campus, a supersecret government program called "the Initiative" captures demons and performs experiments on them. The Initiative is

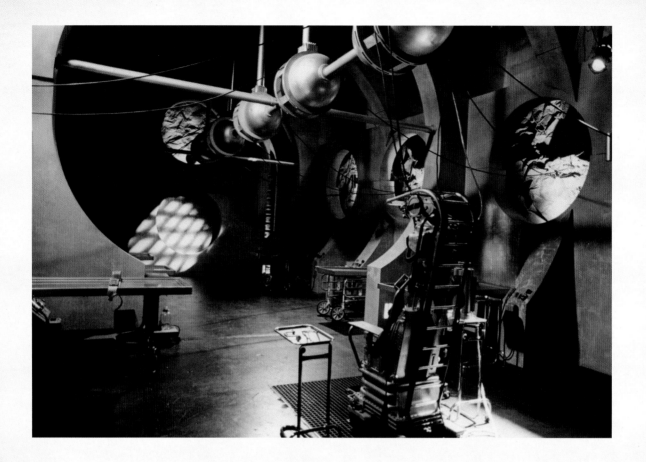

headed by Dr. Maggie Walsh, Buffy and Willow's psychology professor, and Riley is a team leader.

"We thought you were a myth," Walsh says to Buffy when they meet. The Initiative uses high-tech weaponry to subdue demons and vampires (which they call Hostile Sub-Terrestrials, or HSTs), in contrast to Buffy, who "pokes them with a sharp stick" ("A New Man" [4x12]). Buffy, whose world is based in magic and intuition, attempts to join her new boyfriend's world, firmly rooted in science and black-and-white thinking. Riley is forced to reexamine his rigid mind-set as he gets to know Buffy and her friends. By the time he meets Angel, he is better able to understand why Buffy was able to love a

vampire . . . and also why she can't seem to love a nice, normal guy like him.

"The important thing for us," said Joss, "was to find a character that was the anti-Angel and to have Buffy go through something very different, part of which was the question 'How do I get over Angel?' That was the same thing

LEFT: Joss Whedon directs Sarah Michelle Gellar and Marc Blucas while shooting "Hush," the tenth episode of season 4.

ABOVE: Production designer Carey Meyer's behind-the-scenes set photo of the Initiative's underground research center, complete with restraining chair.

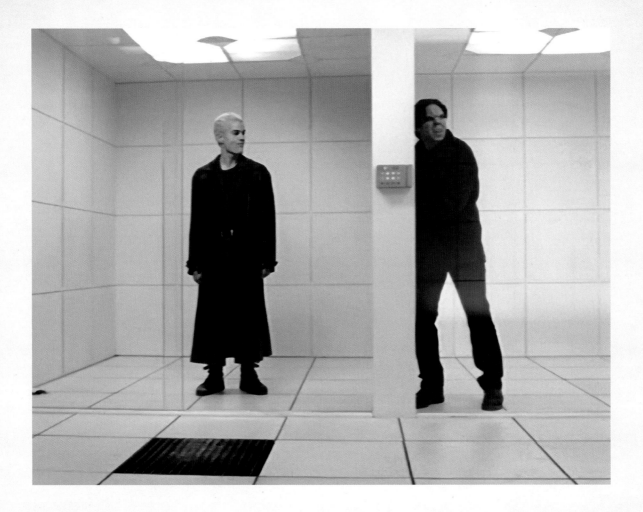

the audience was going through. We knew it wasn't going to be easy, and it was very hard trying to find somebody. But Marc [Blucas] has a quality that I love very much: he has sort of an un-David-like, firm, strong, trustworthy quality."

ABOVE: Spike is imprisoned in the Initiative's secret demon-research facility in "The Initiative."

RIGHT: Spike races off to find Buffy when he escapes from the Initiative and finds Willow alone. He attacks her right before the commercial break—but when we come back, it turns out he can no longer attack humans.

Spike is captured by the Initiative when he returns to Sunnydale to find the legendary Gem of Amarra, and they lock him up in the underground complex. When he escapes, he heads straight for Buffy's dorm room. Rumors had been swirling on the Internet that Willow was going to die in this season, so Joss and his writers responded: they established that Willow was alone in the room she and Buffy now share, and sent a vengeful Spike there. Spike attacks Willow in the seconds before the commercial break. Then, in true *Buffy* fashion, the expectation that she's dead is subverted after the commercial break: it turns

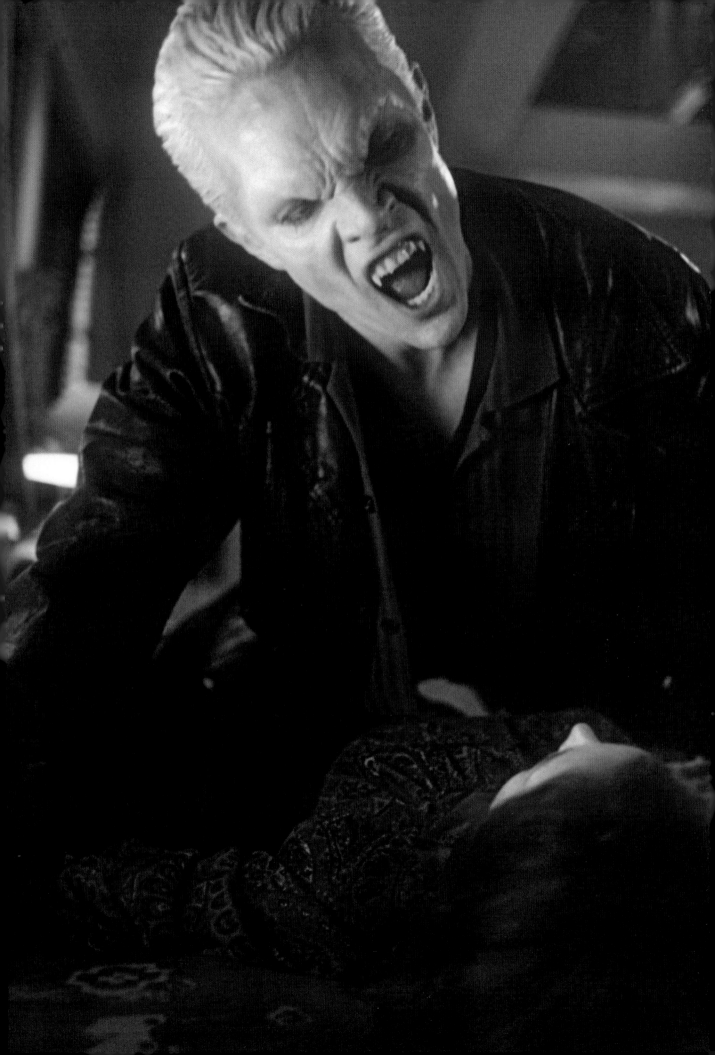

out that Dr. Walsh's surgical team has implanted a behavioral modification chip in Spike's head. Every time he tries to harm a human being, he receives a jolt of excruciating pain.

NEW IDENTITIES

Thanks to the new chip in his head, Spike can't even hit a human, as he explains in his own special way: "I'm saying that Spike had a little trip to the vet, and now he doesn't chase the other puppies anymore" ("Pangs" [4x08]). This renders him so vulnerable that Buffy and company can't bring themselves to stake him. Mostly, they shower him with insults, especially whenever he tries to remind them that he's still evil. Devastated, he attempts suicide—and fails even at that. Marti Noxon has said that the Slayer is interesting only when she is human—with human emotions and frailties—and the same can be said of Spike. He shares Buffy's longing for a festive Thanksgiving and the good old times with Drusilla, the same as she's missing with Angel. He rejoices when he discovers he can "kick some demon ass."

In her essay "The Undemonization of Supporting Characters," in *Fighting the Forces*, Mary Alice Money says: "Of course, he lives (in a manner of speaking) for the day when he can once again wreak havoc among the humans, beginning with the despised Buffy, for whom he, William the Bloody, harbors some hidden tenderness. For the nonce he is impotently good, like Milton's Satan nearly beguiled by Eve." Thus the character of Spike began his trajectory from arch-nemesis to

ensouled champion, his status by series end—a journey ultimately made possible not by his chip, but by magic and love.

Structurally, Joss and his writers envisioned Spike stepping into the role of blunt truth-teller—Cordelia's role—when the characters of Angel and Cordelia were moved to *Angel*. However, while Spike might have been a truth-*seer*, Joss felt that giving him Cordelia's lines didn't quite work, and added Anya to the mix. A human turned vengeance demon, Anya was changed back into a human when a spell went awry. Anya feels pressure to behave correctly to please Xander, which means getting along with his friends. But her bluntness often provides a great source of mortification for Xander and comic relief for the *Buffy* audience.

A similar trying-on of an identity occurs when Faith Lehane, the murderous Slayer, wakes up from the coma in which Buffy left her at the end of season three. Armed with an amulet left to her by her old boss, the mayor, she switches bodies with Buffy. Buffy's unsuspecting friends—and Riley, her lover—shower Faith-as-Buffy with love and affection. Faith was not prepared for this, and is forced to respond as she assumes Buffy would—not as smoothly in all cases. She hurts Tara's feelings, comes on sexually to Spike, and perplexes Riley with her sex-play. Still, her encounters floor her, and force her into a new perspective on what it means to be Buffy—and Faith. "What I was interested in seeing," said Joss, "was the character of somebody who's hated and considers the world

her enemy getting the chance to completely destroy the life of somebody who's got everything she doesn't have, and represents everything she doesn't believe—and having it affect her instead."

In "Who Are You?" [4x16], Joss showed this by calling upon the narrative power of three: Faith says the words "Because it's wrong" three times during the episode. The first time, she's practicing her Buffy persona in front of a mirror while at the same time making fun of Buffy. The second time, she exercises sexual power over Spike by coming on to him, then rejects him by informing him that having sex with him would be wrong. But the third time, Faith abandons her escape plans to save some people from a vampire attack in a church. She tells the vampire she can't let him kill these people because it's wrong. And this time she means it.

"She wants more than anything to be Buffy, which is impossible," Joss concludes. She finally sees the world through Buffy's eyes. Shaken, she leaves Sunnydale, and in crossover episodes on *Angel*, will eventually seek redemption before returning to *Buffy* for the last battle against the First in season seven. Ironically, Buffy is "the only person who can really understand Faith's pain, because she's also a Vampire Slayer," writer Doug Petrie says. "She's also isolated from the world, and alone, and lonely."

In both of these characters' lives, some kind of external pressure (a chip, an amulet) causes them to try on a new persona—another theme of the season—and to align their behavior to

ABOVE: Faith has lain in a coma in the hospital basement since the end of season 3, but awakens in "This Year's Girl" and goes hunting for Buffy.

match that persona. And behavior is the purview of Maggie Walsh, leader of the Initiative.

THE SCIENTIFIC METHOD

To dramatize the idea that it's hard to keep the old gang together after high school is over, Buffy forgets to tell Giles anything about the Initiative—that Riley's in it, and that Maggie Walsh is in charge of it. Then she officially joins the military operation, shiny new security pass and beeper in hand. She blows off social engagements with her old friends (or brings *all* her new friends to them) and seems to have no need of Giles, Xander, and Willow, who, so recently, were vital to her victory over Sunday.

Despite Buffy's attempts to fit in, the differences in the approaches of the Slayer and the military collide. Buffy works in the realm of magical prophecies, spells, and amulets. The Initiative employs high-tech weaponry (Joss refers to their "tricorders" in his commentary) and treats all HSTs as mindless animals—despite Buffy's arguments to the contrary.

But everybody has secrets; and it falls to Giles's old nemesis, Ethan Rayne, to offer the information that there are rifts in the magical forces, and demons are spouting free verse about "pain as bright as steel" and "314." Sure enough,

RIGHT: Special makeup effects supervisor and artist John Vulich shot this behind-the-scenes photo of Adam. The painstaking details show Professor Maggie Walsh's melding of human, demon, and mechanical parts to create a super-soldier.

Riley spots a secret lab door marked 314. Soon afterward, Buffy begins to ask the questions that Riley never has, because he's a good soldier who does what he's told. Alarmed, Maggie Walsh attempts to have Buffy killed—and ends up dying herself. Betrayed by "Mother," Riley leaves the Initiative and joins the magical side of the battle against evil.

Enter Adam, symbol of all that is wrong with science. Dr. Walsh had a highly classified ulterior motive—to create an army of super-soldiers pieced together from demon and human parts and mechanical enhancements. And Dr. Walsh fully intended for Riley to become one of them. She'd been dosing all the Initiative soldiers, including him, with chemicals to give them superior strength and stamina. But she reserved special treatment for Riley: he has a chip, too, one that compels him to present himself to her prototype, Adam, for a bit of reconstructive surgery. Computer programs have already been created that will be inserted into Riley, as they have been into Adam, making them brothers.

In the aptly named "The Yoko Factor," Spike feeds hurtful lies to Willow, Xander, Buffy, and Giles in exchange for Adam's promise to take out his chip. The Core Four fragments, delaying the piecing-together of valuable clues about Adam's goal: to force a deadly battle between the demons imprisoned in the Initiative complex and their human guards, giving Adam plenty of pieces to build an army of superior beings like himself.

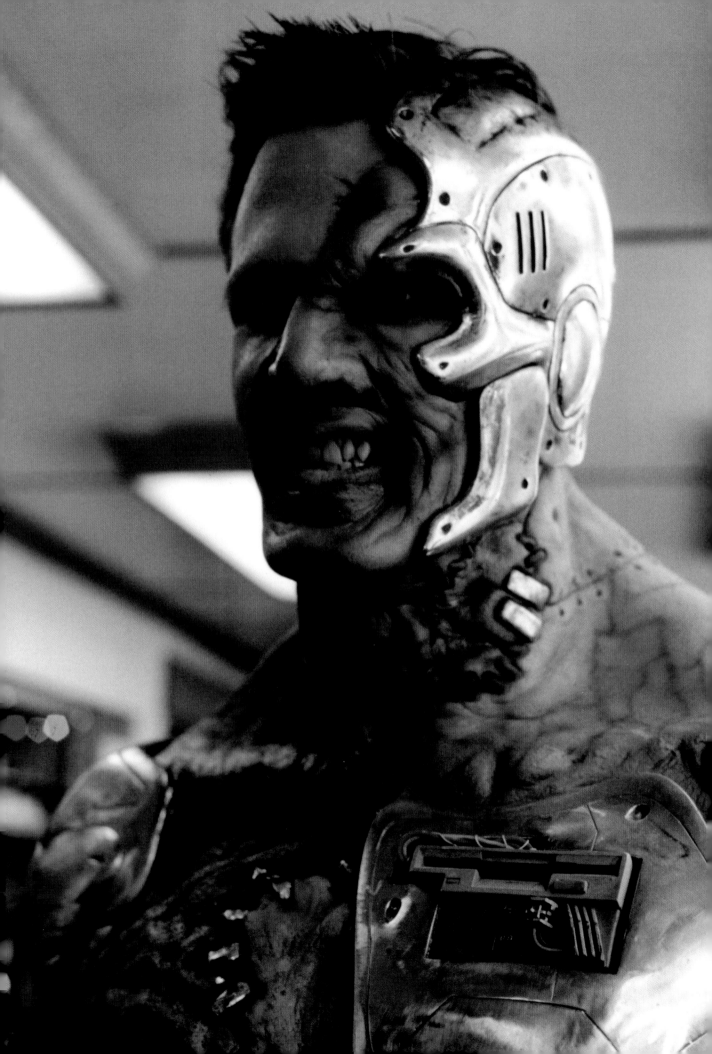

But the Core Four rebuild their trust, and they "get the band back together" to perform a spell that imbues Buffy with all the power of the Slayer line. Supercharged with magic, Buffy defeats Adam in dreamy, strange visuals reminiscent of *The Matrix*, Joss's favorite movie, provided by Loni Peristere's digital effects team. "Magic kicks science's ass," as *Buffy* writer Doug Petrie says, and the Initiative is shut down.

Subverting expectations as usual, Joss chose to end the season on "a grace note." In "Restless,"

the last episode of the fourth season, Buffy, Xander, Willow, and Giles fall asleep and have dreams that are, in essence, character studies. Their dreams and fears are shown in the disjointed manner of real dreams, held together by "the connective tissue" of a strange cheese man and murderous appearances by the spirit of the First Slayer. Joss was just as anxious as the dreamers: "I was basically sitting down to write a forty-minute tone poem. Now, I don't write poetry because I'm very literal-minded. And it was extremely liberating

and strange—and another 'Oh, my God, they're gonna hate me' experience."

In their dreams, the First Slayer kills Willow, Giles, and Xander, but Buffy connects with her, communicating with her through Tara, because the First Slayer "has no words." Tara delivers the message: "You think you know . . . what's to come . . . what you are. You haven't even begun."

Buffy wakes filled with questions about who she really is. Unaware that Giles had been planning to return to England because he's no longer needed, Buffy asks him to become her Watcher again. She wants to explore what it means to be a Slayer—where she comes from, and where she's going.

And that will require more magic.

LEFT: Buffy encounters the "Cheese Man" and the original Slayer in her dream sequence in "Restless."

ABOVE: The original Slayer confronts Buffy in "Restless."

MAGIC AS METAPHOR: WILLOW AND TARA

In high school, Willow began her study of magic by successfully restoring Angel's soul, and only occasionally performed spells for her own personal gain—to get rid of a zit, for example. She also assisted Anya in a spell that accidentally let an alternative version of herself as a vampire into our dimension. "Our" Willow lamented that Vamp Willow is "skanky—and I think I'm kind of gay" ("Dopplegangland" [3x16]).

and Willow seek refuge in a room equipped with a soda machine. Willow attempts to use magic to move it, and Tara quickly catches on. Gazing meaningfully at Willow, she locks hands with her. Together they move the machine, saving their lives. Joss called this moment "one of the most romantic images we've ever put on film."

Soon, Willow is visiting Tara in her room, attempting beautiful spells such as levitating a rose and plucking off its petals. However, everyone in Sunnydale has secrets, and Willow hides

Sometimes I think about two women doing a spell ... and then I do a spell by myself.

—XANDER, "Restless"

In college, Willow discovers that she *is* gay. After Oz leaves her, she attends the Daughters of Gaea, the "wanna-blessed-be" campus Wiccan club. The meeting is a bust, except that she first lays eyes on Tara, who becomes the love of her life. During "Hush," when the terrifying Gentlemen and their footmen race after Tara, she

RIGHT TOP: In Willow and Tara's first spell (in "A New Man") they levitate a rose together.

RIGHT BOTTOM: Willow and Tara perform a spell in "Who Are You?" to find the real Buffy after Faith takes over Buffy's body.

her relationship from the others, assuring Tara that it's because she wants something that's just hers. But Tara correctly assesses that Willow's wrestling with coming out to Buffy and company as a lesbian. The working of magic spells together is clearly a metaphor for their attraction, culminating in "Who Are You?" As they use magic to discover if Buffy's possessed, their foreheads are beaded with perspiration, their chests are heaving, and Willow falls back in ecstasy against beautiful soft cushions.

At a *Buffy* reunion at the Academy of Television Arts and Sciences, Joss recalled that after a run of ten episodes using spells and magic

as metaphors for Willow and Tara's lesbian relationship, he and Marti Noxon felt they were "losing the reality of this." In "Who Are You?" Tara lovingly tells Willow that she is hers, and the metaphor is finally dropped and the relationship becomes "literalized" when Willow introduces Tara to Buffy (who is really Faith in Buffy's body) at the Bronze. Cagey Faith and truth-seer Spike both know immediately that Willow and Tara are lovers.

In "The Body" [5x16], Willow and Tara kiss during the aftermath of Joyce's death. This is the first lesbian kiss on *Buffy*, and it was not the focus of the episode. The network was very nervous about it and did approach Joss about deleting it. He informed them that it was "not negotiable," and would yank the episode rather than allow it to be cut.

The kiss stayed in, and the use of magic as the metaphor for Willow and Tara's relationship was over.

As Amber Benson recalls, it was clear by the time they shot "Restless" that there would be no more tiptoeing around the relationship: "The end of season four finale had Alyson and me in the back of an ice cream truck, all sex-kittened

up, 'pretending' to make out. We got onto the set—and I'm not kidding you—every male member of the crew had found a way to be 'necessary' to the shot. There were literally guys who'd never seen the inside of the soundstage before, there, ready to 'help out.' I guess that's what happens when you mix Buffy, ice cream, and hot lesbians making out in the back of a truck."

BEYOND BOUNDARIES

Willow's exploration of magic moves from an expression of love to a search for power when the Big Bad of season five makes herself known: Glorificus, a hellgod who is searching for the magical key that will open the portal between our world and hers. Glory had ruled over a terrible hell dimension in a triumvirate with two other hellgods, but they exiled her because she was too barbaric and cruel even for them. She is sentenced to be concealed inside a magically created human male named Ben, who is an intern at the Sunnydale Hospital. Glory morphs into Ben and vice versa, at first with no memory of what the other has been doing (or knows). But the boundary between them is breaking down, and each is losing control of their identity—another case of alternate personae.

The key to Glory's home dimension is likewise concealed, inside a human female— Buffy's sister, Dawn. Dawn first appears in "Buffy vs. Dracula," the first episode of season five. Although the arrival of Dawn had been foreshadowed in dream sequences featuring Buffy, Faith,

LEFT: Willow and Tara kiss for the first time in the emotional whirl of "The Body," taking their relationship out of the realm of metaphor and into reality.

ABOVE: The exiled hellgod Glorificus shows up in Buffy's living room in "Checkpoint."

and Tara, Dawn's appearance is not initially explained, with everyone in the show behaving as if she has always been there. As David Fury explains, "Dawn was introduced as an idea way back in the third season . . . in "Graduation Day, Part 2," in a dream that [Buffy] and Faith [seemed to] share." In this dream, Faith referenced "Little Miss Muffet counting down from 7-3-0." Joss elaborated that 730 was exactly two years later, when Buffy would give up her life for Dawn. In that same dream, Tara told Buffy to "be back before Dawn," mentioning her by name.

Dawn was presented as "the baby," more immature than Buffy at the same age—Buffy was soon to become the Slayer—and many felt she was whiney, including Michelle Trachtenberg, the actress who played her. Despite Buffy's wistfulness that while her mother depends on her to be the self-reliant daughter and babies Dawn, Joss deliberately chose to add a character with whom Buffy could have a loving but non-romantic relationship. There is no one Buffy cares about as passionately as Dawn.

"It was tricky to introduce someone new to the *Buffy* universe," Marti Noxon said, "and some people were suspect of it as a sort of a gimmick, but it was . . . a way to explore more issues, and to keep the *Buffy* universe alive and growing."

RIGHT: Buffy falls under the charm and control of Dracula in the season 5 premiere, "Buffy vs. Dracula." The episode contains several elements that echo the plot of Bram Stoker's novel.

Then Buffy's mother becomes ill, and Buffy suspects that something supernatural is causing it. By performing a spell, she realizes that something's off about Dawn, and discovers that Dawn is the key. As she says to Giles in "The Gift" [5x22], the Monks of Dagon "made her out of me. She is me." Dawn has existed as a human for only six months. Buffy and Giles eventually share the information with the inner circle, but keep the secret from Dawn herself. With everyone acting so oddly around her, Dawn ferrets out the truth on her own: she is a created being, and all her memories are false. She is devastated; she feels as bewildered and powerless as a young teenager might feel upon learning that she was adopted. She cuts herself to see if she will actually bleed and burns all her diaries because she has no real past. Ironically, it is her blood that is required to open the portal.

Willow is also on a journey of transformation. Her early magic use is more exploratory than directed toward a specific goal. She often casts spells for trivial reasons such as starting a barbecue, and occasionally Giles or Tara will voice surprise or concern that she's advancing so fast. Her magic use is still responsible: when Buffy begs Willow to heal her mother with a spell, Willow correctly hesitates, leaving it to Giles to explain that natural illnesses (and deaths) cannot and should not be dealt with magically. They are part of the natural order of things.

But Willow continues to push the boundaries of "appropriate" magic, and her power

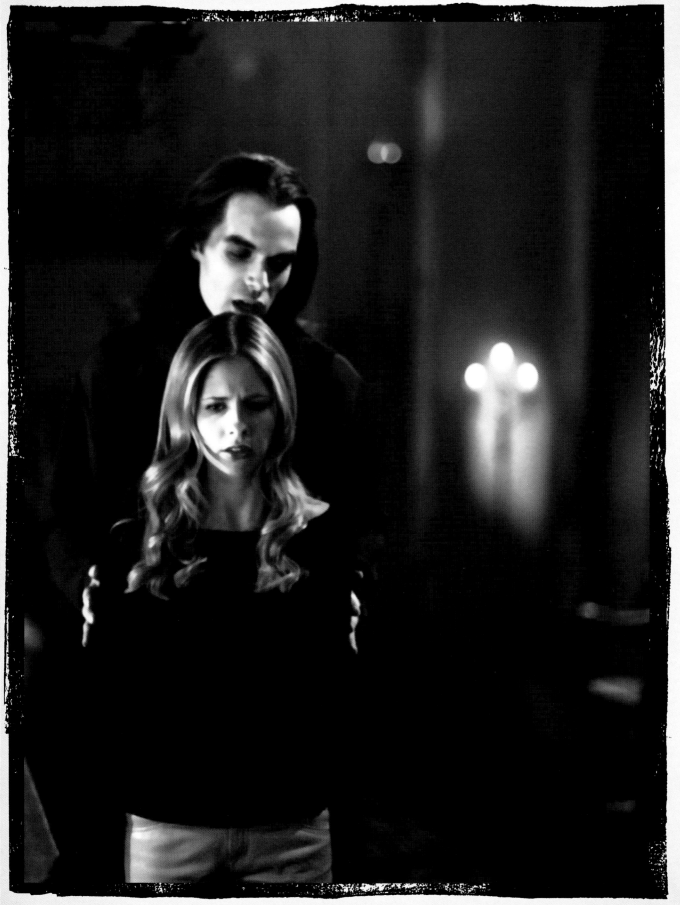

The Body

Critics and fans have hailed "The Body" as one of the most moving hours of television ever and an excellent dramatization of the harsh realities of bereavement. It also served as an example of the writers' fearlessness in killing off beloved characters whom fans were heavily invested in, to fulfill Joss's insistence that the audience be continually surprised. When actress Kristine Sutherland, who played Buffy's mother, told Joss she'd like to take some time off to live in Tuscany, he said, "You have to come back for season five, because I'm going to kill you."

The episode begins with one of Joss's favorite cinematic devices, a long take—a "oner," in which the camera continually runs without cuts. Sarah Michelle Gellar had to go through the entire take about seven times, running the gamut from discovery of the body to the realization that her mother is dead, and she "has to make a call." When she stares at the phone, it finally sinks in that her mother has died. "I wanted to show not the meaning or catharsis or the beauty of life," Joss said, "or any of the things that are often associated with loss, or even the

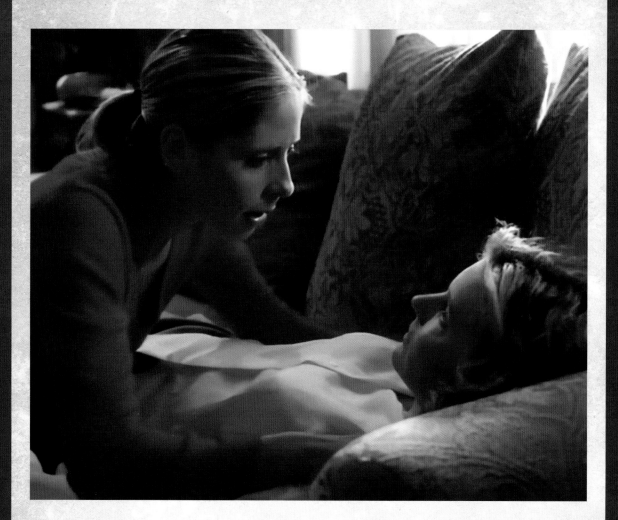

extreme grief, some of which we do get in the episode. What I wanted really to capture was the extreme physicality, the almost . . . boredom of the very first few hours. . . . I wanted to be very specific about what it felt like the moment you discover you've lost someone." As mentioned earlier, "The Body" is the only episode with no music at all, driving home Joss's point even harder.

The call Buffy finally makes is to Giles, and all she does is tell him to come. He is her father figure. But the death of Joyce signals the death of Buffy's childhood. She must become Dawn's parent now.

Buffy is faced with two things she can't beat in this season—the hellgod Glory, and natural death. Although she can still save the world through her own death, there is absolutely nothing she can do to save her mother. And rather than bringing Joyce's loved ones closer together, her death briefly pushes them apart: After the funeral, Dawn spends the night with Tara and Willow. Angel comes and offers to stay as long as Buffy needs him, but she needs him too much and he has to leave. She has no choice but to be alone with her grief.

LEFT: Buffy's mother Joyce (Kristine Sutherland) the way Buffy finds her, lying dead on the couch in the living room.

ABOVE: Buffy tries to revive her mother and slowly comes to the realization that she is gone.

begins to change her. Rather than letting her occasional mishaps teach her about the dangers of magic, Willow uses her experience as a prod to become even more powerful. After Joyce dies of an aneurysm, Dawn wants to employ a spell to raise her from the grave. Tara carefully re-explains that since Joyce died from natural causes, using magic to resurrect her would be wrong. But in "Forever" [5x17] Willow surreptitiously pushes one of the magic books she and Tara own out of their bookshelf so that Dawn will find it. This leads Dawn to cast a serious dark magic spell (aided by Spike) that does bring something back . . . something that viewers could see was clearly not Joyce . . . but just in time, Dawn breaks the spell.

As Glory puts pressure on Buffy and her friends to find her key, Willow works harder on her magic. Her obsession reaches a point where Tara is frightened by her growing power, and even feels their relationship is threatened—or worse, that Willow's lesbianism is just another experiment. She tells Willow, "You're changing so much, so fast." Willow interprets this as Tara's uncertainty that Willow is really gay, and not just experimenting with her sexuality as people often do in college. The ensuing quarrel is more about whether Willow's commitment to Tara is real, or just something she's trying out.

RIGHT: Dawn bleeds from a self-inflicted knife wound in "Blood Ties," tearfully questioning who she is—and whether she is really human.

SLAYER ETHICS: DEATH IS YOUR GIFT

With Glory breathing down Buffy's neck, Buffy goes on a vision quest in the desert to readdress the question of what it means to be a Slayer. She has intended to look for the answer ever since her shared power-dream experience with Giles, Willow, and Xander, but the threat posed by Glory has forced her to back-burner her exploration. Now, her need to understand her own power so she can defeat the Big Bad adds new urgency. The spirit of the First Slayer reappears to her and tells her firmly that "death is your gift." Buffy assumes she means that as the Slayer, she is a death-dealer. Other characters, including Dracula, have referred to her as "killer" ("Dracula" [5x01]).

But despite everything, Buffy will not countenance—nor allow—dealing death to human beings. This becomes highly problematic when the ancient order of the Knights of Byzantium begins a campaign against Buffy and her friends, regarding the Slayer as an accidental ally of Glory, whom they call "the Beast." They know that Buffy is protecting the key, and if Glory gets ahold of it, the universe will plunge into eternal darkness and torment. Although the Knights don't know the form the key has taken, they have sworn to destroy it.

Amassing clues that the key has been turned into a human under Buffy's protection, Glory methodically attacks one after another of Buffy's circle. When she suspects that it's Spike, she captures him and tortures him. He

steadfastly refuses to give Dawn up, signaling a sea change in how Buffy regards him. Another connection is made between them: they would both sacrifice their very lives to save Dawn. Doc, a demonic worshipper of Glory, is bemused by Spike's sacrificial devotion to the Slayer and her little sister ("I don't smell a soul"), underscoring the changes that are taking place inside Spike. While Angel's soul prompted him to act out of guilt, Spike acts out of love. This has partly been forced on him by his chip. In this way, his experience echoes Faith's.

Glory attacks Tara as the possible key, then sucks Tara's brain energy, leaving her in a vegetative state. In this moment of highest crisis, Willow's magic use abruptly shifts. She goes into revenge mode, racing to the magic shop and reading the *Book of Darkest Magic*. For the first time, Willow's eyes turn black and she invades Glory's home, attacking her and dealing her pain. The power of Willow's fury has translated into more power than even Buffy has, as Willow is the only person so far who has been able to hurt Glory.

Those "outside reality"—those whose identities have been altered by insanity and whose brains Glory has fed on—are able to see that Dawn is the key to the portal. Joyce first saw that Dawn wasn't her daughter when her brain tumor started affecting her. Reduced to a gibbering village idiot, Tara accidentally reveals that Dawn is the person Glory has been looking for. The Slayer and all her friends go on the run, pursued by the Knights of Byzantium (on horseback!). With Glory after Dawn as well, Buffy says, "We're not going to win this with stakes

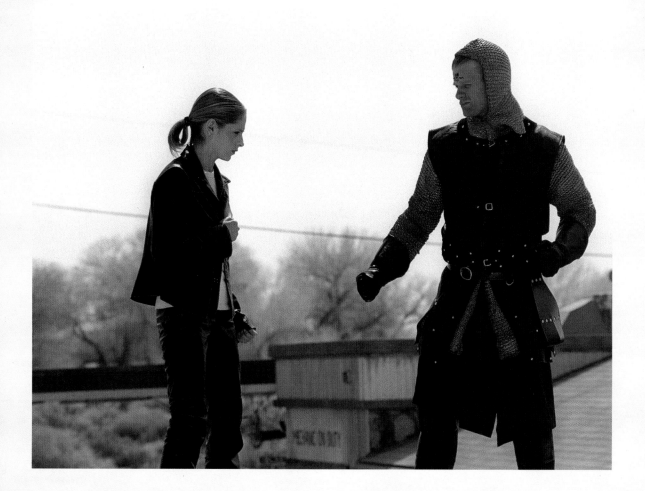

or spells." Feeling assailed on all fronts, Buffy questions herself—she's the Slayer, "all mythic and defendery." But she's in full-blown retreat, unable to win against a god.

BUFFY: I can't beat Glory.

WILLOW: You can't know that.

BUFFY: I didn't just know it. I felt it. Glory will beat me. And in that second of knowing it, Will, I wanted it to happen. . . . I wanted it over. This is all—all of it—it's too much for me.

—"The Weight of the World" [5x21]

Buffy loves Dawn so much that she takes this momentary loss of faith as proof that she has, in essence, murdered her sister. Her despair is palpable—yet she resumes her identity as the Chosen One to battle on. The death of Dawn is *not* her gift.

LEFT: Glory feeds on Tara's mind in "Tough Love." Because the attack has put Tara "outside reality," she's able to see that Dawn is the key that Glory has been searching for.

ABOVE: Buffy faces off against one of the Knights of Byzantium, who have sworn to destroy the key that Glory seeks, in "Spiral."

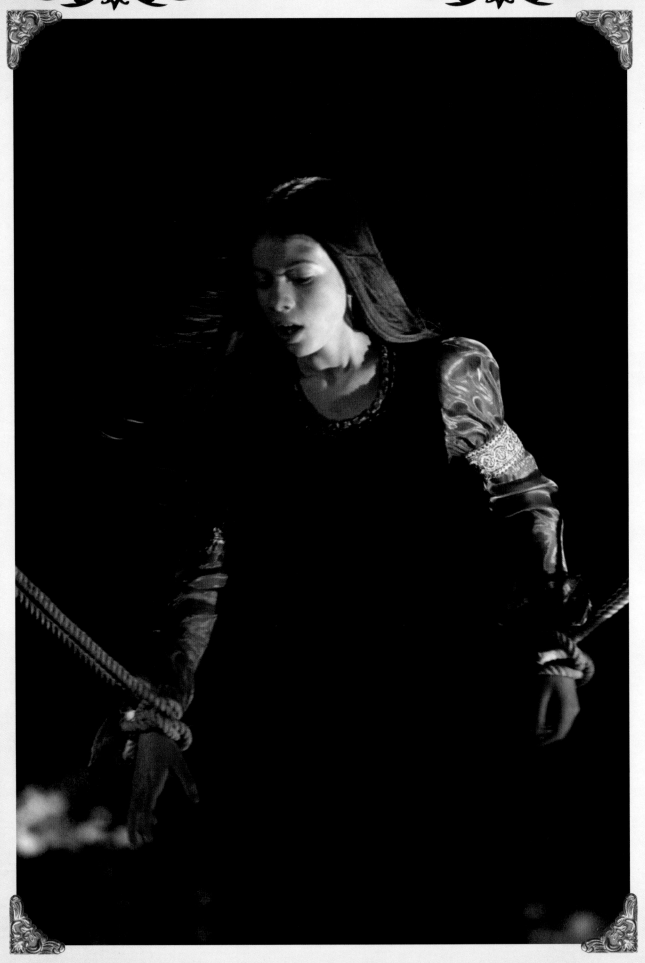

As season five draws to a close, Glory's plan is revealed: Glory intends to bleed Dawn to death in a magic ritual to open the portal she needs to go home. A side effect of this spell will be that all the portals of all the dimensions will open and every single living being will suffer terrible torment and die. The portals will close only after Dawn is dead. Giles urges the death of Dawn as a preemptive strike to preclude the ritual, pointing out that either way, Dawn will die. But "killer" Buffy can't bring herself to countenance Dawn's death, and threatens to hurt anyone who tries. While she was able to kill Angel to save the world, she can't kill her sister. In *What Would Buffy Do?: The Vampire Slayer as Spiritual Guide*, Jana Riess makes this observation about killing Angel: "Giving her own life is one thing, but asking her to obliterate her greatest love is almost more than Buffy can bear. This sacrifice tests the very limits of her sense of identity." But Dawn *is* Buffy. When the Monks transformed the key into a human, they made her "out of" Buffy. And so the limit is drawn. Buffy is willing to sacrifice all living things rather than allow Dawn— "blood of my blood, flesh of my flesh," in biblical terms—to be killed. "The last thing she'll see is me protecting her," she tells Giles, when he insists that by not killing her sister, Buffy will fail to prevent the apocalypse.

Buffy turns to Willow, telling her that she's the big gun, "the strongest person here," and asks her to find some kind of magic that will stop Glory. Willow's earlier attack against Glory

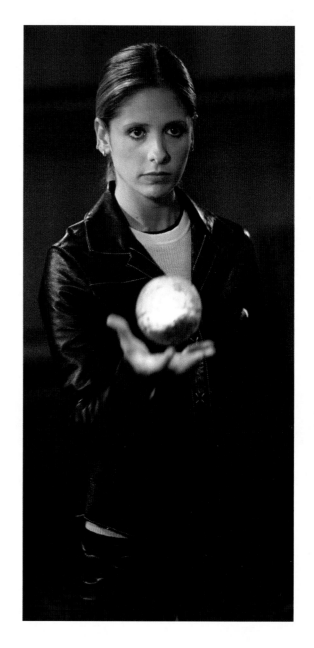

LEFT: Dawn stands atop the tower erected by Glory's minions just as Glory begins the ritual that is intended to end with Dawn bleeding to death.

ABOVE: Buffy about to attack Glory with the dragon sphere, a crystal ball created to repel "that which cannot be named."

was forged out of rage—in other words, she performed magic while emotionally off-balance, which Giles has told her repeatedly not to do. But it was extremely effective, even if temporary. Willow confesses that rather than concentrate on hurting the Big Bad, she's been trying to figure out how to heal her great love—a healing, positive use of magic. She ventures that restoring Tara might weaken Glory, but it's clear that weakening the hellgod was not her motivation for working on a cure. This is an important plot point, given that later, Willow will become addicted to magic, and in another time of crisis, other characters will attempt to pressure her into using it anyway.

As the ritual is about to begin, everyone arrives at Glory's ritual site. Willow successfully sucks energy out of Glory to give to Tara, which does weaken Glory. But ultimately, Dawn's blood is spilled. The portal to hell opens, and monsters (and a dragon) escape. Bolts of energy crash into Sunnydale. Unknown to Buffy, Giles kills Ben, thus killing Glory.

But Glory's death does not end the ritual. Buffy finally comprehends what the First Slayer has been telling her: *her* death is her gift. Since Buffy's blood is the same as Dawn's blood, if Buffy's blood is spilled, the portal will close. This underscores the important message that Buffy has learned: what she has to offer is not so much death as self-sacrifice. In essence, the Slayer is, in *Angel* parlance, a Higher Being, humbly accepting that "this is the work I have to do."

After telling Dawn to live a long and happy life in remembrance of her, Buffy leaps into the portal in a beautiful, perfect swan dive—a cruciform—and dies in a sea of magical energy. Her

LEFT: Willow launches a magic attack that transfers energy from Glory to Tara and restores Tara's sanity.

ABOVE: Buffy dives off the platform into the portal to her death. Her sacrifice causes the portal to close.

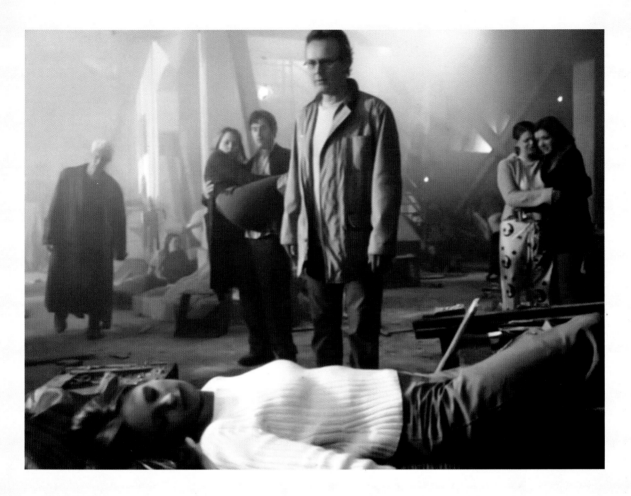

dead body lies in peaceful repose at the base of the tower as her loved ones—including Spike—grieve. The final shot of the episode shows Buffy's grave, driving home the fact that Buffy really has died.

On her grave are the words "She saved the world a lot"—emphasizing that the Slayer's job is to be a killer—in order to protect the ones she loves. Violence was not the answer, nor was magic: The power of love saved the world.

"I think I had originally thought about ending the series then," Joss said, "and I wanted to make that day (the last day in 'The Gift') truly different—and also sort of sum up the whole series. That's why 'The Gift' begins with a very generic vampire killing. . . . I wanted to say, 'This is what we started with.' Because in a way, we were finishing."

Until, of course, season six.

LEFT: A sketch of the tower on which the final scenes of season 5 play out, created by production designer Carey Meyer.

ABOVE: Buffy's friends find her lifeless body at the base of the tower after the sacrifice that saved the world.

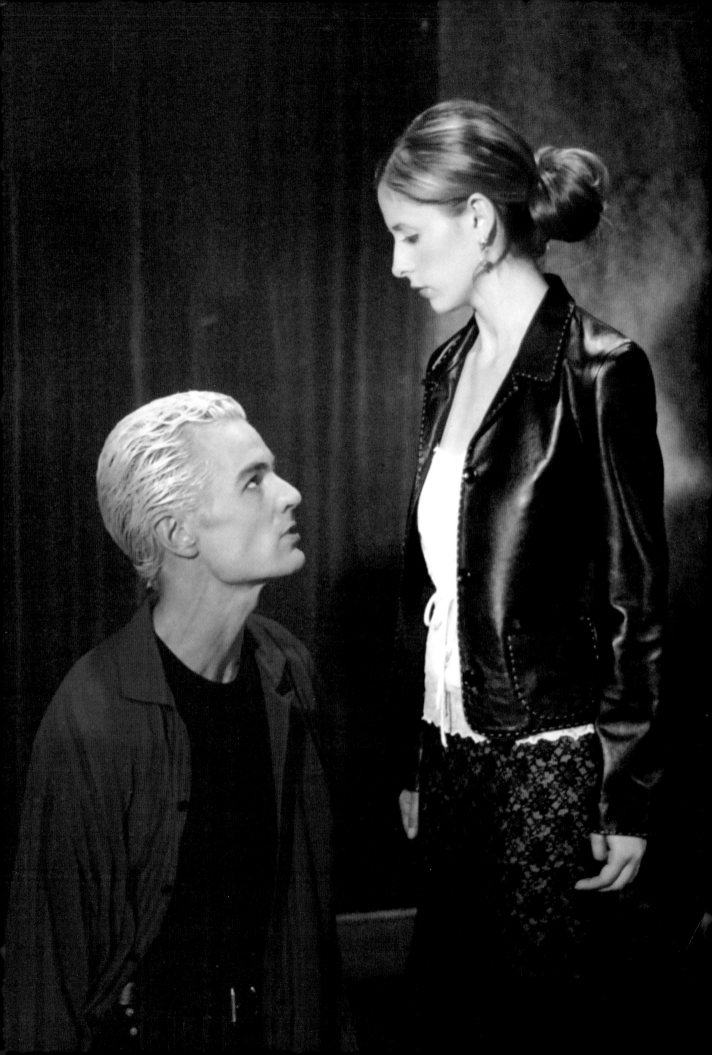

CHAPTER IV

Beyond

Despite *Buffy*'s success, the show was having trouble staying alive: Newspaper articles suggesting that the WB was about to cancel *Buffy* sent ripples of fear through *Buffy* viewers and Joss Whedon alike. Articles began appearing with headlines such as "'*Buffy*' Slaying Feared." Fox was asking for more money to produce the show, and the WB not only said no, but WB CEO Jamie Kellner publicly dissed the show, commenting that *Buffy*

Rowan University. "The WB was the network that came into its own as a real entity partially based on the cult following of *Buffy the Vampire Slayer*. The two were synonymous, and so when the business side of the WB ended up dissolving its relationship with Joss and the show because of sagging ratings and higher production costs, viewers didn't understand what that functionally meant for *Buffy*. . . . And despite Sarah saying she was part of season six ad nauseam, the perception

The mission statement of season six is "Oh, grow up."

—— Joss Whedon

had never garnered the following of a show like *ER*, and reminded readers that *Buffy* had been a show no other network had wanted. Marti Noxon recalled her shock that *Buffy* "could go off the air over money," as opposed to ratings. Other networks indicated interest, but Sarah Michelle Gellar announced at one point that if *Buffy* left the WB, she would quit. That was a distinct possibility, as the contracts of the Core Four were up.

"I think a lot of the panic about season five being the end of the *Buffy* series (as it was known and loved) going away when it moved to UPN was because such a high-profile show moving channels was such a foreign concept to mainstream viewers," recalls Tara Bennett, former writer for *The Official Buffy the Vampire Slayer Magazine* and adjunct professor of TV Writing at

of the *Buffy* season five finale being her swan song (due to the incredibly creative and emotional season finale) really stuck with viewers."

Fan anxiety was generated by promotional announcements on the WB that "The Gift," the last episode of season five, was *Buffy*'s *series* finale (instead of the *season* finale), and at the end of "The Gift," a placard thanked viewers for watching one hundred episodes.

But UPN did embrace *Buffy* in the end. The network put up "BUFFY LIVES" posters and billboards and added more than half a million dollars to the budget for each episode. Marti Noxon took over the showrunner duties, while beloved *Buffy* alumni Jane Espenson and David Fury served as co–executive producers. UPN was very excited about having landed *Buffy*, and

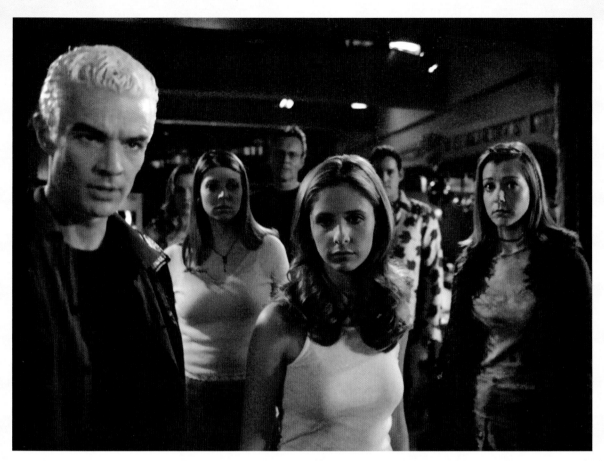

asked for a two-episode premiere "Buffy Event." This premiere set the stage for the darkest of the seven seasons of *Buffy*.

Joss was extremely busy, even without his showrunner duties on *Buffy*. *Angel* had just begun its third season, with Angel grieving over Buffy's death. Joss and *Angel* cocreator David Greenwalt were executive producers on that show. Joss's *Fray* comic book was about halfway through its eight-issue run, and his third TV series, *Firefly*, would debut the following year. When asked if Joss was stretched too thin, Marti Noxon said, "He has this scary alien ability to do more." But in interviews, one of his favorite words was *exhausted*.

Joss has stated many times that he is interested in created families—families you choose for yourself—and his family of cast and crew have appeared and reappeared in many of his projects. When interviewed for *The Watcher's Guide, Volume 1*, writers and actors related stories of somehow "having" to be on the show, turning down more likely prospects (to the chagrin of agents and managers). When describing

PREVIOUS: Spike sings "Rest in Peace" to Buffy, saying that she must leave him alone if she won't love him.

ABOVE: Led by Giles, the gang theorizes about the cause of the singing—in song—in "Once More with Feeling."

I Wrote My Thesis on You: Buffy in Academia

When asked why Joss Whedon's work is studied so fervently by academics, Jane Espenson, who has herself edited respected collections of essays on *Firefly/Serenity* and *Dollhouse*, has this to say: "I think Joss and his works are so widely studied because you get the sense that he has unifying elements underlying everything that he does. The story and the characters never have that 'made up to fit the moment' feeling because he is always conscious of the big picture. This makes his series feel like novels, and thus worthy of being taken seriously as unified works."

This certainly resonates within the academic community, as Joss has been compared to Charles Dickens, who also serialized his work—and who is Joss's favorite author. Like Dickens, there seems to be something about Joss himself that transcends study of a specific show or work. Independent scholar Roz Kaveney, who edited *Reading the "Vampire Slayer,"* puts this down to "depth of text," and adds, "Some areas of fiction are very good at generating mythopoeia; this is one of the things that popular TV at its best does." This dovetails with Joss's own intention for *Buffy*.

Considered "the Mother and Father of *Buffy* Studies," academics Rhonda V. Wilcox and David Lavery put out a call for papers to create the first American academic text on *Buffy*. The result, *Fighting the Forces: What's at Stake in "Buffy the Vampire Slayer,"* was published in 2002. Overwhelmed with submissions, they founded *Slayage: The Online Journal of Buffy Studies.* "Furthermore, while the two of us came to the series from a literary/televisual perspective, we found more and more academics looking at it from a variety of other disciplines: musicology, linguistics, sociology, take your pick," Wilcox says. "For those of us who have been lucky enough to pay attention, there is always more to pay attention to."

A Cultural Institution

Slayage has evolved into the Whedon Studies Association, and its website, Slayage.org, is the go-to repository for all things Whedon in the academic world: a peer-reviewed journal; vast archives of papers; databases of *Buffy* scholars and critics; books and articles; a bibliography; an encyclopedia; and a list of conferences past and present where ardent Whedonians gather together to study the Matter of Whedon. At the first Slayage conference, 180 papers were presented over Memorial Day weekend; at night, there were presentations about fan art and

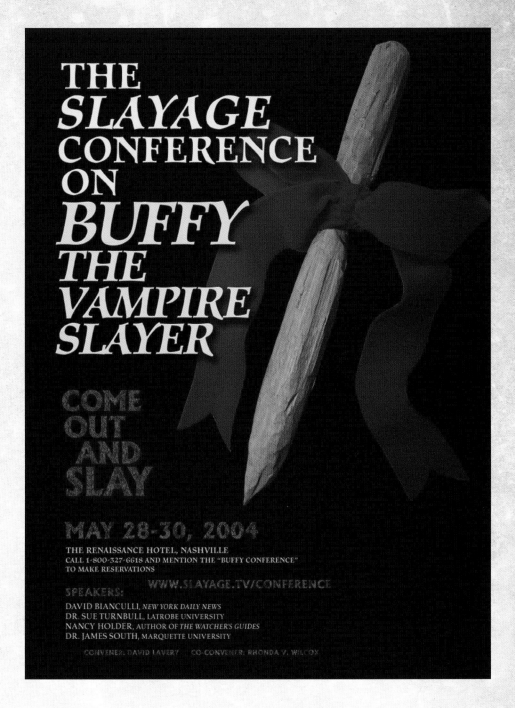

THE SLAYAGE CONFERENCE ON BUFFY THE VAMPIRE SLAYER

COME OUT AND SLAY

MAY 28-30, 2004

THE RENAISSANCE HOTEL, NASHVILLE
CALL 1-800-327-6618 AND MENTION THE "BUFFY CONFERENCE"
TO MAKE RESERVATIONS

WWW.SLAYAGE.TV/CONFERENCE

SPEAKERS:
DAVID BIANCULLI, *NEW YORK DAILY NEWS*
DR. SUE TURNBULL, LATROBE UNIVERSITY
NANCY HOLDER, AUTHOR OF *THE WATCHER'S GUIDES*
DR. JAMES SOUTH, MARQUETTE UNIVERSITY

CONVENER: DAVID LAVERY CO-CONVENER: RHONDA V. WILCOX

vidding (cutting images from the shows together in a thematic way and setting them to music). The big night boasted a banquet with the presentation of the Mr. Pointy Awards (Long, for books; Short, for essays) and a sing-along of *Once More with Feeling*.

Carrying the Torch

New academic texts and popular culture studies continue to be published. (Jana Riess, author of *What Would Buffy Do?: The Slayer as Spiritual Guide*, recently put out a call for papers for a new book she is editing about *Buffy* and religion.) When asked why scholarly interest never seems to abate, Wilcox replied, "The books keep coming because the work of Whedon and company is inexhaustibly good. New viewers continue to find their way to it, and scholars continue to find it worth writing about."

ABOVE: A flier from the Whedon Studies Association conference.

their feeling of community and delight in their work, they would get tears in their eyes. "It's a big challenge every week," said producer-director David Solomon. "That's the fun of it. Every week, we somehow meet that challenge. No one ever says, 'This can't be done, we can't afford it, we don't know how to do it'; we always find a way." So with such a strong base, there was a sense of

ABOVE: The resurrected Buffy breaks out of her coffin and claws her way out of her grave, terrified, at the beginning of season 6.

RIGHT: In the season premiere of season 6, Willow has programmed the Buffybot to continue staking vampires in order to keep the demon world unaware of Buffy's death. When it malfunctions in front of a vampire, the secret quickly gets out.

security when Joss moved on from *Buffy* to work on *Angel*. Marti Noxon said: "Joss would never move to something else unless he felt it was time."

THE DARK AGES

As season six opens, Willow resorts to dark magic to resurrect Buffy from the dead. Because Buffy died to close the portal between Glory's hell dimension and our world, Willow is convinced that Buffy must be suffering horrible torment, as Angel did when he tried to send the world to hell. Willow decrees that she will stop at nothing to free the Slayer, and she cuts out the beating heart of a fawn as part of a resurrection spell. Harley-riding demons interrupt the ritual, and Willow, Xander, Tara, and Anya scatter. They're unaware

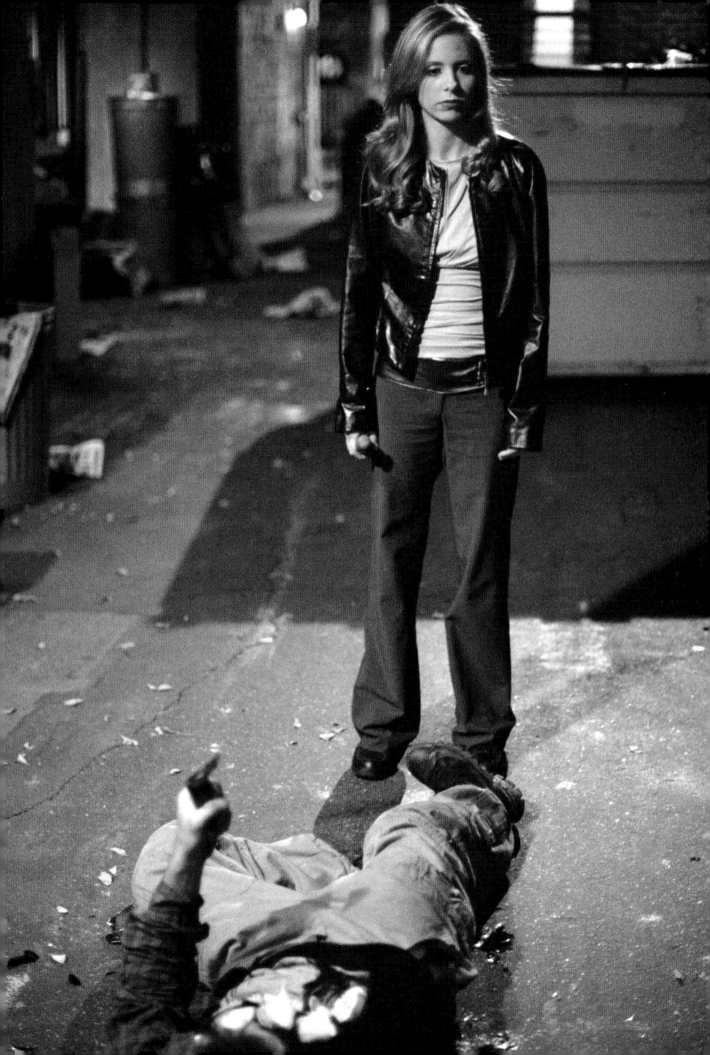

Though she tries to hide her despair, Buffy is far from happy at being back. She confides to Spike that her friends ripped her out of paradise. "Everything here is hard and bright and violent," she says. "Everything I feel, everything I touch. This is hell. Just getting through the next moment, and the one after that. Knowing what I've lost" ("Bargaining" [6x01/02]).

This darkness attracts Spike, who has always had a thing for the Slayer. Buffy responds, and they form a bond that changes over time into an extremely sexual, sadomasochistic relationship. Their first encounter, in "Smashed" [6x09], is so violent that it literally brings down the house. "We had played metaphor for five years," Joss recalled. "Eventually you have to put your cards on the table a little bit. It's like when Buffy and Spike first had sex, my first comment was, 'Au revoir, Monsieur Metaphor!' It was *so* graphic. But at the same time, they were *in* a metaphor—they were in a falling-down house. Which was very, very clearly what was happening in her life then. She was losing herself."

Being with Spike seems to be the only way Buffy can feel anything—she's depressed and numb. Her mother's medical problems have eaten up Joyce's life insurance payout, and the house needs work. She can't get a bank loan. Social workers are threatening to take Dawn away if Buffy can't provide a stable home environment, so she pounds the pavement looking for a job. She gets financial help from Giles when he returns from England, but she tries to

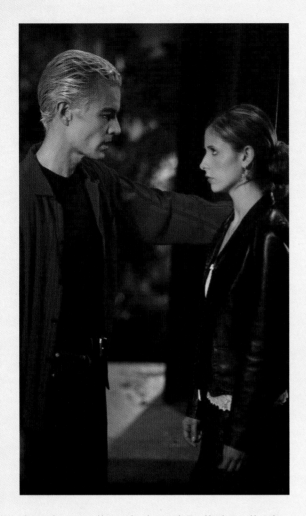

that their spell worked until Buffy literally digs her way out of her grave. Traumatized, she can't make sense of her surroundings until she sees the platform where she leaped to her death. Awareness returns, and her friends are ecstatic.

ABOVE: Spike is attracted to the new darkness in Buffy after her resurrection tears her away from paradise.

RIGHT: Giles helps Buffy out financially, but refuses to take on more of her burdens. He returns to England to force her to become independent and take responsibility for Dawn. Here, she begs him not to leave in "Tabula Rasa."

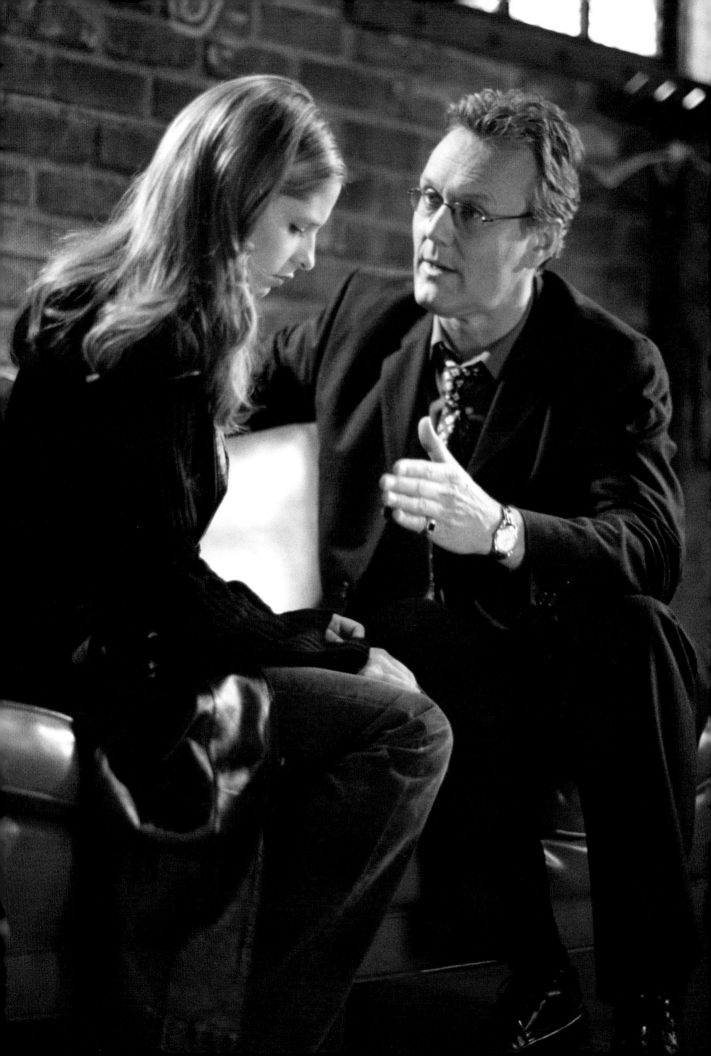

pass off even more of her burdens on him. He is dismayed when she attempts to get him to take over the parenting of Dawn. When Dawn and her best friend sneak out on Halloween with two "boys" (who turn out to be vampires), Buffy leaves the stern parental lecture to Giles. Giles decides that he should return to England

ABOVE: Warren, Jonathan, and Adam, the "Evil Trio," spy on Buffy from their van in "Life Serial."

RIGHT: The Evil Trio make Buffy hallucinate that she's in a mental hospital, where a doctor tells her she's imagined everything that's happened in the past six years.

because Buffy is too dependent on him. One of them has to leave the nest, and since Buffy's not going anywhere, it falls to him. He goes back to England to make Buffy grow up. This all fits with the evolving theme of the season: growing up and learning to rely on yourself. "Part of the process of doing a show for six years and growing up means you say good-bye to some of these more essential metaphors," Joss explained later. "Life isn't this great battle, it's this tiny little mundane thing." This will be Buffy's lesson for the season.

Throughout Buffy's struggles, she's unaware that three "supernerds" are sabotaging her. The "Evil Trio" of Warren, Jonathan, and Andrew

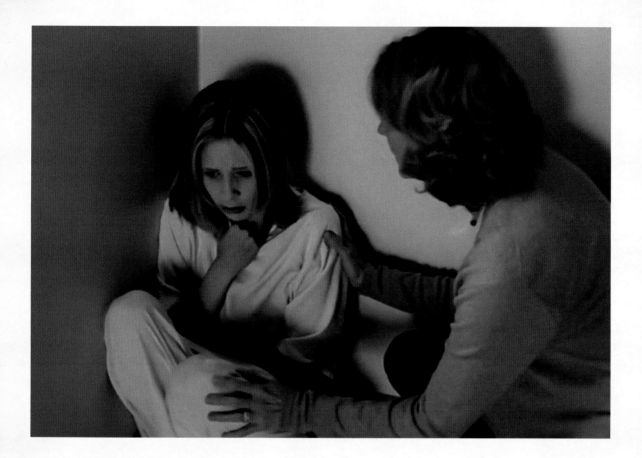

have decided to team up and take over Sunnydale, and they are running a series of tests on the Slayer, their arch-nemesis, to see how they can either get rid of her or turn her into their love slave. Very arrested in their development, the trio have taken over Warren's parents' garage and set up their "lair," complete with spy cams, collectible action figures, and comic books. Initially the Trio were funny and geeky—and the characters most like the show's writers. "The fact is, most of the conversations they had on the show we were having in the room," Joss reported. "They have a special place for us writers." Despite their bickering over the merits of various *Star Wars* Death Star designs

and the creation of cartoony "freeze-ray" guns and invisibility zappers, they become increasingly dangerous. Warren, the ringleader, moves from building a sex robot to murdering his ex-girlfriend after attempting to rape her. Jonathan becomes a magical adept and summons demons with his "magic bone" to convince Buffy that she killed the girlfriend.

Later, the Trio summons a demon that doses Buffy with a poison that makes her hallucinate. She becomes convinced she's in an insane asylum and has invented the entire Slayer story, because, really, what sane person could believe it? Of this episode, Joss has said, "If they [the

audience] decide that the entire thing is all playing out in some crazy person's head, well the joke of the thing to us was, it is, and that crazy person is me. It was kind of the ultimate postmodern look at the concept of a writer writing a show."

MAGICAL ADDICTION

The abuse of magic in season six is not metaphorical. When Giles finds out that Willow performed a resurrection spell to bring Buffy back, he lays into Willow for employing dark and dangerous magic, calling her a "rank, arrogant amateur." Willow is not cowed; she's filled with pride at her accomplishment and reminds Giles that

it's not in his best interest to "piss me off." Tara also tells Willow she's using too much magic, and they quarrel. Willow promises to lay off, but instead, she places a sprig of Lethe's bramble, an herb used in forgetting spells, beneath Tara's pillow so that she'll forget their argument.

Then Xander summons a demon that forces people to sing (and dance) the truth about what they're feeling. In "Once More, with Feeling," Buffy tells everyone the truth about her afterlife—that they pulled her out of heaven, and she can barely cope with daily life ("Give me something to sing about"). Overcome with remorse, Willow tries to make it better by erasing her

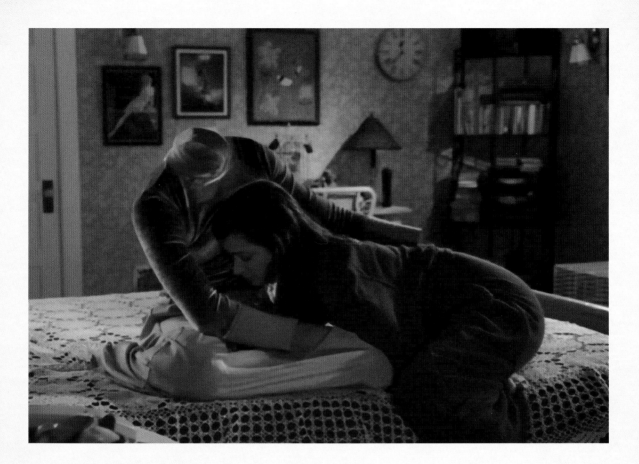

memories of paradise—and succeeds in wiping out the memories of everyone involved. They nearly lose their lives, and once the spell is broken, Tara leaves Willow.

Even after losing Tara, Willow continues to use magic, and finally "de-rats" Amy, the witch who was almost burned at the stake in "Gingerbread." She and Willow go out partying . . . magic style. Amy takes Willow to a warlock named Rack who runs a magic crack house. He doses both of them with magical energy. Willow and Amy get high, and cast spell after spell at the Bronze. Willow finally drags in well after daybreak. So does Buffy, who has just spent her first

night with Spike. Each of them had shirked her responsibility to Dawn, assuming the other was home with her. It fell to Tara to wait up all night with her. Tara gives Buffy a bye, assuming she's been out on patrol, but Willow has no excuse.

Rather than take any of this as a warning, Willow feeds her addiction, until one night she

LEFT: Willow hangs out on the ceiling of Rack's magic crack house, seeing spots and images caused by addictive spells.

ABOVE: After her night of magic abuse, Willow performs a spell on Tara's clothes to invoke the feeling of being in her arms.

"Once More, with Feeling"

Joss had always loved musicals, and dreamed of writing one of his own. He invited some *Buffy* actors to his home to do a play reading. Everyone was nervous, so they got a little tipsy to calm their nerves, "just comfortable enough to sit around a piano singing." What started it all was that they wanted to hear Anthony Stewart Head sing. Marsters started bringing along his guitar (Marsters fronts his own band, Ghost of the Robot). Joss realized that he had some great voices to work with, and felt that *Buffy*, as genre-busting as it was, might be his one opportunity. "This show is musical, so over-the-top, so overwrought it feels like they're about to burst into song anyway," he said. "It seemed so logical."

Ready to create

Despite not being able to so much as strum a chord on a guitar when *Buffy* began, he learned to play so he would have an instrument to use while composing. During season five, he had told producer Gareth Davies that he wanted to do a musical episode. Davies humored him, saying "whatever you want," but assuming Joss would never actually get around to writing it. "Then we came back off hiatus," Davies recalled. "He had written the script; he had written the music; he had orchestrated the music; he'd played the music; and he and Kai (his wife) had sung everything. So there was the complete package sitting on my desk, which was mind-boggling."

Convincing the cast

Although Joss worried that people would be bored and stop watching—that "Once More with Feeling" would be a flop—he persisted. James Marsters said that some of the actors were terrified, insisting, "This isn't what we signed on for." But Joss himself quotes Marsters as saying, "Well, let's face it. If we're not getting the shit scared out of us, we're not working hard enough." It took Joss a total of four months to write all the music; then the actors had three months of voice training. Alyson Hannigan and Michelle Trachtenberg didn't want to do much singing. Michelle got a ballet instead, and later, at a *Buffy* tribute panel at the Academy of Television Arts and Sciences, Alyson sounded a bit wistful that she'd been so adamant about not singing. She said, "Once I found out the magic of technology . . . *wow*, give me a solo, Joss!"

Send in the pros

Adam Shankman (*Rock of Ages, So You Think You Can Dance*) and his assistant, Anne Fletcher, choreographed the dancing. Broadway star Hinton Battle played the demon whose magic pushes Buffy and the gang to reveal their true feelings in song. David Fury and Marti Noxon both made cameo appearances, with Fury in the big "Mustard Song" extravaganza, and Marti Noxon as the woman who begs the police officer not to give her a parking ticket.

Most critics loved it: Jonathan Bernstein of the *Observer* wrote, "What could have been, at best, an eccentric diversion and, at worst, a shuddering embarrassment, succeeded on every level." Fans list "OMWF" in their top ten lists, and Joss puts it at number two on his own. (His number one is "Innocence.") "I'm happier with this than just about anything else I've ever made," he has said. "It's incredibly silly, but I meant every word."

LEFT: Writer David Fury makes a cameo appearance in "The Mustard Song"; Tara sings "Under Your Spell" to Willow.

ABOVE: Anya and Xander do a song and dance number about their relationship, "I'll Never Tell."

takes Dawn to Rack's crib, conjures a demon while she's high, and then nearly kills Dawn in a car crash while attempting to escape. Buffy and Spike rescue them, and Willow finally admits her powerlessness over her addiction. She completely gives up magic.

The ethics of this choice can be questioned. During Buffy's birthday party (she's twenty-one, a very advanced age for a Slayer!), Dawn's wish for company results in everyone's inability to leave the Summers residence. A demon emerges from a sword and seriously wounds one of the party guests. Tara fully backs up Willow's refusal to use magic even though there's a real possibility that the guest might be dying. All is made well, but not by Willow, and Tara praises her for staying out of it. This paves the way for their reconciliation.

SEXUAL ADDICTION

As the season progresses, Buffy is dismayed by her seeming inability to stop having violent, degrading sex with Spike. She doesn't know why he can hurt her, since he still has the chip that prevents him from harming humans. He claims that she "came back wrong" from the grave and insists she's got "a little demon in her." Tara does a magical full-body scan on Buffy and assures her that while she's different, the changes are about as serious as a sunburn. The only conclusion to be drawn is that Spike can hurt her because she has invited him to.

Buffy's moment of clarity about her relationship with Spike comes when Riley

returns—with a wife in tow. Buffy has the grace not to tell Riley that she ran after him the night he left Sunnydale to beg him to stay with her. She's embarrassed when he sees her in her fast-food uniform and cow hat—she works at the Doublemeat Palace—but humiliated when he finds her naked in Spike's arms. Her shame is complete when Riley reveals that Spike is planning to sell dozens of demon eggs on the black market; Spike is still evil. Seeing what she doesn't have—a warm, loving relationship based on mutual respect with a good, decent man, Buffy breaks up with Spike.

Soulless, Spike can't discern the difference between loving and wanting. He attempts to rekindle her addiction to him by trying to rape her. Joss explained in the *New York Times* that "although [Spike] did love Buffy and was moved by her emotionally, ultimately his desire to possess her led him to try and rape her because he couldn't make the connection—the difference between their dominance games and actual rape." Horribly upset by what he's done, and surprised that he didn't go through with it (because he's evil), he leaves town when she tells him to get out. He goes to Africa so he can become "what she deserves."

Some viewers felt that the rape attempt was out of character for Spike, and that Buffy's conventional female reaction to it—crying and struggling—was inconsistent with her superhero gifts. "People went crazy when we put them together and even crazier when we pulled them apart,"

David Solomon said. The fans had developed their own ideas of what Buffy and Spike's relationship should be. Fan art shown at the first Slayage, the biannual academic conference on Whedon Studies, showed Buffy and Spike in mythic poses, such as a Pre-Raphaelite Buffy in a flowing gown and crimped hair with Spike in armor, bent on one knee before her—romanticizing their relationship to be more like Buffy and Angel's. This art was made after the episode with the rape attempt aired, showing that some fans did not feel it was a barrier to their preferred "reading" of the Spike/Buffy relationship.

The third couple to succumb to the pressures of life is Anya and Xander. Though each has had reservations about getting married, Anya, who wreaked vengeance on behalf of scorned women for more than a thousand years, manages to overcome hers. But Xander, who has grown up in an abusive, alcoholic home, leaves Anya at the altar. He begs her to go steady with him until "they" are ready for marriage, but she tells him he's a "scared little boy" and decides to resume her career as a vengeance demon instead. "Monsters is one thing. Marriage is another," Joss quipped in the DVD commentary.

LEFT: Still photography film from the Twentieth Century Fox archives showing Spike's dream sequence from "Out of My Mind" that reveals his desire for Buffy.

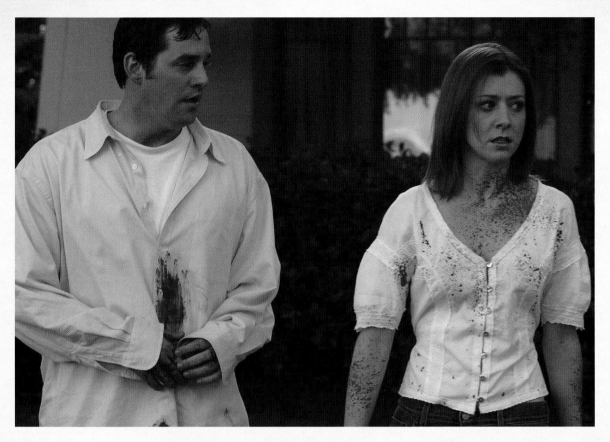

DARK WILLOW RISING

As Buffy and Spike and Anya and Xander fall apart, Willow and Tara reunite. They celebrate their love, reveling in bed for hours and then kissing and cuddling in front of a delighted Dawn once they finally get up. Veteran viewers should have braced themselves for bad news—especially since, for the first time since she joined the show, Amber Benson (Tara) was listed as a cast regular in the opening credits. Joss finally got his chance to put a doomed character in his opening credits to play on the audience's expectations—as he had wanted to do with Jesse, back in the very first episode.

Having finally tracked down the Evil Trio, Buffy puts two of them in jail. But their ringleader, Warren, escapes. Enraged, Warren comes after Buffy in her backyard with a gun. It was vital to the writers that Warren use a gun—a mundane object so clearly of this world, and not a magic potion or otherworldly object imbued with any kind of mystical properties. "Don't underestimate science, my friends," Warren later tells a vampire and a demon in a bar. He shoots wildly, hitting Buffy—and Tara, too. She dies in

LEFT: Anya waits nervously for Xander before their wedding in "Hell's Bells," unaware that he has changed his mind.

ABOVE: Xander explains to Willow that Warren was the one who killed Tara and injured Buffy, as rage begins to well up inside Willow.

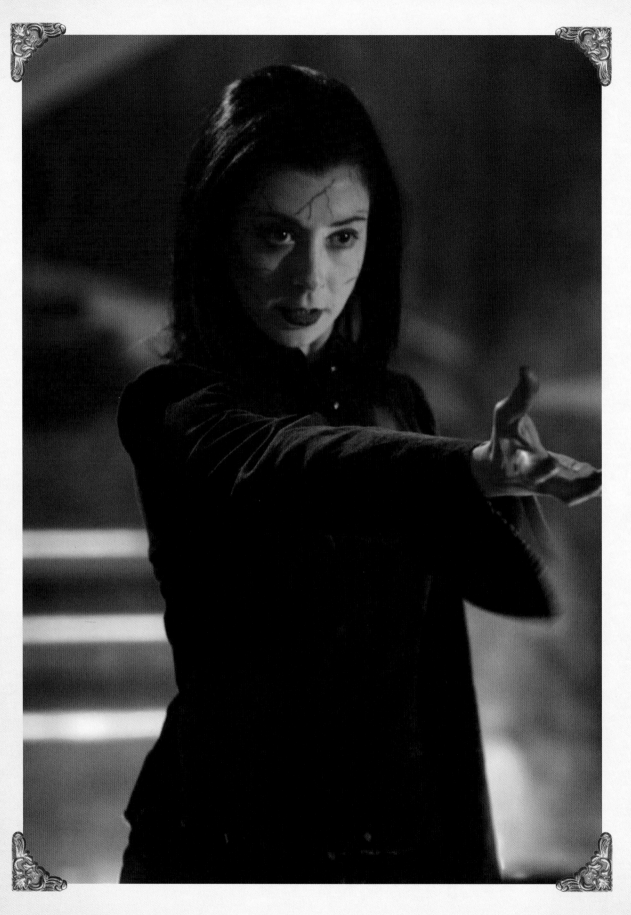

Willow's arms. Willow petitions Osiris, the same god she called upon to raise Buffy, to bring her back to life. But Osiris refuses to intervene in this situation, because Tara died a "human death by human means."

Willow goes completely berserk. She races into the Magic Box and sucks evil magic from the darkest spell books, turning her hair and eyes deep black. Dark blue veins pop out all over her face.

The reaction to Dark Willow wasn't all negative: the out-of-control witch has become a popular niche character in her own right. You can buy Dark Willow collectible statuettes, or join her online fan club. She also comes back in the season eight comic book. Author Yvonne Navarro, who wrote the Wicked Willow trilogy of novels, says: "The dark and dirty truth is that I would have taken Willow to the nth degree of

And there's no one in the world with the power to stop me now.

— Dark Willow, "Two to Go"

Dressed all in black, she chases Warren down. When she finds him, she tortures him by pushing a bullet into his body so he can feel exactly what Tara felt in her last moments, and then she flays him alive.

Fan reaction was vociferous. Some viewers interpreted the death of Tara and Willow's vengeful rage as proof that *Buffy* was homophobic at its core. Others were so upset by the loss of the only long-term gay relationship on TV that they stopped watching. But the death of Tara stayed consistent with the *Buffy* convention of denying any of the core characters a happy relationship: Angel killed Jenny Calendar hours after she and Giles reconciled; the character of Riley was ultimately written out because he was "the right guy" for Buffy.

evilness, but alas, such darkness wasn't allowed and I had to swing my alternate universe back to jive with the current Willow's. But even now, I wonder what might have been."

At the peak of Willow's rage over Tara's death, Giles arrives just in the nick of time (Joss had kept him out of the credits so that his arrival would be a surprise). He's been filled with "real" magic, good magic, by a coven in England. Willow takes it from him and is thoroughly dosed. Overwhelmed by pain, she determines to destroy the world to put it out of its misery— and she would have, too, except that Xander

LEFT: Dark Willow battles Buffy and Giles in "Grave" as her power and anger reach their peak.

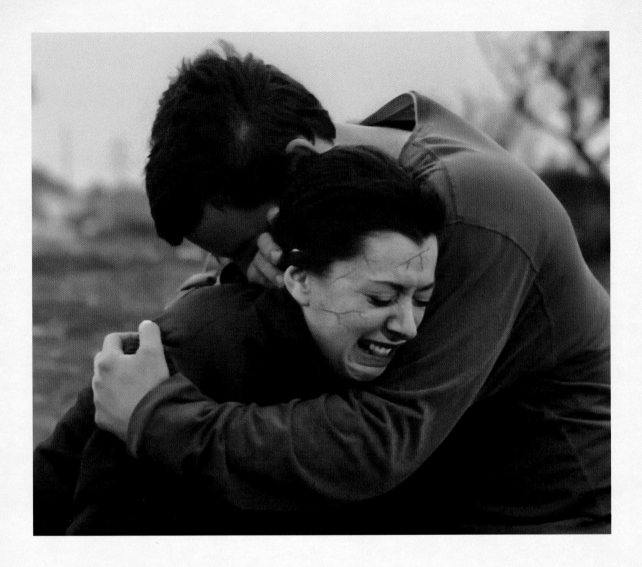

intervenes. He is at her mercy as she slashes his body with invisible knives as a prelude to killing him—but he answers her spell with a chant of his own, telling Willow again and again that he loves her. He will not leave her when she's in so much pain. He delivers the heartfelt lines that fans call the "Yellow Crayon Speech" to try to reach her:

XANDER: First day of kindergarten. You cried because you broke the yellow crayon, and you were too afraid to tell anyone. You've come pretty far: ending the world, not a terrific notion. But the thing is? Yeah. I love you. I loved crayon-breaky Willow and I love . . . scary veiny Willow. So if I'm going out, it's here. If you wanna kill the world? Well, then start with me. I've earned that.

WILLOW: You think I won't?

XANDER: It doesn't matter. I'll still love you.

His love prevails against rage and hate, and Willow breaks down in his arms. Her hair turns red again, and her eyes and face return to normal. Later, she and Giles leave for England, where a coven of witches can help Willow control her magical power. The power is part of her now, and she no longer has the option simply to not use it. She must take responsibility for it.

Willow's misguided tampering with Buffy leads to a revelation for the Slayer. Dark Willow has dropped Buffy and Dawn into a grave with two swords, and she conjures demon after demon to keep Buffy distracted. Among coffins and bones, the two sisters do battle. When Xander gets through to Willow and she stops, the monsters die. Both Buffy and Willow break down, and Buffy realizes that she wants to live not so that she can protect Dawn from the world, but to show it to her. Now, when Buffy crawls out of the grave, she brings Dawn with her.

Her sister's life has yet to unfold, and she can play a part in it. "In the sixth season, [Buffy] has to make a . . . decision, choosing to remain with Dawn in the pain-filled world rather than trying to regain the paradise she lost before being wrenched back to earth," Jana Riess writes in *What Would Buffy Do?: The Vampire Slayer as Spiritual Guide*. "Although it's certainly crucial that Buffy dies twice and risks her life countless times to save others, this sacrifice—to choose to embrace the pain of life in order to help her sister every day—may be the one we can most relate to."

COMING TOGETHER TO FIGHT

Joss decreed that season seven could be retitled "Buffy, Year One." He deliberately returned to the original mission statement, saying, "Remember why we came." He built Buffy's last season around the tropes and conventions that had made *Buffy* a cult favorite. Sunnydale High school is rebuilt and reopened; Dawn enrolls as a student there, and Buffy gets a job as a sort of older sister/near-peer counselor. Xander works on the school's construction, and he and Buffy drive Dawn to school together, like the couple some fans of the early seasons wished they had become. Willow returns from England so anxious that she accidentally makes herself invisible to the group at first, but the original crew is back together in Sunnydale.

In dialogue, the writers reminded the viewers of Buffy's earliest *Buffy* adventures when she gives Dawn advice on the first day of school: "And stay away from hyena people, or any lizard-type athletes, you know, or if you see anyone that's invisible." More nods to *Buffy*'s early days include Dawn wearing Buffy's cheerleading uniform when she tries out for the squad. And the crypt where Buffy and a classmate-turned-vampire battle it out looks very similar to the one where Buffy first encountered Darla and Luke, minions of the Master.

LEFT: Xander embraces Willow after he talks her down from giving in to evil in the "Yellow Crayon Speech." The dark veins begin to fade from her face and her eyes return to their normal color.

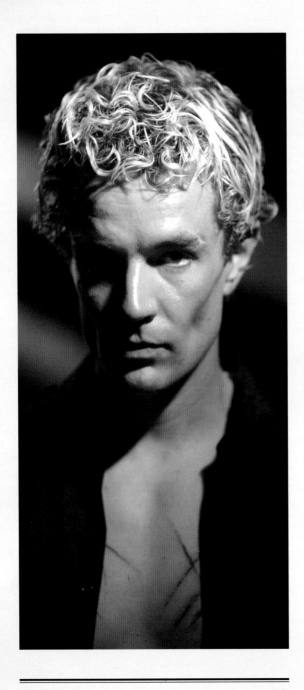

The character of Spike becomes more Angel-like—more romantic—when he returns to Sunnydale with a soul. He speaks from his heart of his devotion to Buffy as he embraces a large cross, shirtless, and says, "She shall look on him with forgiveness, and everybody will forgive and love. He will be loved." It appears to Buffy that his soul has driven him crazy (he wonders aloud why Angel never told him that it burns all the time), and she weeps for him. Then he is given his turn to become "Angelus-ized" when, despite the presence of both his human-protecting chip and his new soul, he begins attacking humans and siring vampires. It turns out that he is under the sway of the Big Bad, not only of season seven, but of all the seasons—the First Evil.

In "Amends" [3x10], the First Evil—that which existed in time and space even before form—appeared to Angel in the guises of people he had killed, trying to drive him to suicide. Now, as the last season of *Buffy* gets under way, the First appears to Spike in all the forms of the seasonal Big Bads, from Glory to the Master, and states the theme of all that is to come: "The next few months are going to be quite a ride. And I think we're all going to learn something about ourselves in the process. You'll learn you're a pathetic schmuck, if it hasn't sunk in already. Look at you. Trying to do what's right, just like her. You still don't get it. It's not about right, not about wrong . . . it's about power."

Buffy learns that she is still powerless over natural death when Cassie, a prescient

ABOVE: In the premiere episode of season 7, Buffy finds a deranged, vulnerable Spike who has earned a soul.

RIGHT: Andrew, Anya, and Buffy recoil at the reappearance of Warren, conjured by Amy Madigan, the vengeful witch who enabled Willow's magic addiction.

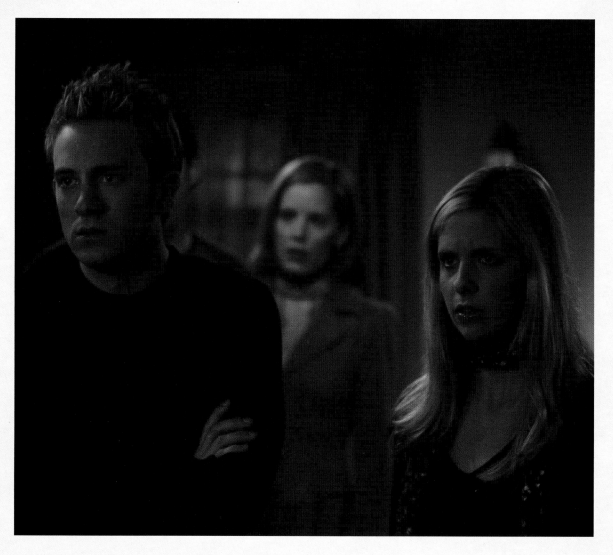

Sunnydale student, predicts her own death. Though Buffy rescues her from a ritual reminiscent of the one in "Reptile Boy" (another example of circling back to the early seasons of *Buffy*), the girl, Cassie, dies of heart failure.

The First masquerades as Cassie and appears to Willow, urging her to kill herself so that she can be with Tara again. The First appears to Dawn as Joyce Summers and warns her that when the chips are down, Buffy won't choose her above her work. Dead people are appearing to everyone, and the group is beginning to realize that something is up.

After Willow killed Warren, Buffy, Anya, and Xander helped the supernerd villains Jonathan and Andrew break out of jail to stop Willow from killing them, too. The two escaped to Mexico. But they have been plagued with dreams about a door to the hellmouth inside the school, and they decide to return to Sunnydale.

Jonathan believes that both of them want to find this door so they can warn Buffy about it. This is the Seal of Danzalthar, which, like Glory's portal, must be opened with blood. The First, appearing as Warren, has "Iago-ed" his way into Andrew's mind, convincing him that if he kills Jonathan on top of the Seal with a specific knife, all three of them will become gods. Andrew kills Jonathan—but it turns out that Jonathan is anemic, and his blood is too weak for the task. In the guise of Warren, the First encourages Andrew to kill a tiny pig that looks exactly like Herbert, the school mascot Xander ate in the first-season episode "The Pack" [1x06]. Although he fails, this serves as another reminder to fans that Buffy is "back."

TRUE POWER

The last season of Buffy was a deliberate return to the Slayer's original mission statement. In Joss's words: "The joy of female power. Having it, sharing it, using it."

Buffy has had dreams of girls in foreign lands being hunted and killed by strange, hooded men with X's over their eyes. Buffy calls Quentin Travers and the Watchers Council, searching for Giles—one more reminder of the early days of Buffy. The Watchers have also been attacked by the Bringers, but Travers, as usual, keeps this vital

RIGHT: Nathan Fillion appears as Caleb, the right-hand man of the First Evil. Fillion had previously played Malcom Reynolds in Joss Whedon's TV series *Firefly*.

information from Buffy. After quoting Winston Churchill's stirring speeches of bravery during World War II, Travers informs the Council that they will be leaving for the Sunnydale hellmouth. The First Evil has declared war, and they will respond. Once he has finished his speech, the First's right-hand man, Caleb (Nathan Fillion), blows up the Council headquarters. As in the earlier seasons of Buffy, she is free from their control (and their help).

Giles arrives with three girls in tow. It turns out that these girls are Potentials—girls who have the spark inside them to become Slayers. The men who have been hunting them down are the Harbingers of Death—the Bringers, minions of the First. Caleb is their commander, an insane, misogynistic defrocked preacher and murderer. Caleb is the lieutenant of the First, and together they are trying to wipe out the Slayer line. They plan to open the Seal of Danzalthar and let out the original vampires—pure demons, called the Turok-Han. This was the original threat that the hellmouth posed, as Giles explained in the second episode ever aired: "This world is older than any of you know. Contrary to popular mythology, it did not begin as a paradise. For untold eons demons walked the earth. They made it their home, their hell. But in time they lost their purchase on this reality. The way was made for mortal animals, for, for man. All that remains of the old ones are vestiges, certain magics, certain creatures."

In the months leading up to these revelations, Buffy has been struggling with what to do

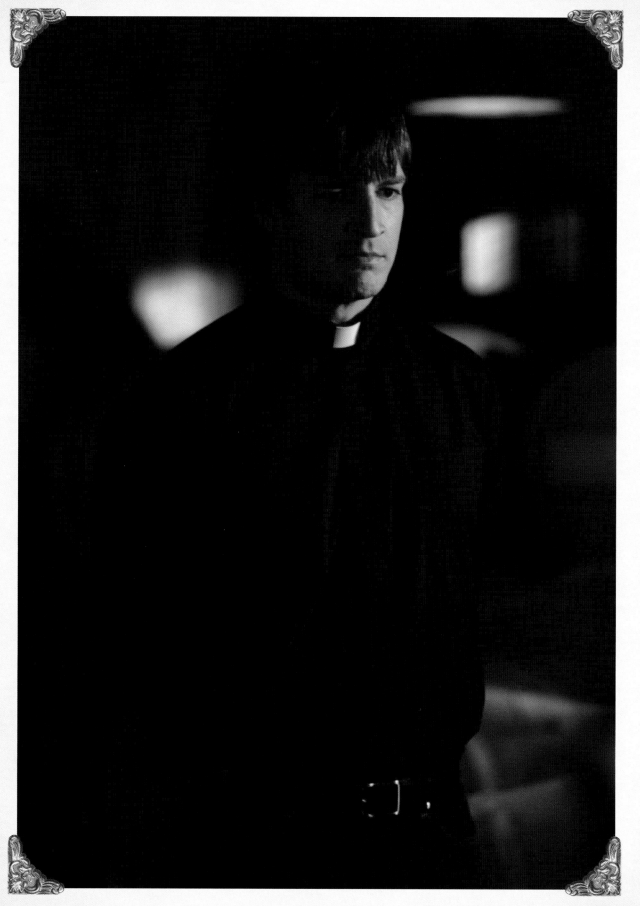

about Spike, who has returned to his evil ways thanks to the manipulations of the First. Anya rightly points out that Buffy tried to kill her when she murdered humans, and she is resentful that Spike is being spared. Spike himself wants her to stake him. He goads her, reminding her that she's "never met the real me." He has the capacity for unbelievable cruelty and brutality. Buffy insists that he's being played. Xander thinks a demon or ghost is triggering him. "This is me, Buffy," Spike counters. He reminds her of their past S&M relationship, insisting that she hasn't been able to kill him because "you like men who hurt you." She needs the pain and the hate to be the Slayer.

But Buffy assures him that she knows that's not true. She has moved on from that dark place. She has spared him because she has watched him change. She has seen his penance. "You faced the monster inside you and you fought back. You risked everything to be a better man. And you can be." In other words, Buffy believes—correctly—that Spike has the power to defeat his inner demon, because he has done it before. It is this belief in him that prompts her to have his anti-human-hurting chip removed by the

Initiative because it is misfiring and killing him. This, of course, is a highly controversial decision.

Robin Wood, the new principal of Sunnydale High, is the son of one of the Slayers Spike killed, and he attempts to exact his revenge by playing the song that triggers Spike's demonic interior. He puts on the folk song "Early One Morning," and once Spike goes into vamp face, Robin beats him to a bloody pulp as a prelude to killing him. Giles is aware that Wood is planning to kill Spike, and has been keeping Buffy busy so Robin could get the job done—but when she becomes aware of what has happened, she steps in to save Spike.

Informing Robin that she still needs him in the big fight, Buffy and the principal declare a truce. Robin provides Buffy with a "Slayer Emergency Kit"—a satchel of magical items including a book and a set of metal shadow puppets like a zoetrope—that he withheld from her after his mother passed away. Using them, she is able to visit the original Shadow Men, who chained the Primitive to a rock and forced the Shadow Demon into her, thus beginning the Slayer line. In preparation for what is to come, they offer her more power—essentially allowing her to be violated by the Shadow Demon—but she refuses. Then the Shadow Men show a vision of what lies beneath the hellmouth—an enormous army of Turok-Han—thousands upon thousands of them.

Now that the Potentials have arrived, Buffy finds she must impress upon them that they have

RIGHT: An on-set portrait of the Potentials in training outfits during the filming of season 7.

FOLLOWING PAGE: Buffy, Spike, and the Potentials confront Caleb in the old vineyard where he's hiding out.

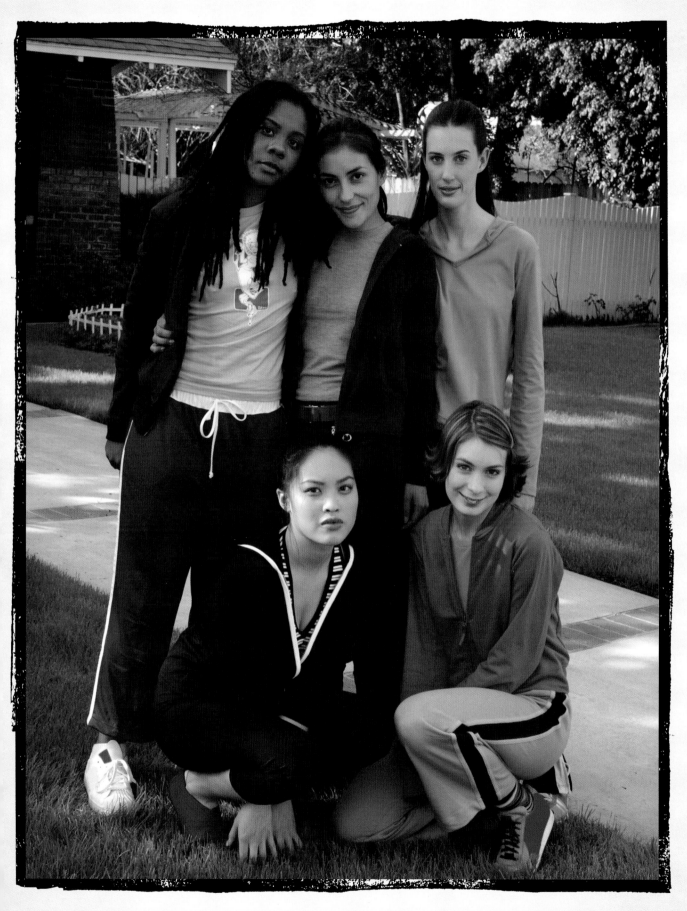

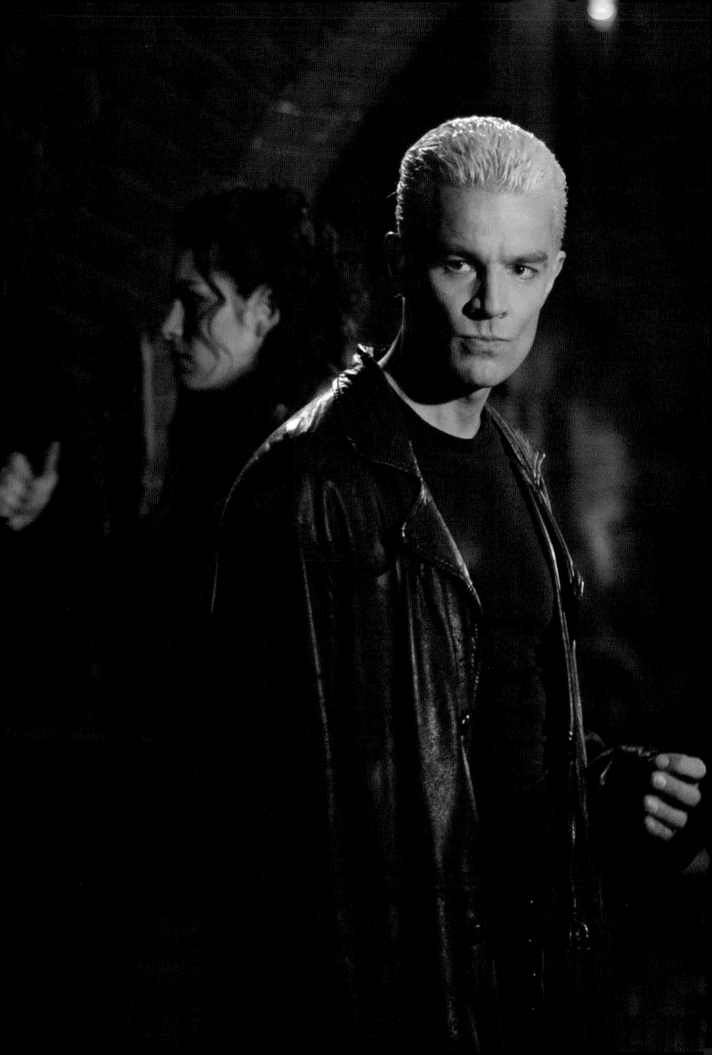

been brought to Sunnydale not for their protection, but so that they can fulfill their destinies and battle the huge horde led by the First. She gives a lot of long speeches over several episodes, so many that Buffy herself makes a later aside about them, a wink to the fans who had been complaining online (and an implicit agreement by the writers that they were right to complain). The First appears to frighten and demoralize them, causing one to hang herself.

ABOVE: The Potentials train in Buffy's backyard under her increasingly strict guidance.

RIGHT: Faith breaks out of jail to help Buffy in the fight against the First, but Buffy can't bring herself to trust her again. Here, Faith listens to Buffy's speech to the Potentials in "Chosen."

Then reinforcements arrive in the person of Faith. She has broken out of jail to come to Buffy's aid, and Buffy greets her with a lot of suspicion. Buffy is trying to give her the benefit of the doubt, but this *is* Faith, who tried to murder Angel and took over Buffy's life. Faith tries to be clear that she is there to help, but Buffy's animosity toward Faith and her harshness toward the Potentials cause a schism in the group. Buffy

ABOVE: Caleb almost kills Buffy with her own scythe before Angel steps in to save her.

RIGHT: Buffy takes possession of the scythe as the Guardian tells her that the scythe was forged for this final battle, in "End of Days."

finds herself battling for control, and ultimately loses. The Potentials choose Faith as their leader, and Buffy is thrown out of her own house.

The one person who stands by her is Spike, delivering the Spike version of the Yellow Crayon Speech: "I love what you are, what you do, how you try. I've seen your kindness and your strength. I've seen the best and the worst of you. And I understand with perfect clarity exactly what you are. You're a hell of a woman. You're the one, Buffy" ("Touched" [7x20]).

Following a trail of clues, Buffy comes into possession of a red-and-silver scythe. The inscription, "It is meant for thee," indicates that it belongs to the Chosen One. A Guardian in a tomb reveals that there has been a group of women guarding the scythe, and that they created it so that one day, the Slayer could destroy the last pure demon. They kept all this a secret from the Shadow Men, who later became the Watchers Council. The powerful weapon hums with energy when Buffy holds it, but it also hums when Faith touches it. Still Faith believes it was meant for the "real" Slayer—Buffy.

Then Faith leads the team into disaster against Caleb and the First. Girls are killed and Xander loses an eye to Caleb. The group puts Buffy back in charge, and, armed with the scythe, she prepares her final battle plan.

She has a nostalgic meeting with Angel, begun with a soaring kiss that answers many fan needs. But then Buffy explains to Angel that she's not sure who she'll end up with, or when.

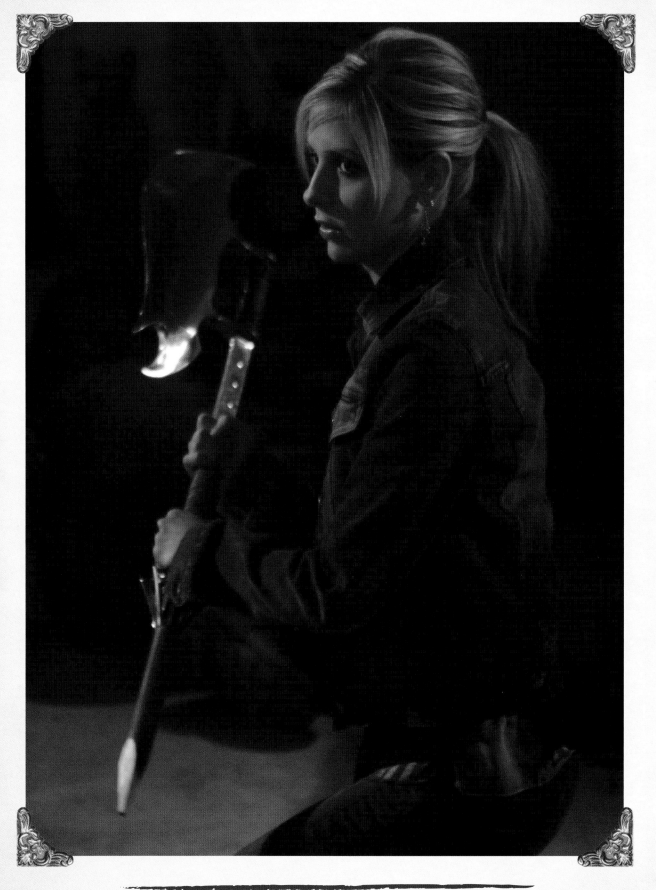

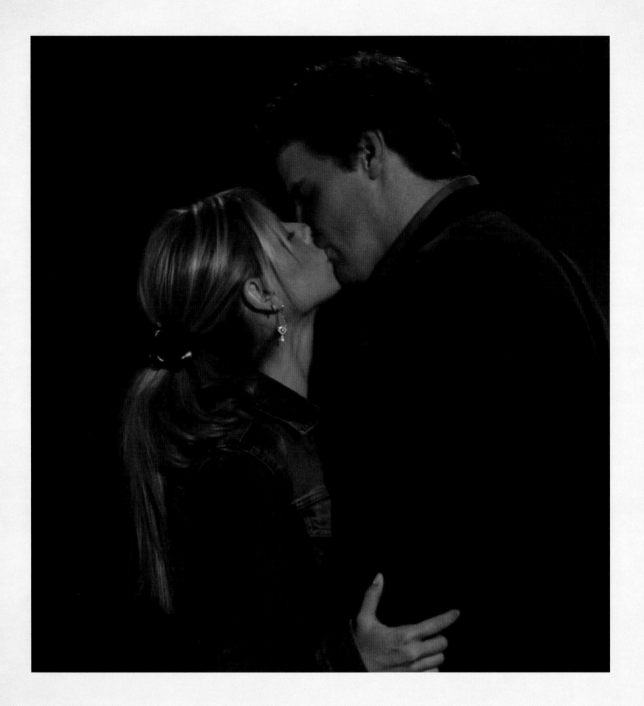

"I'm cookie dough," she says. "I'm not done baking. I'm not finished becoming whoever the hell it is I'm going to turn out to be" ("Chosen" [7x22]). The door is left open for a reunion between the two; then he gives her an amulet that must be worn by a champion. Buffy sends him away because he will be needed if she fails. Then she gives the amulet to Spike, who has become the man Buffy always knew he could be. They spend the night together. Joss deliberately

left it ambiguous about what happened between them on the eve of the big battle to answer the needs of the "Spuffies."

There is one last, nostalgic walk for the Core Four through the hallways of the original Sunnydale High School. One last exchange of banter, echoes of the old Buffy quipping about shopping while Giles sighs that "the earth is definitely doomed," as he so often did. Then each peels off, leaving the Slayer to walk alone.

Then we see what kind of power *Buffy* has been about. "In every generation, one Slayer is born," Buffy tells the Potentials, "because a bunch of men who died thousands of years ago made up that rule. They were powerful men . . . So I say we change the rule. I say my power should be our power. . . . From now on, every girl in the world who might be a Slayer, will be a Slayer. Every girl who could have the power, will have the power. Can stand up, will stand up. Slayers, every one of us. Make your choice. Are you ready to be strong?" This speech, this moment, is the beating heart of *Buffy the Vampire Slayer*. The mission statement of the show, "girl power," is no longer just a phrase. It began as the surprise power of the little blonde walking alone down a dark alley. But now, when it is the strongest it could ever be, the most powerful woman on earth offers to share it.

Courtesy of Willow's mighty magical power, forged in a crucible of rage and, finally, love, all the Potentials the world over receive the power of the Chosen One. In a moving montage, a girl

stands up to her abusive father; a nervous little softball player smiles with new confidence. And all the Slayers at the hellmouth get ready to rumble.

Slicing open their palms to open the hellmouth with their blood, they battle in hand-to-hand combat while Buffy, and later Faith, wields the scythe. Having reconciled with Xander, Anya is killed. Later, having become romantically entangled with Faith, it appears that Robin Wood is killed, but he survives: "Surprise!" he says when she thinks he is dead.

As they have done before, Buffy's lieutenants ambush the bad guys with daylight. Spike's amulet brings down the power of the sun and bathes the hellmouth in it, causing mass destruction of the Turok-Han. As the town of Sunnydale begins to collapse, Buffy exhorts Spike to leave with her. He refuses, staying behind to guarantee victory. She tells him that she loves him, holding hands with him as he burns.

Sunnydale is swallowed up, and Buffy no longer carries the burden of Slayer power alone. She finally has her own kind of power—the power of making a future for herself.

LEFT: Angel says, "At least you could tell me you're glad to see me?" At which point Buffy and Angel kiss and the fans cheer.

FOLLOWING: An on-set photo shows the survivors after the Hellmouth collapses. From left: Michelle Trachtenberg, Sarah Michelle Gellar, Anthony Stewart Head, Eliza Dushku, Nicholas Brendon, and Alyson Hannigan.

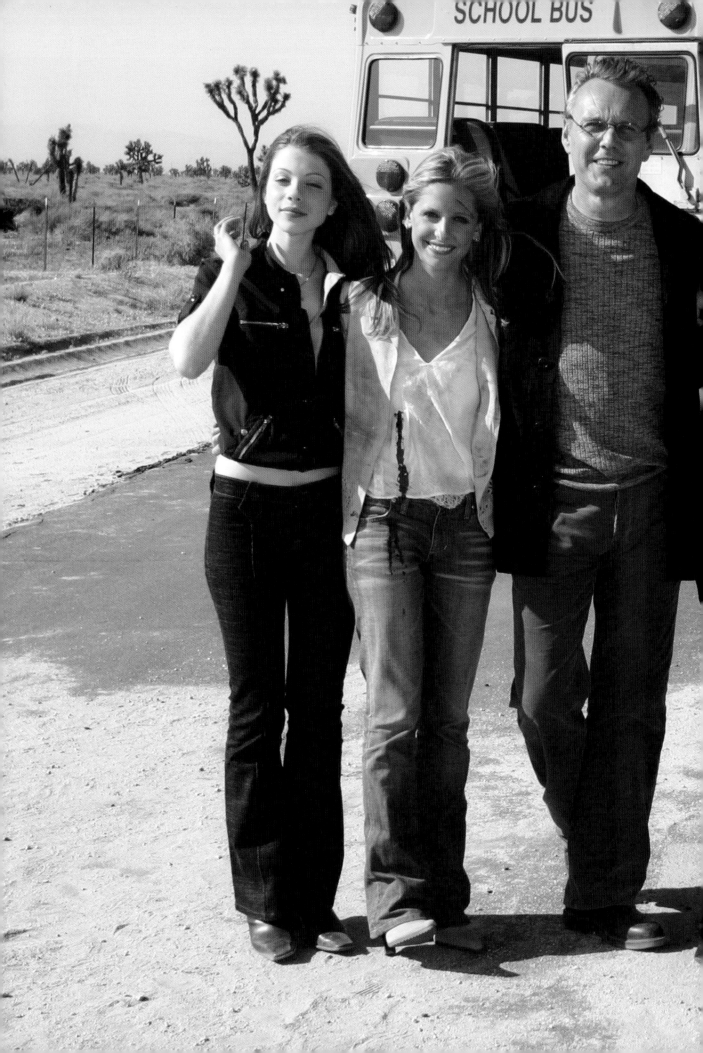

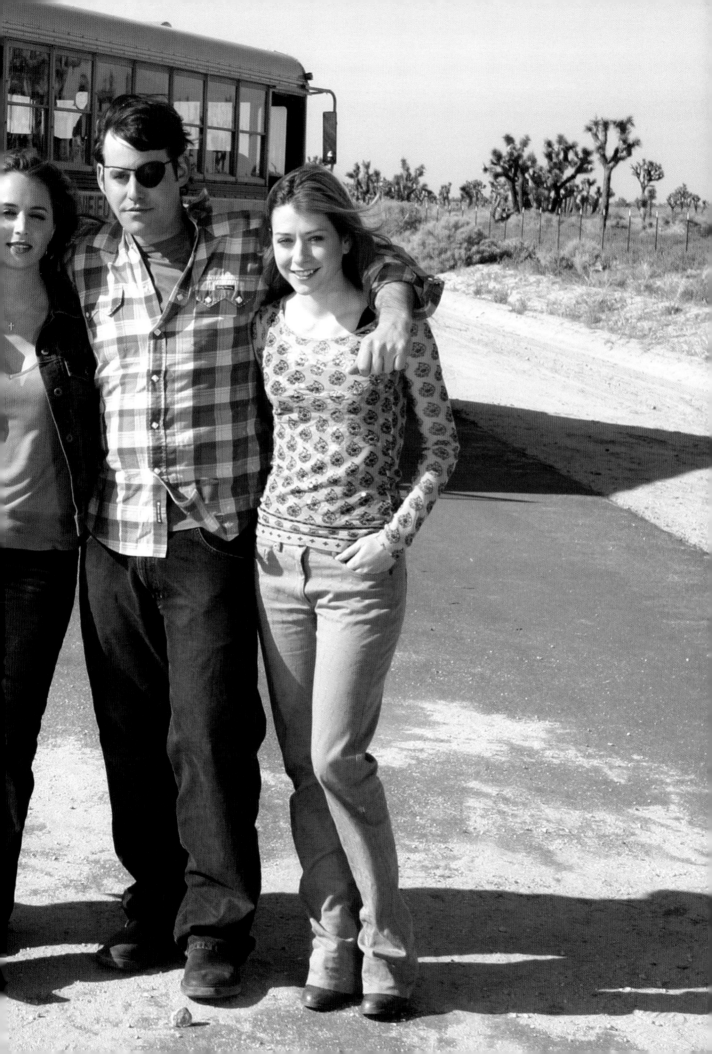

BEYOND BUFFY

As the series was ending, a reporter for the *New York Times* asked Joss where he would take the show if he had the cast for another year. "Honestly," he said, "if I had a strong answer for that question there probably would be another season. I think it's time they all went their separate ways. And so my answer is, I can't possibly think of anything, I'm simply too tired."

Luckily, that proved not to be so. Buffy's further adventures are chronicled in the comic book series from Dark Horse, with season eight picking up immediately after the TV series finale. Now into season nine, the line is overseen

by Joss, and is considered "canon"—as much part of the official lore about *Buffy the Vampire Slayer* as the show itself.

Joss Whedon said that he designed *Buffy* to be an icon, not just a TV show, and that has certainly proved to be the case. There are active fan groups on the net, and fans have in many cases moved from being *Buffy* fans to Joss Whedon fans, illustrated by the Whedon Studies Association and the publication of a 2011 paean to his work, *Whedonistas!: A Celebration of the Worlds of Joss Whedon by the Women Who Love Them*. Numerous science-fiction conventions feature sing-alongs for "Once More with

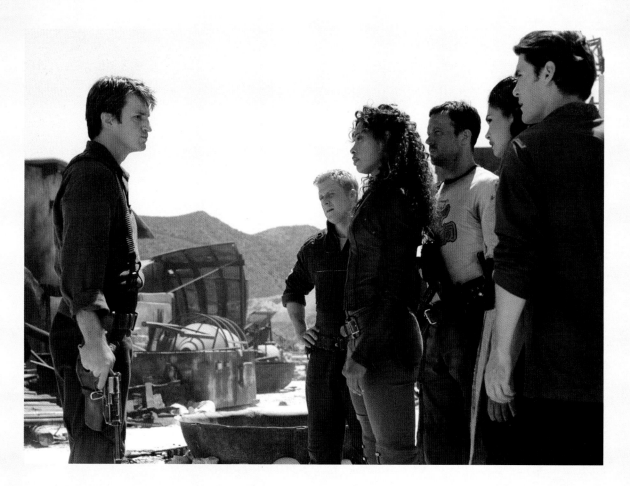

Feeling," attracting thousands of participants.

There are still active fan groups, many of whom embrace all aspects of the "Jossverse," such as Whedonesque. Other online groups, such as Buffyfest and SlayerLit.us, are *Buffy/Angel*-centric but include information about other aspects of Joss Whedon's work. Buffyfest's website shows pictures of group gatherings such as barbecues. SlayerLit works hard on the Slay-A-Thon charity, where fans gather and watch episodes of *Buffy* and *Angel* in a marathon session to raise money for the Make-A-Wish Foundation.

In addition to *Buffy* and *Angel*, Joss has had two more of his shows produced on TV: *Firefly*, which also became a feature film titled *Serenity*; and *Dollhouse*, starring Eliza Dushku (Faith), which ran for two seasons. Joss wrote, directed, and produced *Dr. Horrible's Sing-Along Blog* during the 2007–2008 Writers Guild of America strike.

LEFT: Cover of *Buffy the Vampire Slayer #1* from 1998, with art by Arthur Adams; cover of *Buffy the Vampire Slayer Season 8 #1: The Long Way Home* from 2007, the comic that continued the official Buffy story beyond the TV show. Art by Georges Jeanty.

ABOVE: Nathan Fillion, Alan Tudyk, Gina Torres, Adam Baldwin, Morena Baccarin, and Sean Maher on the set of *Serenity* in 2004. The feature film was greenlit after constant pressure from fans of the TV series *Firefly* demanded it.

A musical streamed on the net in three "acts," it has won numerous awards, including a Creative Arts Emmy and a Hugo Award (from the World Science Fiction Society). He wrote *The Cabin in the Woods* with Drew Goddard, a Hugo Award–winner (with Jane Espenson, for "Conversations with Dead People"). He has even gone into the superhero comics world, writing several issues of *Amazing X-Men* and making other "guest-star" appearances as a writer. To great fan rejoicing, he wrote and directed the film *The Avengers*, which set a new record for the biggest domestic opening weekend ever. He also directed and wrote the screenplay for *Much Ado About Nothing* for his own production company, Bellwether Pictures, while a second film, *In Your Eyes*, is in preproduction (as of this writing).

Serenity/Firefly has generated a cult following of its own, supporting two three-issue comics miniseries. Fans also continue to start new chapters of Browncoats (named for the political affiliation of the captain, Malcom Reynolds). Many Browncoats came to their fandom without having watched *Angel* or *Buffy*. The Browncoats website attempts to define the term as someone who's helped keep the show alive: "A fan is someone who watches the show and likes it—simple enough. But a Browncoat (in my mind, anyway) is much more of a fan activist, someone who has sent postcards and e-mail or has written a review or donated money for something *Firefly*-related, etc., etc., etc."

As with *Angel, Buffy, Firefly, Dr. Horrible,* and to a lesser extent *Dollhouse,* in Joss Whedon's work, fans find dense and immersive created realities that they feel they can be a part of. Despite the differences in their worlds, they also find kinship in being part of the "Jossverse," following Joss himself. In return, he posts online (in Whedonesque, for example) and keeps his nerd street cred fresh (referring to San Diego Comic-Con as "the goodwill tour").

He has already created a body of work that for many would comprise an entire career. Yet fans breathlessly await news of his next project. Every sentence he utters that could contain a hint about what he will do next is dissected and discussed on the Internet. Fans post on Facebook, tweet, and send out feeds about the comics, which, of course, are the continuing stories of *Buffy* designed by Joss himself. *Buffy the Vampire Slayer* is where it all started. Buffy has become the popular cultural icon Joss had hoped for . . . and *Buffy the Vampire Slayer* is the show that legions of fans still *need* to watch.

LEFT: A publicity photo for season 5 of *Angel.* From left: Mercedes McNab, Amy Acker, Alexis Denisof, David Boreanaz, Andy Hallett, James Marsters, Sarah Thompson, and J. August Richards.

ABOVE: Black Widow, Thor, Captain America, Hawkeye, Iron Man, and the Hulk assemble in *The Avengers.*

FOLLOWING: A panorama of the Sunnydale set, photographed and assembled by production designer Carey Meyer.

The Comics Index

For the most part, the original run of sixty-three comic books published by Dark Horse during seasons 1–7 are not considered canon. There are a few exceptions, notably, *Buffy: The Origin* (three issues), which is an adaptation of Joss's film script, and those by the writers of the TV show. The four-parter "Haunted" and "Jonathan" by Jane Espenson is canon, and Doug Petrie's "Double Cross" might be included by some Whedon/comic experts. The omnibuses republished all the pre-season eight comics in chronological order, excluding *Fray*, *Tales of the Slayer*, and *Tales of the Vampires*, which were collected in volumes of their own. An excellent reference resource is *Buffy the Vampire Slayer: Panel to Panel* (Dark Horse Books, 2007), written by Scott Allie, who was the editor of the line.

ORIGINAL SERIES

Buffy the Vampire Slayer, 63 issues, Sept. 1998–Nov. 2002

Buffy the Vampire Slayer Omnibus, vol. 1, trade paperback, July 2007

Buffy the Vampire Slayer Omnibus, vol. 2, trade paperback, Aug. 2007

Buffy the Vampire Slayer Omnibus, vol. 3, trade paperback, Jan. 2008

Buffy the Vampire Slayer Omnibus, vol. 4, trade paperback, May 2008

Buffy the Vampire Slayer Omnibus, vol. 5, trade paperback, Sept. 2008

Buffy the Vampire Slayer Omnibus, vol. 6, trade paperback, Feb. 2009

Buffy the Vampire Slayer Omnibus, vol. 7, trade paperback, June 2009

CANONICAL SERIES

The Origin, 3 issues, Jan. 1999–Mar. 1999

Fray, 8 issues, June 2001–Aug. 2003

Fray: Future Slayer, trade paperback and trade

hardcover, Nov. 2003

Tales of the Slayers, trade paperback, Nov. 2001

Tales of the Slayers: Broken Bottle of Djinn, 1 issue, Oct. 2002

Tales of the Vampires, 5 issues, Dec. 2003–Apr. 2004

Tales of the Vampires: The Thrill, 1 issue, June 2009

Buffy the Vampire Slayer: Tales, trade paperback, Jan. 2011

Buffy the Vampire Slayer: Season 8, 40 issues, Mar. 2007–Jan. 2011

Willow: Goddesses and Monsters, 1 issue, Dec. 2009

Riley: Commitment through Distance, Virtue through Sin, 1 issue, Aug. 2010

Buffy the Vampire Slayer, Season 8: The Long Way Home, trade paperback, Oct. 2007

Buffy the Vampire Slayer, Season 8: No Future for You, trade paperback, May 2008

Buffy the Vampire Slayer, Season 8: Wolves at the Gate, trade paperback, Nov. 2008

Buffy the Vampire Slayer, Season 8: Time of Your Life,

trade paperback, May 2009

Buffy the Vampire Slayer, Season 8: Predators and Prey, trade paperback, Sept. 2009

Buffy the Vampire Slayer, Season 8: Retreat, trade paperback, Feb. 2010

Buffy the Vampire Slayer, Season 8: Twilight, Oct. 2010

Buffy the Vampire Slayer, Season 8: Last Gleaming, June 2011

Buffy the Vampire Slayer, Season 9, 8 issues (25 planned), Sept. 2011–

Buffy the Vampire Slayer, Season 9, vol. 1: Freefall, trade paperback, Aug. 2012

Angel and Faith, 9 issues (25 planned), Aug. 2011–

Angel and Faith, vol. 1: Live Through This, trade paperback, June 2012

Angel: After the Fall, 44 issues, Nov. 2007– Apr. 2011

SPECIALS (NOT CANON)

The Dust Waltz, trade paperback, Oct. 1998

Buffy #1/2, limited edition, Wizard Magazine edition, July 1999

Buffy 1999 Annual, trade paperback, Aug. 1999

Lover's Walk, trade paperback, circa 2001

Buffy/Angel: City of Despair #1/2, trade paperback, circa 2000

Giles, trade paperback, Oct. 2000

Ring of Fire, trade paperback, Aug. 2000

Jonathan, trade paperback, Jan. 2001

Lost and Found, trade paperback, March 2002

Creatures of Habit, paperback, May 2002

Buffy/Angel: Reunion, trade paperback, June 2002

Chaos Bleeds, trade paperback, June 2003

LIMITED SERIES (NOT CANON)

Angel, 3 issues, May 1999–July 1999

Spike & Dru, 3 issues, Apr. 1999–Dec. 2000

Oz, 3 issues, July 2001–Sept. 2001

Haunted, 4 issues, Dec. 2001–Mar. 2002

Willow & Tara: WannaBlessedBe, 1 issue, Apr. 2001

Willow & Tara: Wilderness, 2 issues, July 2002– Sept. 2002

Buffy the Vampire Slayer: Willow & Tara, trade paperback, June 2003

Bibliography of the Whedonverse

Abbott, Stacey. *Angel*. Detroit: Wayne UP, 2009.

Abbott, Stacey. *Celluloid Vampires: Life After Death in the Modern World*. Austin: U of Texas P, 2007.

Abbott, Stacey, ed. *Reading "Angel": The TV Spin-Off with a Soul*. New York: Tauris, 2005.

Adams, Michael. *Slayer Slang: A "Buffy the Vampire Slayer" Lexicon*. Oxford: Oxford UP, 2003.

Anderson, Marilyn D. *Sarah Michelle Gellar*. Philadelphia: Chelsea House, 2002.

Attinello, Paul G., Janet K. Halfyard, and Vanessa Knights, eds. *Music, Sound, and Silence in "Buffy the Vampire Slayer."* Burlington: Ashgate, 2010.

Avon, Alexandre. *Buffy contre les vampires: Une épopée trifonctionnelle dumézilienne*. Paris: Éditions le Manuscrit, 2009.

Baker, Jennifer. *Sarah Michelle Gellar*. New York: Aladdin, 1998.

Bar Lev, Jenifer. *"Buffy the Vampire Slayer" and the Israeli-Palestinian Conflict*. Tel Aviv: JBL, 2011.

Battis, Jes. *Blood Relations: Chosen Families in "Buffy the Vampire Slayer" and "Angel."* Jefferson, NC: McFarland, 2005.

Beatrice, Allyson. *Will the Vampire People Please Leave the Lobby?: True Adventures in Cult Fandom*. Naperville, IL: Sourcebooks, 2007.

Beckmann, Annika, ed. *Horror als Alltag: Texte zu "Buffy the Vampire Slayer."* Berlin: Verbrecher, 2010.

Billson, Anne. *Buffy the Vampire Slayer*. London: BFI, 2005.

Boris, Cynthia. *"Buffy the Vampire Slayer" Pop Quiz*. New York: Simon, 1999.

Brezenoff, Steven, and Micol Ostow. *The Quotable Slayer*. New York: Simon, 2003.

Caelsto, Mary. *The Fool's Journey through Sunnydale: The Archetypes of the Major Arcana as Seen in "Buffy the Vampire Slayer."* Jupiter Gardens Press, 2010.

Comeford, AmiJo, and Tamy Burnett, eds. *The Literary "Angel": Essays on Influences and Traditions Reflected in the Joss Whedon Series*. Jefferson, NC: McFarland, 2010.

Daniels, Susanne, and Cynthia Littleton. *Season Finale: The Unexpected Rise and Fall of the WB and UPN*. New York: Harper, 2007.

Dath, Dietmar. *Sie ist Wach: Über ein Mädchen, das hilft, schützt und rettet*. Berlin: Implex-Verlag, 2003.

Davidson, Joy, ed. *The Psychology of Joss Whedon: An Unauthorized Exploration of "Buffy," "Angel," and "Firefly."* Dallas: BenBella, 2007.

Delaume, Chloé. *La nuit je suis Buffy Summers*. Paris: Éditions e®e, 2007.

Dial-Driver, Emily, Sally Emmons-Featherston, Jim Ford, and Carolyn Anne Taylor, eds. *The Truth of "Buffy": Essays on Fiction Illuminating Reality*. Jefferson, NC: McFarland, 2008.

Durand, Kevin K., ed. *"Buffy" Meets the Academy: Essays on the Episodes and Scripts as Texts*. Jefferson, NC: McFarland, 2009.

Edlund, Ben, Jane Espenson, Brett Mathews, and Jose Molina. *"Firefly": Still Flying: A Celebration of Joss Whedon's Acclaimed Series*. London: Titan Books, 2010.

Edwards, Lynne Y., Elizabeth L. Rambo, and James B. South, eds. *"Buffy" Goes Dark: Essays on the*

Final Two Seasons of "Buffy the Vampire Slayer" on Television. Jefferson, NC: McFarland, 2008.

Edwards, Richard, ed. *Worlds of Whedon: The SFX Interviews*. Future Pub, 2011 (e-book only).

Edwards, Ted. *Buffy X-posed: The Unauthorized Biography of Sarah Michelle Gellar and Her On-Screen Character*. Rocklin, CA: Prima, 1998.

Espenson, Jane, ed. *Finding Serenity: Anti-Heroes, Lost Shepherds and Space Hookers in Joss Whedon's "Firefly."* Dallas: BenBella, 2005.

Espenson, Jane, ed. *Inside Joss' Dollhouse: From Alpha to Rossum*. Dallas: BenBella, 2010.

Espenson, Jane, ed. *Serenity Found: More Unauthorized Essays on Joss Whedon's "Firefly" Universe*. Dallas: BenBella, 2007.

Frankel, Valerie Estelle. *Buffy and the Heroine's Journey: Vampire Slayer as Feminine Chosen One*. Jefferson, NC: McFarland, 2012.

Furman, Elina, and Leah Furman. *Seth Green: An Unauthorized Biography*. New York: St. Martin's, 2000.

Gabriel, Jan. *Meet the Stars of "Buffy the Vampire Slayer": An Unauthorized Biography*. New York: Scholastic, 1998.

Gatson, Sarah N., and Amanda Zweerink. *Interpersonal Culture on the Internet: Television, the Internet, and the Making of a Community*. Lewiston, NY: Edwin Mellen, 2004.

Genge, Ngaire E. *The Buffy Chronicles: The Unofficial Companion to "Buffy the Vampire Slayer."* New York: Three Rivers, 1998.

Ginn, Sherry. *Power and Control in the Television Worlds of Joss Whedon*. Jefferson, NC: McFarland, 2012.

Gouezel, Guy. *L'intégrale de "Buffy contre les vampires" en DVD*, vol. 1-3. Editions Atlas, 2005.

Havens, Candace. *Joss Whedon: The Genius behind "Buffy."* Dallas: BenBella, 2003.

Höhl, Thomas. *Coole Vampire. Von Angel bis Spike: Alles über die beliebtesten Blutsauger*. Königswinter: Heel, 2004.

Holder, Nancy, Christopher Golden, and Keith R. A. DeCandido. *Buffy the Vampire Slayer: The Watcher's Guide*. New York: Simon, 1998.

Holder, Nancy, Jeff Mariotte, and Maryelizabeth Hart. *Buffy the Vampire Slayer: The Watcher's Guide 2*. New York: Simon, 2000.

Holder, Nancy, Jeff Mariotte, and Maryelizabeth Hart. *Angel: The Casefiles*, vol. 1. New York: Simon, 2002.

Holt, Julia. *Sarah Michelle Gellar*. London: Hodder and Stoughton, 2003.

Johns, Michael-Anne. *David Boreanaz*. Kansas City: Andrews McMeel, 1999.

Johns, Michael-Anne. *Sarah Michelle Gellar*. Kansas City: Andrews McMeel, 1999.

Joss Whedon: The Complete Companion: The TV Series, the Movies, the Comic Books and More: The Essential Guide to the Whedonverse. London: Titan Books, 2012.

Jowett, Lorna. *Sex and the Slayer: A Gender Studies Primer for the "Buffy" Fan*. Middletown, CT: Wesleyan UP, 2005.

Kaveney, Roz, ed. *Reading the Vampire Slayer: The New, Updated, Unofficial Guide to "Buffy" and "Angel."* 2nd rev. ed. New York: Tauris, 2004.

Kern, Claudia. *Das grosse Handbuch der Dämonen & Vampire: Aufgezeichnet vom Wächter, kommentiert von Buffy und Spike*. Königswinter: Heel, 2003.

Kirby-Diaz, Mary, ed. *"Buffy" and "Angel" Conquer the Internet: Essays on Online Fandom.* Jefferson, NC: McFarland, 2009.

Kiss Me Jane. *It's Never Too Late to Become a "Buffy" Fan: Your Complete How-To Guide.* Ottawa, ON: KMJ, 2004.

Koontz, K. Dale. *Faith and Choice in the Works of Joss Whedon.* Jefferson, NC: McFarland, 2008.

Kowalski, Dean A., and S. Evan Kreider, eds. *The Philosophy of Joss Whedon.* Lexington: UP of Kentucky, 2011.

Kreider, Jodie A., and Meghan K. Winchell, eds. *Buffy in the Classroom: Essays on Teaching with the Vampire Slayer.* Jefferson, NC: McFarland, 2010.

Laslo, Cynthia. *Sarah Michelle Gellar.* New York: Children's, 2000.

Lavery, David, and Cynthia Burkhead, eds. *Joss Whedon: Conversations.* Jackson: UP of Mississippi, 2011.

Leonard, Kendra Preston, ed. *"Buffy," Ballads, and Bad Guys Who Sing: Music in the Worlds of Joss Whedon.* Lanham, MD: Scarecrow, 2010.

Levine, Elana, and Lisa Parks, eds. *Undead TV: Essays on "Buffy the Vampire Slayer."* Durham: Duke UP, 2007.

Lukas, Christian. *Zauberhafte Hexen: Die Charmed-Schwestern, Sabrina, Willow and Tara aus "Buffy."* Königswinter: Heel, 2003.

Lukas, Christian, and Sascha Westphal. *Angel, der dunkle Engel: Das inoffizielle Fanbuch über die ersten beiden Staffeln der Kultserie und ihre Hintergründe.* München: Droemer Knaur, 2002.

Lukas, Christian, and Sascha Westphal. *Buffy: Die Jagd Geht Weiter. Das inoffizielle Buch über die 4.*

Staffel der Kultserie und ihre Hintergründe. München: Droemer Knaur, 2001.

Lukas, Christian, and Sascha Westphal. *Buffy: Die Jägerin schlägt zurück: Das inoffizielle Fanbuch über die 5. Staffel der Kultserie und ihre Hintergründe.* München: Droemer Knaur, 2002.

Lukas, Christian, and Sascha Westphal. *Buffy: Die neuen Arbenteuer.* München: Droemer Knaur, 1999.

Lukas, Christian, and Sascha Westphal. *Buffy: Im Bann der Dämonen: Das inoffizielle Fanbuch über die neue Kultserie und ihre Hintergründe.* München: Droemer Knaur, 1999.

MacDonald, Elizabeth. *Sarah Michelle Gellar.* London: Carlton, 2002.

Macnaughtan, Don. *The Buffyverse Catalog: A Complete Guide to "Buffy the Vampire Slayer" and "Angel" in Print, Film, Television, Comics, Games and Other Media, 1992–2010.* Jefferson, NC: McFarland, 2011.

Maio, Barbara. *Buffy the Vampire Slayer.* Rome: Aracne, 2004.

Maio, Barbara, ed. *Buffy the Vampire Slayer: Legittimare la cacciatrice.* Rome: Bulzoni, 2007.

Mann, Peter. *The Slayer Files: A Completely and Utterly Unauthorised Guide to "Buffy the Vampire Slayer."* Rev. ed. Harpenden: Pocket Essentials, 2000.

Mason, Paul. *Sarah Michelle Gellar.* Chicago: Raintree, 2005.

McCracken, Kristin. *Seth Green.* New York: Children's Press, 2000.

Mestre, Robert. *The Big Book of Buffy Bites 2008: The Ultimate Resource for the "Buffy" Fanatic.* Morrisville, NC: Lulu, 2008.

Moretti, Marie. *Sarah Michelle Gellar: La vamp de "Buffy."* Paris: La Mascara, 2000.

Moretti, Marie. *Vampirserien: Buffy privat; Sarah Michelle Gellar*. Königswinter: Heel, 2001.

Nickson, Chris. *David Boreanaz*. New York: St. Martin's, 1999.

Norris, Gregory L. *The Q Guide to "Buffy the Vampire Slayer."* Los Angeles: Alyson, 2008.

Noyes, Mimi. *Firefly Episode Guide: An Unofficial, Independent Guide to Joss Whedon's "Firefly" with Complete Facts and Critiques*. Port Orchard, WA: Windstorm, 2005.

Osteried, Peter. *Buffy, die Vampirjägerin: Alle Hintergründe und Fakten zur Kultserie*. Königswinter: Heel, 1999.

Osteried, Peter. *Buffy Exklusiv: News, private Shots, Die Aktuelle 5. Staffel, Die 6. Staffel, Die Neuzugänge*. Königswinter: Heel, 2002.

Osteried, Peter. *Vampirserien: Buffy und Angel*. Königswinter: Heel, 2000.

Ouellette, Jennifer. *The Physics of the Buffyverse*. New York: Penguin, 2007.

Pateman, Matthew. *The Aesthetics of Culture in "Buffy the Vampire Slayer."* Jefferson, NC: McFarland, 2005.

Pearson, Lars, and Christa Dickson. *Redeemed: The Unauthorized Guide to "Angel."* Des Moines: Mad Norwegian, 2006.

Pearson, Lars, Christa Dickson, and Lawrence Miles, *Dusted: The Unauthorized Guide to "Buffy the Vampire Slayer."* New Orleans: Mad Norwegian, 2003.

Poli, Chiara. *Ammazzavampiri: La prima guida Italiana al serial TV Buffy*. Pisa: Edizioni ETS, 2003.

PopMatters, ed. *Joss Whedon: The Complete Companion*. London: Titan Books, 2012

Powell, Phelan, and Rose Mary Powell. *Sarah Michelle Gellar: A Real-Life Reader Biography*. Bear, DE: Mitchell Lane, 2000.

Recht, Marcus. *Der Sympathische Vampir: Visualisierungen von Männlichkeiten in Der Tv-Serie Buffy*. Frankfurt am Main: Campus, 2011.

Reisfeld, Randi. *Sarah Michelle Gellar: She Is the Slayer*. New York: Scholastic, 1998.

Richardson, J. Michael, and J. Douglas Rabb. *The Existential Joss Whedon: Evil and Human Freedom in "Buffy the Vampire Slayer," "Angel," "Firefly" and "Serenity."* Jefferson: McFarland, 2007.

Riess, Jana. *What Would Buffy Do?: The Vampire Slayer as Spiritual Guide*. San Francisco: Jossey-Bass, 2004.

Ruditis, Paul. *Buffy the Vampire Slayer: The Watcher's Guide 3*. New York: Simon, 2004.

Ruditis, Paul, and Diana G. Gallagher. *Angel: The Casefiles*, vol. 2. New York: Simon, 2004.

Rumor, Mario A. *Created by: Il nuovo impero delle serie TV: "Buffy," "C.S.I.," "Alias" e tutte le altre*. Tunué, 2007.

Scaglioni, Massimo. *TV di culto: La serialità televisiva americana e il suo fandom*. Milan: Vita e Pensiero, 2006.

Short, Sue. *Cult Telefantasy Series: A Critical Analysis of "The Prisoner," "Twin Peaks, " "The X-Files," "Buffy the Vampire Slayer," "Lost," "Heroes," "Doctor Who" and "Star Trek."* Jefferson, NC: McFarland, 2011.

Sippert, Günter. *Die Stars von "Buffy": Eine nicht autorisierte Biographie der Darsteller aus der TV-Serie "Buffy—Im Bann der Dämonen."* Orig.-Ausg ed. Kaufbeuren: Action-Media-Verlag, 2000.

Sippert, Günter. *Sarah Michelle Gellar: Eine*

unautorisierte biographie. Kaufbeuren: Action-Media-Verlag, 2001.

Smith, Emily. *The Eliza Dushku Handbook: Everything You Need to Know about Eliza Dushku*. Tebbo, 2012.

Smith, Emily. *The Nathan Fillion Handbook: Everything You Need to Know about Nathan Fillion*. Tebbo, 2012.

Smith, Emily. *The Sarah Michelle Gellar Handbook: Everything You Need to Know about Sarah Michelle Gellar*. Tebbo, 2011.

South, James B., ed. *"Buffy the Vampire Slayer" and Philosophy: Fear and Trembling in Sunnydale*. Chicago: Open Court, 2003.

Stafford, Nikki. *Bite Me! The Unofficial Guide to "Buffy the Vampire Slayer": The Chosen Edition*. 2nd rev. ed. Toronto: ECW, 2007.

Stafford, Nikki. *Once Bitten: An Unofficial Guide to the World of "Angel."* Toronto: ECW, 2004.

Stevenson, Gregory. *Televised Morality: The Case of "Buffy the Vampire Slayer."* Dallas: Hamilton, 2003.

Thomas, Lynne M., and Deborah Stanish, eds. *Whedonistas!: A Celebration of the Worlds of Joss Whedon by the Women Who Love Them*. Des Moines: Mad Norwegian, 2011.

Topping, Keith. *The Complete Slayer: An Unofficial and Unauthorised Guide to Every Episode of "Buffy the Vampire Slayer."* 4th ed. London: Virgin, 2004.

Topping, Keith. *Hollywood Vampire: An Expanded and Updated Unofficial and Unauthorised Guide to "Angel."* 4th ed. London: Virgin, 2004.

Topping, Keith. *Slayer: A Totally Awesome Collection of "Buffy" Trivia*. London: Virgin, 2004.

Topping, Keith, and Deborah Williams. *Hollywood Vampire: A Totally Awesome Collection of "Angel" Trivia*. London: Virgin, 2005.

Tracy, Kathleen. *The Girl's Got Bite: The Original Unauthorized Guide to Buffy's World; Completely Revised and Updated*. 2nd ed. New York: St. Martin's Griffin, 2003.

Turnbull, Sue, and Vyvyan Stranieri. *Bite Me: Narrative Structures + "Buffy the Vampire Slayer."* Victoria, Australia: Australian Centre for the Moving Image, 2003.

Waggoner, Erin B., ed. *Sexual Rhetoric in the Works of Joss Whedon: New Essays*. Jefferson, NC: McFarland, 2010.

Wasserer, Annabell. *"Buffy—Im Bann der Dämonen": Lieben, leben und sterben in Sunnydale: Eine wissenschaftliche Auseinandersetzung mit der Thematik der Serie*. Saarbrücken: VDM, 2009.

Whedon, Joss. *Dr. Horrible's Sing-Along Blog: The Book*. London: Titan Books, 2011.

Whedon, Joss. *Firefly: The Official Companion*. London: Titan Books, 2006.

Whedon, Joss. *Firefly: The Official Companion*, vol. 2. London: Titan Books, 2007.

Whedon, Joss. *Serenity: The Official Visual Companion*. London: Titan Books, 2005.

Whedon, Joss, and Drew Goddard. *The Cabin in the Woods: The Official Visual Companion*. London: Titan Books, 2012.

White, Mark D., ed. *The Avengers and Philosophy: Earth's Mightiest Thinkers*. New York: Wiley, 2012.

Wilcox, Rhonda V. *Why "Buffy" Matters: The Art of "Buffy the Vampire Slayer."* New York: Tauris, 2005.

Wilcox, Rhonda V., and David Lavery, eds. *Fighting the Forces: What's at Stake in "Buffy the Vampire Slayer."* New York: Rowman and Littlefield, 2002.

Wilcox, Rhonda V., and Tanya R. Cochran, eds. *Investigating "Firefly" and "Serenity": Science Fiction on the Frontier*. New York: Tauris, 2008.

Yeffeth, Glenn, ed. *Five Seasons of "Angel": Science Fiction and Fantasy Writers Discuss Their Favorite Vampire.* Dallas: BenBella, 2004.

Yeffeth, Glenn, ed. *Seven Seasons of "Buffy": Science Fiction and Fantasy Writers Discuss Their Favorite Television Show.* Dallas: BenBella, 2003.

Zier, Nina. *David Boreanaz.* New York: Aladdin Paperbacks, 1999.

Zubiller, Cora. *Philosophical Potential in "Buffy the Vampire Slayer."* München: GRIN, 2010 (online only).

TRANSLATIONS

Boris, Cynthia. *Buffy contre les vampires: Le quiz.* Trans. Isabelle Troin. Paris: Fleuve Noir, 2000. Translation of *Buffy the Vampire Slayer Pop Quiz.*

Genge, Ngaire E. *Chroniques de* Buffy: *Tout sur Buffy, Angel, et les vampires: Le guide non officiel de "Buffy contre les vampires."* Paris: Fleuve Noir, 2000. Translation of *The "Buffy" Chronicles.*

Golden, Christopher, Nancy Holder, and Keith R. A. DeCandido. *Buffy contre les vampires: Le guide officiel.* Trans. Isabelle Troin. Paris: Fleuve Noir, 1999. Translation of *The Watcher's Guide.*

Golden, Christopher, Nancy Holder, and Keith R. A. DeCandido. *Buffy im Bann der Dämonen: Der offizielle Serienguide, Band 1.* Trans. Christiane Jung. Stuttgart: Panini, 2001. Translation of *The Watcher's Guide.*

Holder, Nancy, Jeff Mariotte, and Maryelizabeth Hart. *Buffy contre les vampires: Le guide officiel 2.* Trans. Isabelle Troin. Paris: Fleuve Noir, 2001. Translation of *The Watcher's Guide 2.*

Holder, Nancy, Jeff Mariotte, and Maryelizabeth Hart. *Buffy im Bann der Dämonen: Der offizielle Serienguide, Band 2.* Trans. Christiane Jung. Stuttgart: Panini, 2001. Translation of *The Watcher's Guide 2.*

Riess, Jana. *Que ferait Buffy?: La tueuse de vampires comme guide spirituel.* Trans. Sophie Beaume. Varennes, Québec: AdA, 2007. Translation of *What Would Buffy Do?*

South, James B., ed. *"Buffy, a caça-vampiros" e a filosofia: Medos e calafrios em Sunnydale.* Diversos, 2004. Translation of *"Buffy the Vampire Slayer" and Philosophy.*

Stafford, Nikki. *Sarah Michelle Gellar: Buffy la tueuse de vampires.* Trans. Valérie Dariot. Paris: Editions 84, 1999. Translation of *Bite Me!*

Topping, Keith. *Le vampire d'Hollywood: Le guide non officiel de la serie.* Trans. Alexandre Deschamps. Paris: Hors Collection, 2000. Translation of *Hollywood Vampire.*

Topping, Keith. *Tueuse de vampires: Le guide non officiel de "Buffy."* Trans. Alexandre Deschamps. Paris: Presses de la Cité, 2000. Translation of *Slayer.*

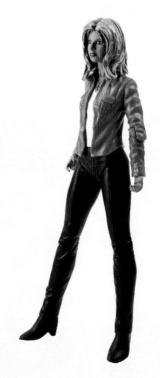

Nancy Holder

New York Times best-selling author Nancy Holder (the Wicked saga) has written nearly three dozen *Buffy* and *Angel* novels, novellas, and episode guides, as well as academic textbook chapters, essays, and articles. Many of her early *Buffy* projects were cowritten with Christopher Golden, including the first original *Buffy* novel (*Halloween Rain*) and the first licensed episode guide, *Buffy the Vampire Slayer: The Watcher's Guide: Volume 1*. *The Watcher's Guide: Volume 1* appeared on the *Los Angeles Times* best-seller list and reached #2 on amazon.com, which lauded it as "superb." Amazon.com also presented Holder with a special sales award for *The Angel Chronicles, Volume 1*, which was also a Bram Stoker Award nominee. She has served as banquet keynote speaker at three of the five Slayage conferences, and taught a class on *Buffy* at the University of California, San Diego. Other *Buffy* appearances include Geek-GirlCon, for the launch of *Whedonistas!: A Celebration of the Worlds of Joss Whedon by the Women Who Love Them*; the San Diego Comic-Con; and Dragon*Con.

"Universes" for which Holder has written tie-in material include *Firefly*, *Teen Wolf*, *Smallville*, *Hellboy*, *Hulk*, *Saving Grace*, *Highlander*, *Wishbone*, *Sabrina the Teen Age Witch*, and others. With Debbie Viguié, she's written three young adult dark fantasy series—Wicked, Crusade, and Wolf Springs Chronicles. She also co-wrote a number of *Buffy/Angel* crossover novels with Jeff Mariotte. She recently completed the young adult horror trilogy Possessions. *The Screaming Season*, the final novel in the Possessions trilogy, received the 2011 Bram Stoker Award for Best Young Adult Novel. Her short stories have appeared in many "Best of" anthologies, and she has received Bram Stoker Awards for three of them. Her horror novel, *Dead in the Water*, also received a Bram Stoker. She was also honored with a 2012 Pioneer Award from *Romantic Times* for her work in genre fiction.

Recent and upcoming publications include a piece in the mosaic novel *Zombie Apocalypse! Fightback*, and a novella in the threaded narrative, *VWars*. Holder also has stories in *Two and Twenty: Dark Retellings of Mother Goose Rhymes*, *An Apple for the Creature*, and *Shards and Ashes*. She has edited two anthologies: *MOTA: Integrity*, and *Outsiders: All New Stories from the Edge* (with Nancy Kilpatrick), which was a Bram Stoker nominee. She is currently editing a Honey West anthology.

She writes comic books and pulp fiction (the Domino Lady, *Kolchak the Night Stalker*, Zorro) for Moonstone Books. She and Erin Underwood serve as co-columnists for the Science Fiction Writers of America *Bulletin*. She teaches in the Stonecoast MFA in Creative Writing Program offered through the University of Southern Maine.

Holder lives in San Diego with her teenage daughter, Belle, with whom she has published two short stories. They are owned by two corgis, Panda and Tater Tot, and three cats: Kittenen [sic], Snow Vampire, David, and McGee. A former ballet dancer, she has a B.A. in Communications from UCSD and is currently working on her master's in carpool. Visit her at www.nancyholder.com or on Facebook and Twitter.

Acknowledgments

So many people helped so much to make this labor of love a reality. First and foremost, thank you to everyone at becker&mayer!: Amelia Riedler, who invited me; Kjersti Egerdahl, who edited me; Kara Stokes, who got the pictures; Rosebud Eustace; Shirley Woo; and Lauren Cavanaugh. My gratitude to my agent, Howard Morhaim, and his assistant, Alice Spielburg. A special thanks to Jane Espenson for answering so many questions and getting pictures; and to Shiai Mata, for everything from helping with the comic book section to finding great photos and filling in a lot of blanks. A salute to Don Macnaughtan for the *Buffy* bibliography, with an assist from Alysa Hornick. For the quotes, photos, and sketches, my heartfelt gratitude goes out to: Todd McIntosh; John Vulich; Cynthia Bergstrom; Steve Hardie; Amber Benson; David Fury; Juliet Landau; Tara O'Shea; Abbie Bernstein; Amy Bemmes (@AmyWhedonite); Little Willow; Paula "Polgara" Carlson; Cosmic Bob; Whedonesque; Rhonda Wilcox, Ph.D.; David Lavery, Ph.D.; Jennifer K. Stuller; Charlotte Fullerton; Yvonne Navarro; Allyson Beatrice; Tana Bratton; Kristy Bratton; Tara Bennet; Kelli Anne Rucci Creamer; Wendy Lieb Schapiro; Mariann Palmer; @Whedony; Lynne M. Thomas; Deborah Stanish; Timothy Cox; Rebecca Safier, Arielle Kesweder, and all the San Diego and California Browncoats; my Slayage friends and colleagues; and Wayne Hutchinson. On the home front, thanks to my family and especially Belle Holder the Vampire Slayer. You make the world a shinier place.

Special Thanks

Thanks to Lauren Winarski, Gianna Babando, Shana Levin, and Jacque Giebel at Fox for helping us gather great images and props from the Fox archives. Thanks to Tim Wiesch at Dark Horse Comics, Joseph Cultice, Steve Hardie, and John Vulich for supplying us with great images and sketches. Thanks to Cynthia Bergstrom, Carey Meyer, and Todd McIntosh for entrusting us with their original sketches and photos. Thanks to Danny Kaminsky for his help with image permissions and approval. Thanks to Adam Reisinger for sharing his action figure collection with us.

Image Credits